Moll • J. Leach • C. Converse • J. Greco • N̶ ... ner
M. Merims • G. Pechie • P. Leach • R. Standr... ter
lini • M. Tyson • R. Johnson • D. Logan • K. ... inn
dzel • E. Stevens • C. Moloney • R. Franklin • ... ty
• K. Weitzel • R. Totah • N. Degregorio • ... dt
nann • S. Passarell • G. Montanarello • T. M... bo
H. Noren • V. Melvin • C. Quinn • D. Miller • M. Green • M. Barley • M. Flood • E. Teall
S. Urich • S. Cliff • C. Dickerson • F. Tantalo • A. Coriddi • W. Miller • M. Lockwood
G. Cleveland • J. Dennis • W. Graham • M. Naugle • L. Gibbons • R. Daley • H. Truesdale
ssell • K. Wright • C. Fritts • C. Waters • W. Rutter • R. Ahlman • E. Chasse • D. Keys
oolston • R. Bodak • K. Cassese • D. Dardaganis • R. Anciukaitis • W. Champeney • B. Hood
r • D. Adams • A. Secash • J. Vandenbos • R. Daily • P. Marullo • W. Boothby • D. McNeil
Paladino • C. Brown • T. Anders • P. Ryan • N. White • W. Shannon • S. Vanvalkenburg
lein • L. Skipper • K. Richter • L. Gillette • P. Dailey • J. Hultman • A. Garcia • B. Simmons
Lowry • M. Cummings • D. Johnston • W. Thibault • L. Faulstick • J. Gilbert • T. Gahagan
ris • B. Godfrey • G. Skilins • J. Gear • N. Verweire • J. Coger • F. Tremiti • F. Gutowski
• D. Ingham • D. Scheffinger • A. Kerstetter • B. Bethmann • L. Duncan • W. Walburn
strong • T. Robinson • A. Incardone • J. Minwell • J. DiStasio • H. Henshaw • F. Dangelo
er • J. Kierecki • S. Bizok • D. Wood • R. Beyer • C. Roberts • J. Johnson • N. Mantzidis
M. Le • G. Waheibi • S. Luchanko • D. Morgan • T. Fichtner • A. Wagner • G. Lejnieks
Guida • B. Fuchs • W. Lee • M. Laspada • G. Burley • R. Hartung • A. Vanetten • D. Baker
dersen • R. Secash • S. Bunis • A. Jefferson • L. Do • J. Hohman • J. Madigan • A. Alvarez
J. Tillinghast • S. Pruzniak • C. Colon • M. Disanto • M. Lagasse • J. Pacitto • J. Vanslyke
. Dioguardi • A. Ladolce • J. McCullough • F. Martinez • B. Melendez • W. Wolski • R. Grego
K. Johnson • J. Shufelt • B. Seils • R. Marsala • T. Parr • G. Drake • J. Loverde • M. Draper
• R. Stout • W. Anderson • B. Stirk • T. Taricone • M. Dellefave • P. Walsh • D. Shea
Magar • J. Kuchman • D. Miller • G. Poplawski • S. Gerlach • M. McKeown • R. Beachley
M. Warner • T. Barrett • P. Mackey • M. Farmer • S. Quackenbush • D. Dale • D. Anderson
ar • L. Baker • R. Brookhouse • B. Simone • R. Leusch • R. Rada • M. Huussen • M. Nenni
S. Ilievski • G. Chase • C. Burkhardt • T. McCabe • L. Gaddis • M. Erhard • L. Masterson
ubois • J. Johnson • F. Quinones • J. Thomas • K. Best • R. Gill • J. Garlock • J. Halldow
er • L. Houseman • J. Brown • D. Gaylord • D. Rabjohn • G. Brewer • T. Jett • J. Lendeck
arell • J. Kotch • S. Hoffman • T. Trybus • V. Novak • K. Duke • C. Reynolds • F. Yacoby
Sealy • P. Brophy • M. McFarland • W. Greggs • M. Dambrosio • M. Miles • W. Stringer
am • M. Brusso • T. Hackett • N. Valletta • A. Chapman • T. Gilmore • J. Neary • A. Reisig
midt • M. Ross • R. Johnson • L. Wamser • K. Baxter • D. Estey • D. Rohring • D. Betlem
R. Ciaccia • M. Atkinson • P. Tomaselli • T. Vickery • C. Cooper • M. Workman • G. Barkley
es • G. Rivera • D. Dougherty • R. Meiers • E. Krieger • J. Griggs • J. Bopp • R. Zander
• R. Fredenburgh • C. Cuylear • E. Bacon • M. Allen • T. Chapman • D. Conrad • T. Larner
L. Grignol • A. Peres • T. Lapp • R. Carey • M. Tantalo • J. Ellis • T. Boryczka • J. Foster
Welch • F. Spearman • B. Ellis • S. Smith • D. Breemes • D. Lilly • M. Brown • R. Williams
• M. Murray • S. Gibson • R. Summers • D. Borsching • K. Duel • K. Vastola • D. Worboys
agan • T. Boden • D. Greene • C. Rudolph • D. Boddy • J. Dodgson • T. Linn • M. Bianchi
osser • C. Hatch • P. Lobiondo • P. Goodwin • R. Moy • P. Franklin • J. Markle • M. Coil
Bates • B. Conley • T. Walsh • J. Tubbs • R. Steinmetz • D. Barnes • P. Fees • G. Kovac
Fee • A. Caez • V. Sukhenko • R. Chatterson • K. Bhatt • J. Linza • H. Young • D. Schmeer
od • W. Feil • R. Evans • T. Mayer • J. Case • L. Hines • J. Stewart • T. Miller • L. Magin
nby • R. Carson • J. MacConnell • T. Kausch • R. Rozinski • D. Heatherington • T. Hohman
ok • M. Vent • D. Stolp • T. Crouse • W. Maurer • R. Clark • T. Kittelberger • M. Mahone
e • R. Gill • L. Panagiotatos • O. Dennis • M. Snyder • D. Carlson • D. Wilson • M. Sigl
• J. Snow • W. Hennessey • D. Pickett • A. Wielandt • D. Johnson • R. Settles • F. Heglund

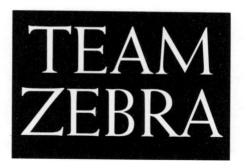

TEAM
ZEBRA

BY
STEPHEN J. FRANGOS
WITH
STEVEN J. BENNETT

omneo

An imprint of Oliver Wight Publications, Inc.
85 Allen Martin Drive
Essex Junction, Vermont 05452

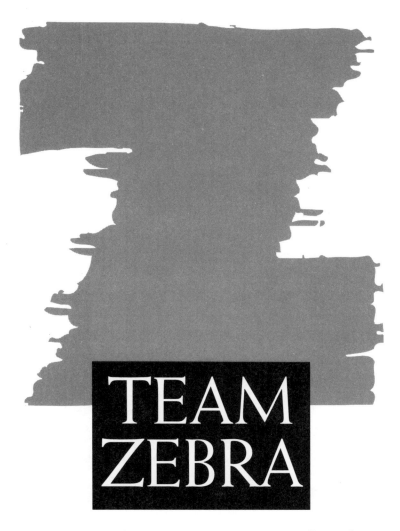

TEAM ZEBRA

How 1500 Partners Revitalized
Eastman Kodak's Black & White
Film-Making Flow

Oliver Wight Publications books may be purchased for educational,
business, or sales promotional use. For information, please call or write:
Special Sales Department, Oliver Wight Publications, Inc., 85 Allen Martin Drive,
Essex Junction, VT 05452. Telephone: (800) 343-0625 or (802) 878-8161;
FAX: (802) 878-3384.

Library of Congress Catalog Card Number: 93-060668

ISBN: 0-939246-38-4

Text design by Marysarah Quinn

Printed on acid-free paper.

Manufactured in the United States of America.

1 2 3 4 5 6 7 8 9 10

To my wife, Kathy, who has creatively inspired and patiently encouraged me for more than 34 years. And to my daughters, Jennifer, Carol, and Stephanie . . . may they and their children be fortunate enough to work and prosper in Team Zebra–like environments.

SPECIAL ACKNOWLEDGMENT

This book would not have been possible without the 1500 Partners and all the spirited and creative energy they put forth as they helped our Zebra dance to new heights. Listed on the inside front and back pages are the names of those Black & White Film Manufacturing partners who were in "the herd" at the end of 1990, the middle of the journey described in this story. I salute and thank them (and others who have followed) for choosing to make such an important difference.

ACKNOWLEDGMENTS

This story would never have come to pass without the 1500 Zebra partners. Likewise, I couldn't have written this book without the assistance of many Zebra helpers.

A group from the Zebra leadership team unselfishly gave time from their extremely demanding work and busy personal schedules to keep me "on track." They responded to a flurry of cries for help, usually at odd times, by phone, fax, or personal visits. Their memories, ideas, and suggestions jogged my remembrances and often helped me reframe my descriptions and analyses of events that contributed to the turnaround of Kodak's Black & White Film organization.

In particular, I want to thank Marty Britt, Bob Brookhouse, Charles Champion, Tim Giarrusso, Beth Krenzer, Rich Malloy,

Bob McKinley, Tony Myers, Deborah Norton, Bill Poole, Gene Salesin, Neil Tornes, Chip Wagner, and Russ Williams. Zebra cheers to you partners!

Others who served on the BWFM leadership team during my tenure at Kodak and played major roles in this story, too, include Tom Babcock, Sue Donovan, Jean Kohler, Don Monacell, Dennis Morgan, Janie Sawnor, Joe South, and Jack Stewart.

A few members of the original Black & White leadership team made their contributions early, then left for other pastures well before I did: Charles Barrentine, Beth DeCiantis, Jackie Hill, and Ken Lamport.

Ron Heidke and Vern Dyke, my "Kodak ambassadors," contributed numerous valuable suggestions, as did Jack McCarthy and Al Sieg. Paul Allen, John Boroski, Ron Roberts, and Chris Veronda also provided me with guidance and assistance. Bill Wallace, who replaced me as the head Zebra, helped coordinate my research visits to the Park and kept me up-to-date about current Team Zebra happenings.

My good friends John and Roz Goldman were great supporters of this writing project. As usual, John's advice and keen insights were appreciated, as was Roz's artistic sense and knowledge.

Many former work associates shared their thoughts and memories about life in the "preflow" and "early flow" days: Bob Bacher, Joe Bourcy, George Davis, Don Delwiche, Tom Fenton, Bernie Girouard, George Greer, Bob Grose, Dan Hedberg, Phil Leyendecker, Roger Maddocks, Charlie Newton, Dutch Schlosser, Marty Sewell, and Shirley Smith.

Other Zebra partners who contributed information or helped make my visits fruitful include John Barrett, Rhonda Beck, John Bonin, Dave Borowiec, Bob Cholach, Randy Ciaccia, Pat Fagbayi, Paul Goodman, Mike Groth, Paul Handzel, Kevin Kennedy, Keith LaFleur, Tom Larkin, Ray Lewis, Sam LoBiando, Paul Lux, Bob Marsala, Terry Mitchel, Vickie Novak, Terry Quetschenbach, Bill

Rutter, Jack Sherwood, Bob Stone, Alicia Strout, Bill Thibault, Pat Traynor, Bill White, and Ken Wiggins.

Among the departed, my parents, John and Eugenia, deserve credit for instilling in me the right values that enabled me to provide the right kind of leadership for the Zebras. Also, George Eastman has to be applauded for founding and growing the kind of superior company that allowed the setting for Team Zebra to take place. Finally, my brother-in-law, Irwin "Riggs" Rohlf, inspired me as he fought a gallant battle against cancer during the writing of this book.

Steve Bennett masterfully crafted and molded my thoughts about and passion for the Zebras into the "reader friendly" form you will experience in the following pages. For his heroic efforts, Steve is bestowed the honorary title "Head Zebra Author."

A special thanks goes to C. J. McNair, who encouraged me to write a book about the Zebra experience, and connected me with Jim Childs of Oliver Wight Publications.

I also want to thank all the people at Oliver Wight for helping to translate a gleam of a book idea into reality. I can't thank Jim Childs enough for his support, encouragement, and help in shaping the project. Jim offered wonderfully constructive suggestions as he guided the "two Steves" (known as "Steve squared") through the process of creating a coherent manuscript. Jim's insights into the Team Zebra story and the people behind it were invaluable. And his patience was nothing less than saintly. For his efforts, Jim is hereby proclaimed "Chief Zebra Publisher/Editor."

Hats off to Jennifer Smith, Debbie Peck, and Mona Ploesser, all of Oliver Wight, for whisking the book from disk into print, and doing all of the behind-the-scenes things that publishers do before a new title hits the shelves. Thanks, too, go to Linda Ripinsky, for her attention to detail during the production phase.

Other people, too, contributed to the making of this book. Hedi Dilmore of The Kodak Image Center and Kathy Wolkowicz-

Connor of the George Eastman International Museum of Photography were extremely helpful in selecting archival photographic materials for the book.

Ruth, Noah, and Audrey Bennett contributed by sharing Steve Bennett's time with me and this project. The many disruptions to their family life caused by this effort were graciously accepted without complaint.

Finally, my deepest thanks go to my wife, Kathy, for putting up with my long hours on the phone, late-night editorial sessions, and general grumpiness that goes along with writing a book. For this, as well as all the important ideas and editorial "catches" contributed, you're entitled to the biggest Zebra cheer of all!

CONTENTS

INTRODUCTION:
YOU PRESS THE BUTTON,
WE DO THE REST

The march of improvement in any given field is always marked by periods of inactivity and then by sudden bursts of energy which revolutionize existing methods sometimes in a day.

For twenty years the art of photography stood still, then a great discovery opened a new channel for improvement, and for the last ten years the art has been in a state of rapid evolution.

Ten years ago every photographer had to sensitize his own plates and develop and finish his negatives on the spot where the picture was taken.

Four years ago the amateur photographer was confined to heavy glass plates for making his negatives, and the number of pictures he could make on a journey was limited by his capacity as a pack horse.

> *Yesterday the photographer, whether he used glass plates or films, must have a dark room and know all about focusing, relations of lens apertures to light and spend days and weeks learning developing, fixing, intensifying, printing, toning and mounting before he could show good results from his labors.*
>
> *Today photography has been reduced to a cycle of three operations:*
>
> *1: Pull the string. 2: Turn the Key. 3: Press the Button.*

So wrote George Eastman in 1888, seven years after he launched the Eastman Dry Plate Company. At the time, Eastman had achieved one of his primary goals—making photography accessible to the common man or woman. With the ease of use of the "Kodak," photography quickly became a fundamental part of American culture. And the firm that Eastman founded (renamed the Eastman Kodak Company in 1892) became one of the most successful enterprises in business history.

Kodak owes its fortunes to a number of factors—technological innovation, savvy marketing, worldwide distribution, and a relentless pursuit of quality. (In 1892, Eastman initiated what may be the world's first product recall; after discovering a defective batch of glass photographic plates, he asked for their return from every customer—at the risk of total financial ruin.) As a result of its reputation and technological prowess, the company came to enjoy a dominant worldwide position during the first 80 years of its existence.

But as Eastman himself noted, every field is marked by fits and starts and "bursts of energy." While Eastman was concerned with technological progress in photography, his insights apply equally to the *business* side of the field. Kodak's dominance in the photographic business was threatened in the 1980s when Japanese companies gained a beachhead in the American markets. Kodak suddenly found itself going head-to-head against highly capable

competitors that could bring sophisticated new products more quickly to the marketplace and at lower prices. The specter of low-price competition was a serious challenge, given that certain segments of the photographic business had become saturated; by the mid-1980s, Kodak could no longer raise prices in tandem with inflation and the cost of materials, as it previously had done for so many years.

When management announced that for the first time in the company's history, Kodak would not achieve its projected profit goals, red lights began flashing on Wall Street, and by 1989, the investment community had become disenchanted with the giant of photography. At home—Rochester, New York—the company also found itself under siege. "Mother Kodak," which had been venerated by generations of families for its benevolence and generosity, became the target of scathing op-ed pieces and letters to the editor following announcements of wage and hiring freezes, cutbacks in shifts, and major restructurings. Panic began to rise amidst rumors of an imminent hostile takeover. Unions took advantage of the current wave of "Kodak bashing" and stepped up their attempts to gain entry into the company (in the United States, Kodak has remained nonunion since its founding). Residents living near the plant suddenly began to worry about toxic emissions and chemical spills. Morale among many employees and managers sank to new lows as people wondered whether they'd have jobs in the near future. I understood their anxieties, because I had to give them straight answers to tough questions.

I joined Kodak in 1957 after receiving a degree in chemical engineering. Following two stints with the army, I settled down into what I assumed would be a straightforward and lifelong career with the company. Neither turned out to be the case. During the course of 34 years, I was given 10 different management assignments that took me throughout Kodak Park, corporate headquarters, and Kodak's manufacturing facility in Colorado. The assignments not only

exposed me to a broad range of operations and manufacturing cultures, but also gave me insights into Kodak's worldwide manufacturing presence. When Kodak underwent a major reorganization in response to the crises of the late '80s. I suddenly found myself in a "do or die" situation, responsible for all of the black and white film production operations at Kodak Park. Less than three years later, with Black & White Film in the black, I accepted an early retirement offer. Both experiences have fundamentally changed my life.

As the manager of the black and white "flow," as Kodak called it, I was honored to work with "Team Zebra": 1,500 men and women who helped bring about a remarkable turnaround in one of the most ailing parts of the company. Through Team Zebra, I had an opportunity to test all the popular conceptions about leading people and operations, to learn new ideas, and to help ensure that one of the bedrocks of our community would continue to support future generations. In the early days of the reorganization, an assignment to B&W had about the same appeal as an all-expense paid vacation to Siberia. When I left, it was one of the most desirable organizations in the Park. And as of the time of this writing, B&W is one of the company's "shining stars" in terms of contributions to the bottom line.

Today, as a consultant and speaker, I devote my time to helping others apply what I've learned from my experience with Team Zebra. The turnaround in black and white, as you'll read about in this book, is unique for a number of reasons. We didn't just "slash and burn"—cut costs and drop product lines—we became more efficient and reorganized our internal operations. We didn't seek major infusions of cash for capital improvements and new technology—some of the greatest production improvements at B&W came about by using scrap parts and good old Yankee inge-

nuity. And we didn't spend a fortune on outside consultants—instead, we unleashed the hidden consulting power within our own ranks, from the people who cleaned the floors to the top decision makers in our group.

In a sense, relying on and recycling our internal resources are techniques very much in keeping with the Kodak tradition. If you were to visit Kodak Park, you'd be surprised at the amount of seemingly homegrown, low-tech gear you'd find in a company that makes high-tech products with incredibly tight tolerances (some of the rolls of film are miles in length, yet cannot vary in thickness by one-tenth of the width of a human hair). The slightest imperfection, a speck of dirt, wrinkle, or smudge can render photographic products unusable. Yet almost all of the production work, much of which is done in total darkness and surgically clean environments, relies on the human eye, human judgment, and simple, low-tech, "people-powered" devices such as the wooden crates (called "caskets") that are used to transport film from one operation to another. Squads of magic gnomes called "commandos"—so named because of their reputation for being able to repair or rebuild any piece of equipment—roam the coating operations in search of equipment in need of repair or modification. The physical plant itself bespeaks an atmosphere of self-reliance; Kodak Park is virtually a self-contained city that provides for the needs of the 17,000 people who now work there.

Interestingly, much of what we discovered during the crisis of 1989 has become popular management theory today:

- We "reengineered" entire production operations, flattening (and inverting) the organizational chart, regrouping operations into efficient "flows and streams," bringing together geographically diverse operations and unifying them through integrated performance measures.
- We created a "learning organization" that encouraged all of

our "partners" (we used this term instead of "employee") to develop new skills and to understand the "big picture" (supervisors and managers referred to themselves as partners as well). We held "town meetings" where people could officially learn about the state of the business and air gripes. We also encouraged people to use E-mail to share their "team victories" with each other, so that successful ideas developed in one part of the business could be adapted easily to another. In short, we fostered an environment that made it possible for people to "shamelessly steal" successful ideas from one another, while always remembering to say "thank you."

- We developed "core competencies" through the establishment of our mission as "the superior film job shop" for Kodak and through our supportive human resources strategy.
- We focused on "organizational architecture" by decentralizing supporting functional staff and creating interdependent work teams that met the needs of the company business units they served. We also sponsored numerous off-site workshops and developed performance management methods designed to change behaviors through education and timely recognition for success.
- We focused on "time-based" competition, which lead to dramatic reductions in cycle time, significant decreases in costs and waste, and the rapid commercialization of stunning new products.

Finally, we gave new meaning to the term "empowerment." By the time you read this book, the "E" word may well have been written off as just another management fad. But if there is one enduring lesson from the Team Zebra experience that I know can be applied to *any* organization, whether it's undergoing a major turnaround or a minor tune-up, it is this:

if you create an environment that motivates people to creatively solve problems and take an active part in their work, you'll realize tremendous gains in productivity, efficiency, and performance.

In B&W, we didn't "zap" anyone or wave any magic wands; we realized that we couldn't really empower anyone to do anything. Rather, we simply made it possible for people to feel that they could do more than "check their brains at the door each morning." We gave them a strong incentive not to waste internal resources, and to become superb problem solvers.

One of our partners who had started as a floor cleaner 27 years ago and worked his way up to the position of process analyst suddenly felt motivated to devise a "real-time" feedback system that allowed him to monitor the processes used in making film emulsions. To create the system, he and his "partners in crime" rescued computer gear destined for the dump and wired it up during their lunch hour and coffee breaks. The system saved tens of thousands of dollars in potential waste and paved the way for the implementation of a sophisticated, dedicated computer system.

Another partner suddenly became motivated to tame a finicky machine that had given people grief for years—by ripping a wooden bumper off the wall and fashioning a shim that kept two parts from scraping together. Now the machine hums away smoothly, greatly boosting the work center's productivity.

Yet another partner noted the difficulties some workers had in manipulating heavy cases of film from a conveyor belt to a loading area. His solution? With help from the engineering staff, he rigged up a large hose and connected it to the building's central vacuum system. With a flick of a switch, even a 90-pound weakling could fling a 75-pound case across the room as if it were suddenly immune to the forces of gravity.

But the notion of an empowering environment extends far beyond the freedom to tinker. People in B&W found new meaning and satisfaction in their work; it was almost as if they were liberated from the "gravitational" forces that often accompany repetitive factory work. One partner who admits that he only stayed on with his box-packing job because of the economy, now works extra hours teaching safety procedures to new employees—in a program that he helped to spearhead.

Throughout the B&W flow, people found a personal thrill in watching performance levels soar to all-time highs and production time plunge to new lows. People began sharing information and taking on more responsibilities; complainers became doers as the doors of opportunity were opened to them.

Of course, not everyone chose to take advantage of the new environment. Some even found the changes too threatening and requested transfers to more traditional pastures within Kodak Park. But for the most part, the excitement of being part of Team Zebra was infectious. As "Zebra mania" spread throughout the workforce, we noticed subtle changes in people's dress habits—anything in black and white became chic. Zebra photographs began appearing on once bare walls. Zebra paraphernalia (mugs, hats, stuffed animals, pens, and the like) began gobbling up desk and bookshelf space. And Zebra celebrations—complete with original skits, songs, and compositions—became favored forms of rejoicing among B&W partners. All of this added up to a major cultural change that enabled the organization to overcome seemingly insurmountable problems.

Before moving on to the story of the turnaround at B&W, I want to point out how my Team Zebra experience put to the acid test one of my most cherished beliefs about work in general and manufacturing work in particular—it should be *fun*. Yes, fun. In my opinion, fun is probably the most underrated, yet critical, element of any work environment. I believe it is also a function of empower-

ment; if you create an environment in which people can make important decisions about solving problems, they should also feel that they have the power to make work an enjoyable experience.

We worked hard. We played hard. We brought about some important change. And that made it all worthwhile.

Stephen J. Frangos
Rochester, New York
June 1993

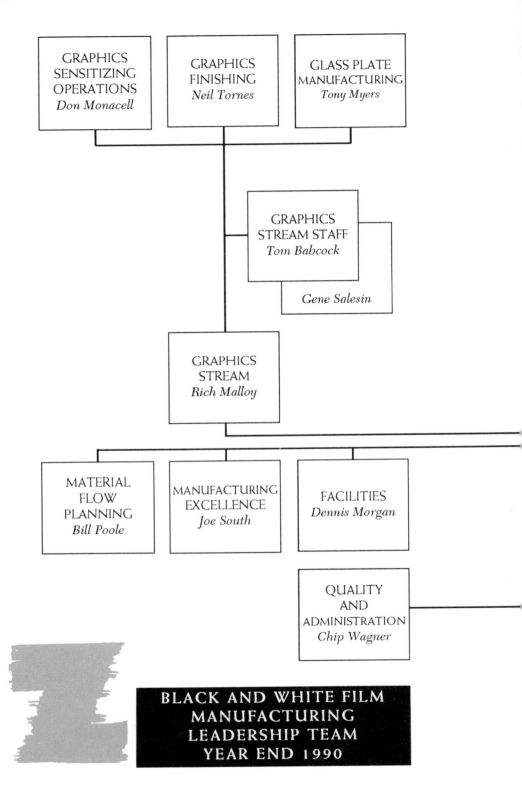

GRAPHICS
SENSITIZING
OPERATIONS
Don Monacell

GRAPHICS
FINISHING
Neil Tornes

GLASS PLATE
MANUFACTURING
Tony Myers

GRAPHICS
STREAM STAFF
Tom Babcock

Gene Salesin

GRAPHICS
STREAM
Rich Malloy

MATERIAL
FLOW
PLANNING
Bill Poole

MANUFACTURING
EXCELLENCE
Joe South

FACILITIES
Dennis Morgan

QUALITY
AND
ADMINISTRATION
Chip Wagner

**BLACK AND WHITE FILM
MANUFACTURING
LEADERSHIP TEAM
YEAR END 1990**

EMULSION MANUFACTURING
Russ Williams

HEALTH SCIENCES SENSITIZING OPERATIONS
Charles Barrentine

HEALTH SCIENCES FINISHING
Jack Stewart

SOLVENT COATING OPERATIONS
Scott Snyder

HEALTH SCIENCES STAFF
Sue Donovan

HEALTH SCIENCES STREAM
Bob Brookhouse

SOLVENT COATING STREAM
Charles Champion

HUMAN RESOURCES
Marty Britt

FINANCE
Bob McKinley

MANAGEMENT SERVICES
Tim Giarrusso

BUSINESS SUPPORT
Jean Kohler
Deborah Norton
Janie Sawnor

FLOW MANAGER
Steve Frangos

Images of Excellence

B&W

Film Manufacturing

TEAM
ZEBRA

Kodak knows no dark days

With its allies, the Kodak flash sheets and a Kodak flash sheet holder, your Kodak camera is ready for every picture opportunity.

Ask your dealer or write us for our little booklet "By Flashlight." There's no charge.

EASTMAN KODAK COMPANY, ROCHESTER, **N. Y.,** *The Kodak City.*

CHAPTER 1

FROM MINTING SILVER DOLLARS TO SQUEEZING COPPER PENNIES

"Annus horribilis," is how Queen Elizabeth II summed up 1992. With the media show surrounding various family divorces and separations, Fergie's scandalous topless escapades on the Rivieria, the conflagration that left Windsor castle smoldering, and changes in the tax law that would drain Her Majesty of £17 million annually, it *was* a horrible year.

Three years earlier, the King of Photography might also have cried *"annus horribilis."* In fact, 1989 was probably the worst year in Eastman Kodak's entire history. Never before had the century-old company found itself assaulted by the local and national media because of its financial performance. Never before had analysts questioned Kodak's ability to dominate the photographic market-place. And never before had Kodak found itself the target of scorn

from the city that had benefited so much from the largess of George Eastman and the company he started. With all the negative press, it seemed that the company was on the verge of collapse.

While "Kodak kicking" was in vogue at the end of the 1980s, there were serious problems facing the company and its primary U.S. manufacturing facility, Kodak Park. Even the staunchest supporters had to admit that Kodak had a crisis on its hands in terms of poor performance, the presence of savvy and aggressive competitors, changes in the marketplace that had deep effects on the company's profitability, and poor morale within the company and surrounding community. Had Kodak not taken steps to improve performance, it might well have been in a precarious position as the 1990s progressed.

In many ways, the crisis at Kodak was one of interpretation and public perceptions—putting aside my fierce loyalty to the company, in retrospect I don't believe that Kodak was in as much danger as the media suggested. Still, the loss of public confidence and the dire predictions of Wall Street put Kodak's entire workforce on "red alert." And had the company not taken swift action to improve performance at Kodak Park, it might well have been in more difficult straits in years to come. Regardless of the realities of the situation, the very fact that Kodak was in a company-wide crisis mode and under siege from the local community, forced it to rethink the way it conducted business. And for Black & White Film Manufacturing (BWFM), at least, the outcome was a remarkable improvement by just about every conceivable measure.

It would certainly be possible to write an entire book analyzing those awful months in 1989. But that wouldn't shed any light on the story of how Team Zebra kicked new life into an ailing, but promising, manufacturing operation. Instead, here is a condensed "cream of crisis," highlighting the major factors that contributed to the growing sense of despair and desperation that pervaded the atmosphere at Kodak and the surrounding community.

SELLING MORE AND MAKING LESS

On May 2, 1989, Kodak reported that despite a rise in sales of 17 percent from the prior year, first-quarter earnings were off by 23 percent. Coming on the heels of speculation about Kodak's potential liabilities in its court wranglings with Polaroid over patent infringements, the news triggered a sell-off that caused the company's stock to fall sharply.

The drop in earnings was especially baffling for many investors, given the fact that the previous year's first-quarter earnings were the best in the company's history. What happened? The press cited Kodak officials, who in turn offered a variety of reasons for the surprising fiscal performance. Said Kodak spokesman Ronald Roberts in the May 2, 1989, edition of Rochester's *Times-Union*, "There's a combination of things that have a hand in depressing earnings." Colby Chandler, who had been CEO since 1983, gave the press more details, pointing to inflation and unfavorable exchange rates as major culprits in the situation. Kodak, he explained, had enjoyed almost no benefits from rising overseas prices during the previous seven years, at a time when the company's costs rose about 35 percent. He also cited the extra $62 million in after-tax interest payments on the $5.1 billion it had borrowed to purchase Sterling Drug. The interest expenses chewed into already flat profits.

Despite the disappointing financial showing, Chandler held to an earlier claim he had made that 1989 would turn in "record earnings" for the company. For one thing, he expected favorable exchange rates to benefit the company by the end of the year. For another, newly instituted cost-containment programs and an "exit from non-strategic businesses" would trim $200 million per year in costs. Chandler also told the *Times-Union* that "a quarter doesn't a year make."

Analysts, however, were more disturbed by the implications of the poor quarterly performance and less optimistic about Kodak's setting any records in the near future. Many noted that Kodak's problems were far more deep-rooted than interest expenses and exchange rates, and expressed concern about Kodak's ability to maintain prices in its core business. Eugene Glazer, who followed Kodak for Dean Witter Reynolds, Inc., commented that "they are finding that the competitive environment . . . won't allow them to raise prices enough."

The *Wall Street Journal* also pointed to competitive pressures as Kodak's main long-term problem. After granting that in 1986 Kodak had been through an even larger cost-containment drive than the one Chandler alluded to, pricing would be more problematic: "Kodak is facing strong pricing pressure in Japan, where Fuji Photo Film slashed prices to stem the wave of so-called gray imports—the sale at deeply discounted prices of export goods that are brought back into the country by an importer other than the manufacturer. Competition has kept a lid on prices in France and West Germany, as well."

Finally, in the immediate aftermath of the disappointing announcement, analysts wanted more details. "There was a lack of real specifics and a feeling that it's going to take longer to get on track," said Charles Ryan of Merrill Lynch Capital Markets. Ryan's assessment was born out on Tuesday, August 1, when Kodak announced its second-quarter profits. The day that Kodak was scheduled to release its earnings report, the Rochester *Democrat and Chronicle* ran a story headlined, "Bleak Kodak Profits Predicted," and reported that "Wall Street analysts are braced for bad news this morning." The paper cited Brian Fernandez, a managing director of Brean Murray Foster Securities in New York City, who prognosticated, "It's not going to be a good reading. I don't know how bad it is going to be."

Fernandez probably couldn't have imagined how bad it was actually going to be—an 85 percent drop in net income. Again, sales were up in comparison to the previous year. Again, Chandler pointed to unfavorable interest and exchange rates, and charges of $338 million that Kodak took against operating earnings. Inside Kodak, Chandler expressed his dismay at what later became known as the "Machete Speech." The infamous talk, which took place at a small auditorium in Kodak's Marketing Education Center on River Road and was attended by some 25 top managers, began in typical "Colby" fashion—firm, yet gentle. Chandler described his dismay with the continuing decline in fiscal performance and his concerns for the company. Then, the soft-spoken man who can easily be characterized as "the grandfather that anyone would want" raised a 12-inch-long machete and began hacking at the wooden lectern, causing managers in the front row to duck as the chips flew by their heads. Having made his point about cutting costs and lopping fat, Chandler resumed his normal composed demeanor and concluded his talk.

Chandler didn't wield a machete when he spoke with the media, but he did promise "strong action." He also didn't commit the same mistake of offering optimistic turnaround news in the face of miserable numbers; he even went so far as to warn that the quarter profits would not be cause for celebration. Almost immediately after this admission, Kodak found itself under heavy fire from the local and national business press. For the next three months, a steady stream of articles warned of Draconian cuts at the Park; business writers, analysts, and pundits all speculated about which organizations would be put on the block and how many heads would roll. While much of this was pure speculation, one thing was sure: *something* was going to happen.

SHARING IN A SHRINKING PIE

In the decades before the crisis, photography had become a basic part of the American experience—everybody's life was touched or influenced by photography in some way (which is exactly what George Eastman had strived to do in his lifetime. When he committed suicide in 1932, in the midst of a debilitating illness, he left the simple note "My work is done. Why wait?"). But by the 1970s and 1980s, the photographic market had changed; the rate of growth had slowed not only because of market saturation, but also because highly sophisticated, yet affordable, video cameras began competing for photo dollars and photo time.

While the market for traditional photographic products was no longer growing as it had in the past, the competition was intensifying, both for consumer and professional products. "Fuji changed the game in the '70s when it stepped up its presence in the U.S. and Canadian markets, and competed on the basis of price," explains Al Sieg, a former director of strategic planning who once headed Kodak's Japan-based operations. "At first, Fuji was confined to the West Coast—but that changed when the Japanese film maker found its way cross-country."

Sieg recalls 1978 as a key year in the new competitive battle for photographic film and supplies. At that time, Fuji introduced to the world advanced technology films. For the first time, it could sell a level of quality that could meet the needs of many customers. "I don't believe it was superior to Kodak's products, but for people who were price conscious, the film was very appealing."

Nothing was more symbolic of Fuji's growing stake in the U.S. market than the sight of the company's great green blimp floating overhead during the 1984 Olympics in Los Angeles; Fuji had outbid Kodak and become the official supplier of film to the Olympics, paying what was reportedly a "king's ransom" to the Olympics

Sponsoring Committee. Not only was this a major slap in the face to Kodak, but it was a sober reminder that no one has a permanent or airtight grip on a marketplace. The auto makers in Detroit learned the hard way after years of laughing at imports. Kodak was already chastened after losing the 35-mm camera market to Japanese manufacturers, so it was hardly cavalier about the potential threat.

(While presiding over Kodak's operations in Japan, Al exacted sweet revenge by renting a dirigible from Japan Airship Service and having it adorned with the yellow and red Kodak logo. When airborne, the blimp ["Kodak Go"—"Kodak Ship"], which dwarfed the JAL 747 that it bunked with in a hangar outside Tokyo, could be seen throughout the city. Sieg used the blimp to "terrorize" Fuji headquarters for the next year and a half. "What better sign that we were going to have a larger-than-life presence in Japan!" he says with impish glee.)

Back in Kodak Park, the realities of the changing marketplace became apparent as we tested competing products. Part of my job as a director of the paper service division during the '70s was to manage the competitive testing of batches of paper from other manufacturers, then display the finished products along with photos printed on Kodak paper during managers' meetings. I remember their amazement at how much our competitors had improved their quality. The good old days of worldwide dominance were certainly in jeopardy; perhaps without our realizing it, they'd already become a thing of the past.

MAKING LESS AND SPENDING MORE

The competition certainly did pose a long-term problem, as the analysts pointed out following the announcement of the first-

quarter earnings. But there was, in fact, another set of problems that had a significant impact on the bottom line, at least in terms of the film and film products business: the company's manufacturing performance. Traditionally, each "fiefdom" in the functional organization kept a narrow focus on its own area of responsibility, and developed a high degree of expertise in its niche.

While the fiefs operated independently on the factory floor, the middle management "barons" gathered daily at the "Lunch Club" held on the third floor of Building 26. With its dark paneling, Remington bronze, and some valuable paintings, along with a portrait of George Eastman, the room resembled a gentleman's club; in fact, once you walked in there was little to remind you that you were in the midst of a massive factory complex. The Lunch Club was a time for sharing ideas and solutions, a rare time when information crossed the "silver curtain" that separated the functional units. By the late '80s, however, the popularity of this dining room dropped as other forms of communication came into play.

The functional expertise of the fiefs unfortunately often came at the expense of satisfying our customers. Each "fief" found itself saddled with mountains of raw materials and "work in process" in order to perform its work. Even if our production couldn't keep up with orders, we knew that in the end, Kodak could always depend on what is known in manufacturing as "safety stock"—product that can be shipped off the shelf to satisfy customers. But safety stock, except when it is used to meet seasonal demands, is expensive to carry, and there are far more cost-effective ways to meet customer deadlines; Kodak's manufacturing organizations just weren't ready to abandon the 100-year-old practices that had served them so well. Some customers even built up their own "reverse safety stock," extra product "just in case" Kodak couldn't deliver. In fact, Black & White Film product deliveries to Kodak distribution centers were late one-third of the time.

Cycle time—how long it takes to create a batch of product from start to finish—was yet another major manufacturing problem at the Park. The sensitizing part of the black and white film operation (i.e., the creation of the emulsion and its application to the support film), took an average of 42 days from the time we'd get an order to the time we'd execute it. This reflected a tremendous inefficiency in our production operation.

Aside from delivery and cycle time problems, new product development ranked high on the Kodak's list of performance woes. It might seem as if change is slow in photography, but as in any industry, new products are the lifeblood and the hope for the future. Even today, Kodak constantly refines existing products and introduces new ones to bring users higher speed, better resolution, more flexibility, greater ease of use, fewer pollutants, and other improvements. Unfortunately, in the late '80s, because of over-optimism and unrealistic schedules, B&W was almost always late with promised products—something we couldn't afford to do with competent and aggressive competitors nipping at our heels.

Finally, there was the very important issue of quality. Since the early days of the company, George Eastman insisted on perfection. And, throughout the years, Kodak had lived up to Eastman's quality standards, gaining a reputation that placed it among the quality elite of the world. Like many American companies that hadn't grasped the concept of "doing it right the first time," however, Kodak maintained quality through the "brute force" method. By conducting extensive testing and inspection during each operation, then throwing out or recycling anything that didn't meet stringent quality criteria, the company was able to maintain high levels of quality, but at great cost to the bottom line. The brute force method also required a tremendous amount of infrastructure and generated an amazing amount of waste. In contrast to products such as radios or televisions, which can be checked for quality

without sustaining damage, photographic products generally require "destructive testing"; that is, the testing process consumes them. For Kodak, destructive testing amounted to millions of feet of film tossed into the recycling bin and millions of dollars down the drain.

Senior management had long been aware of costs associated with the brute force quality method. It also knew that the organizational structure of the Park simply perpetuated the problems. Ron Heidke, who was the general manager of Rochester Film Sensitized Products Manufacturing during the crisis of 1989, points to Kodak's 100-year-old Kodak "stovepipe organization," with its vertical chain of command, as a major cause of poor performance and expensive-to-maintain quality: "Each functional organization had extraordinary knowledge of its own area, and each was allowed to determine its own criteria for success. Unfortunately, each organization was recognized individually for being cost-effective. Because everything was focused on the effectiveness of each functional unit, the units tended to optimize for themselves at the expense of the total operation.

"For example, people would be rewarded for reducing the waste only in their organization. Let's say you were dealing with a final film product that had many different sizes and shapes. You have a machine that can coat 80 inches wide, and you'll only have an inch on either side that's wasted. But for the next operation, 80 inches may not be the right size at all, and you wind up with significant waste. So while you'd get rewarded for being cost-effective in coating, the people in the next organization would get penalized for your success. In the end, the company would be the real loser."

As the most senior executive in Kodak Park, Ron felt enormous pressure to cut costs and become more responsive to the needs of the customers. While Colby Chandler promised "significant action" on a corporate level, Ron would have to take significant action

of his own; manufacturing simply could no longer go on as it had in the past.

TROUBLED WATERS IN ROCHESTER

Following Colby Chandler's announcement of the dismal second-quarter earnings and his pledge of tough action, the residents of Rochester were treated to almost daily articles on Kodak's fiscal woes. Then, on August 10, 1989, the *Times-Union* ran an article entitled "Kodak Makes Another List," referring to a National Wildlife Federation study that rated companies in terms of their toxic releases. Kodak was fifty-sixth on the list, a surprise to many who never made the connection between photographic supplies—film and paper—and chemicals. Another study gave Kodak the dubious distinction of being the nation's largest user of methylene chloride, a solvent used in the making of film base and a possible carcinogen.

The Wildlife Federation's announcement coincided with a visit from CBS reporters who interviewed the co-chairperson of Concerned Neighbors of Kodak Park, a grass roots community group that had formed in response to reports of toxic chemical leaks at the south end of the Park in an area known as "West Kodak." In particular, the local community was concerned with groundwater contamination from a spill along a fence that abutted residential property. While Kodak immediately filed the necessary reports with local authorities, many people were angered that they only learned about the accident through the local press (the company had prepared a newsletter on the incident, but was beaten to press by the local papers).

While the hundreds of millions of dollars that Kodak spent to correct environmental problems could not be blamed for the decline in profitability, the last thing Kodak needed was another

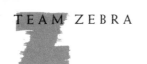

blemish on its image. The fear of sickness combined with fear of job loss merely reinforced the notion that Kodak was a company in serious trouble. Mother Kodak not only seemed to be falling apart at the purse strings, she might be poisoning her children as well.

Perhaps Mother needed "help" from an outsider.

TOO BIG TO SWALLOW?

"All you'd need would be about $25 billion to take over Kodak," said Shirley Smith, the former manager of paper finishing. Shirley's conclusion followed an ongoing discussion he and I had begun in the early '80s, when "merger mania" reached a high point. At the time, Shirley and I had speculated "just for fun" what it would take for someone to walk away with Kodak. In the summer of 1989, the calculations were less of a game.

A Kodak stock devotee, Shirley had every conceivable number relating to the company's stock at the tip of his tongue. The figure of $25 billion was based on the assumption that stockholders would accept a 50 percent premium as a great-enough incentive to sell out. "They'd hesitate for about a nanosecond," he said, as he stretched his arms and rolled his head. "That would be the end of Kodak as we know it."

But could anyone raise $25 billion for a hostile takeover? In the 1970s, raising that kind of money would have been inconceivable. In the "Era of Junk Bonds," though, someone could actually pull together the necessary money. Someone like Carl Icahn, who was reportedly circling the company like a shark contemplating a tasty meal. (One version of the Icahn takeover had Kodak climbing into bed with General Electric to protect itself from the imminent attack.)

In reality, taking over Kodak would have required about the

same cash as that involved with the infamous RJR-Nabisco deal, in the $25 billion range. So a hostile takeover was indeed *possible*, even if not very *likely*. At the time, the company was burdened with debt from the Sterling Drug acquisition, and the uncertainties over the Polaroid lawsuit were dark clouds on the horizon. Later, Kodak devised a unique and potent poison pill—among other provisions, the pill provided "golden parachutes" for *everyone* in the company. Even so, just the fact that it was possible for someone to gobble up the company was enough to strike terror into the hearts and minds of folk throughout the company and community. (It also ran the stock to a year-long high.)

As so often happens when rumors run rampant, people begin thinking and talking as if the speculated outcome had already become a reality. Visions of ruthless corporate raiders abounded, replete with mass terminations and the disemboweling of the Park. The spirit that George Eastman had kindled a century before would be squashed like an ant under the foot of a rogue elephant. And the city that Eastman had said he "loved above all others" would lose a vital force and potent benefactor. Of course, none of this happened. But the anxiety it created certainly contributed to the crisis mentality building within the company and surrounding community.

THE POLAROID FACTOR

Intellectual property attorneys were hardly the only ones eager to hear the outcome of the lawsuit that Polaroid brought against Kodak in 1976. Since the 1950s, Kodak had worked in close cooperation with Polaroid to manufacture the film and papers used in many of the products Polaroid sold. Eventually, Polaroid began making most of its own film, although it continued to purchase some materials from Kodak (Kodak remained a vendor to Polaroid

even during the lawsuit; Kodak people received a legal advisory letter that we were to continue to treat Polaroid as we would any customer, providing top-quality product in a timely way).

In 1976, Kodak announced that it would be offering its own line of instant photography cameras and film. Within days, Polaroid's lawyers filed a suit claiming that Kodak willfully and maliciously violated Polaroid's instant photography patents. Polaroid also charged that Kodak intentionally tried to block Polaroid from entering the conventional photography business by forcing it to suffer losses in the already unprofitable instant photography market. Kodak's attorneys argued that the patents in question were invalid, and Chandler testified that Kodak made its plans to enter the instant photography business for one reason and one reason only—to make a profit.

By August 1989, it was clear that Kodak would have to pay some kind of damages to Polaroid—anywhere from less than $500 million plus interest (Kodak's plan) to as much as $12 billion (Polaroid's plan). Whatever the outcome—and despite the fact that Polaroid would have won rights to be the key player in a market that had been all but destroyed by one-hour photofinishing and inexpensive, yet highly automated, 35-mm cameras—analysts noted that the cash drain on Kodak would not help the company at a time when earnings were so disappointing.

As in the case of the takeover rumors, the psychological effects of the Polaroid lawsuit took their toll. Mother Kodak was apparently in serious financial trouble, accused of spewing toxic waste, and waiting like a sitting duck for a corporate raider. If all this wasn't bad enough, her very integrity was now at stake. Many supporters within the company and community simply found it impossible to believe that Kodak would ever engage in anything unethical or illegal. Nonetheless, there it was in the media almost daily, with all the drama of a low-budget made-for-TV movie. What else could befall the giant of photography?

UNION WOES

George Eastman had a simple philosophy: offer employees a good salary, unprecedented benefits (Eastman Kodak was among the first to offer comprehensive health care benefits for its people), and a "wage dividend day" (Eastman started it in 1899 and called it the "divvy." In 1912, it became institutionalized and the company has shared profits with employees every year except 1932; for some people, the wage dividend constituted as much as 20 percent of their annual income). Local merchants also counted on the wage dividends, often planning their anticipated revenues against "bonus day." When I interviewed for a job at Kodak in March 1957, it happened to be wage dividend day. I was astounded by the circuslike atmosphere and glowing smiles I saw on everyone's face. When I returned home, I reported to my family and friends that Kodak was certainly a "happy place to work."

A lot of Kodak employees felt the same way, and, not surprisingly, all previous attempts to unionize Kodak failed. According to one bit of Kodak lore, in the 1930s, a group of fiercely loyal Kodak employees armed with pipe wrenches chased union organizers from the Park. But in the summer of 1989, things were very different. With fears of layoffs and takeovers, morale among Kodak workers had reached an all-time low, a fact that did not escape the International Union of Electrical Workers. The IUE and several other unions stepped up their leafleting efforts and media campaigns, and claimed growing support from within Kodak's workforce. (Ironically, I remember receiving an IUE leaflet by the copper beech trees near the Kodak Park entrance gate. The trees sit majestically near an underground memorial that contains Eastman's remains.)

The chances of unionization might have been similar to those of a hostile takeover; still, the publicity and attention given to the

unions added to the general image of a company in trouble and under fire. The response to the IUE's overtures represented yet another drain on precious executive time and resources, time that needed to be funneled into bringing about key changes in the way the company did its business.

STRONG MEDICINE FOR TOUGH TIMES

After Kodak revealed the bad news about the first-quarter's earnings, CEO Chandler commented in the May 3, 1989, edition of the *Times-Union* that "I think it's likely we'll do some things to make it change. We've got to do something." After the second-quarter announcement, he said at a press meeting, "Strong steps are being taken to address the earnings shortfall" and also "Nothing is sacred."

Chandler's steps included the reduction of the workforce by 4,500 jobs worldwide, freezing the pay of all Rochester-area workers in 1990, basing future wage dividends on the company's profits, making stronger ties between top executive pay and performance, divesting the company of nonperforming businesses, and further reducing inventories. The idea of restructuring was not new; in 1983, Kodak had eliminated 7,000 jobs in Rochester and 3,800 jobs elsewhere, through voluntary reductions; another major restructuring took place in 1986, primarily through voluntary reductions. Contrary to the reports in the press that cartons of pink slips would be passed out, this restructuring, known as the Limited Separation and Enhancement Plan, was largely a voluntary reduction that offered generous benefits.

None of Chandler's action steps were greeted warmly by the workforce or the surrounding community; the reductions were

reported as "job eliminations," and the union organizers had a field day with the pay freeze and alteration to the wage dividend. But to the financial community, the company was finally taking steps in the right direction. Still, the attitude was "wait and see."

While Chandler and his colleagues were making top-level decisions at Kodak's 19-story headquarters in downtown Rochester, three miles away in Kodak Park, Ron Heidke was administering his own potent therapy in the form of a new organizational structure called "flow." In a nutshell, flow did away with the competing stovepipe organizations and "flattened out" the organizational chart. In the past, many different functions reported to an array of different managers; those involved with film coating reported to the coating manager, while those who packaged the film reported to the finishing manager. This setup led to the "every function for itself" mentality that ultimately caused high inventories and lower responsiveness to customer needs. Under the flow organization, the boundaries between functions blurred and the manufacture of film and paper became a seamless process from raw materials at one end to finished goods at the other.

Now, as the old saying goes, the time to make an escape plan is before you need one. Fortunately for us, Ron Heidke had realized in the middle '80s that a drastic change was necessary if manufacturing was going to cut its costs and improve performance. On January 12 through 14 of 1987, Ron convened a meeting of his senior managers (myself included) at Geneva on the Lake, a scenic resort about an hour from Rochester. A dynamic leader, Heidke wanted to simultaneously energize us and build enthusiasm for the concept of a "high performance workplace." One of the tenets of high performance is that you must perfect a smooth flow of materials through the manufacturing operation, a definite sore point back at the Park. As the group discussed high performance issues, the word "flow" kept cropping up again and again. I could feel the

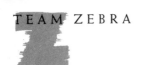

excitement in the air as we began brainstorming the application of high performance to the Park—why not use our existing facilities but organize the work according to natural material "flows"?

In principle, the idea was simple: we would teach people to treat others downline as their "internal customers." So instead of focusing on "what sheet or roll size works for me," people would begin thinking in terms of "what *you* need when you get the work from me." In return, those downline would provide valuable information to those "upstream," so that they could improve their operations and products. Such a cooperative approach would put an end to the expensive and nonproductive turf battles plaguing the Park that compromised our responsiveness and performance. Exuberant, the group left the shores of Seneca Lake agreeing to meet again soon to begin developing a major reorganization plan.

During the next two years, we met off-site numerous times to discuss the mechanics of converting the Park into a flow organization ("reengineer" the Park, in today's management vocabulary). Not only were there immense logistical problems in redefining the way work would be done, but we also had to worry about the loss of expertise in each area of the manufacturing process—as problematic as the stovepipe organization was, it did produce high-quality work and high levels of profit for the past 100 years. Could Kodak really abandon its heritage and still maintain quality and excellence? Finally, there was the challenge of getting people to feel comfortable with yet another change in a world that seemed to be collapsing under their feet.

By the end of 1988, we had a plan that called for reorganizing the Park into six flows: two for photographic paper products, and four for film products. The film flows included Consumer Products (amateur film); Professional (commercial, industrial, journalistic, and scientific use); Motion Picture (for the professional movie and television industries); and Black & White Film (X-ray, graphic arts,

microfilm, aerial photography, and scores of other products—in other words, anything else that wasn't made by the other flows).

To explain the flow concept, Kodak produced a brochure, *The Flow Team Way*, in which the three Kodak Park general managers, Ron Heidke, Ken Hoffman, and Vern Dyke, described how flow would not only be a "formidable competitive weapon," but also would ensure that "the Kodak Park site remains a competitive force into the 1990's and beyond." Dyke assured the Park employees that "it's like starting out together on a long and exciting journey. We know our destination, but we're going to create our own road maps as we travel." And Hoffman commented on the role of the newly created core groups (units that supported the flows, such as plant services, utilities, human resources, engineering, etc.), which would ensure Kodak's "continuing commitment to functional and technical excellence."

When the flow concept was officially announced in early 1989, Kodak began a pilot reorganization of the paper operations, both color and black and white. The idea was to first iron out the kinks in the paper flow, then convert the film operations to a flow structure. The plan called for going with the paper products first, because the paper operations were already aligned closer to a flow fashion and the facilities were easier to separate. Film would be a far greater challenge.

Our original goal was to begin the film flows in January 1990. But as Ron put it, when the crisis reached "fever level" in August of 1989, there was no choice but to "go with the flow" immediately. And to demonstrate the seriousness of his intent, shortly after he announced the film flows, he sent a letter to supervisory people, which in essence said, "If you can't meet the performance criteria we've agreed to, you are to stop making product. And only after we have talked about why you can't meet performance criteria are you allowed to proceed. If you proceed without this discussion, you'll be demoted or dismissed." (Looking back, Ron recalls, "A lot of

people interpreted my letter as saying that I was going to shut down a lot of operations because they weren't meeting their goals. In fact, what I wanted to do was to have them explain to me how they planned to solve the waste problem. [Actually, the production of only one product was suspended—for about three months.] Ron's decision was nothing less than a bombshell. No one knew for sure whether the flows would work and how to overcome problems that would inevitably occur. The workforce was also leery of more change at a time when the company seemed to be unraveling; already suspicious of just about anything that management was up to, many people were skeptical that the new plan would work at all. For some people assigned to the black and white flow, the news was mortifying. The color end of the business had taken on an aura of its own; working for color carried a certain cachet and a special status (color films are the limelight products and backbone of the company). Though black and white products were important and necessary, by contrast they were associated with yesterday's technology—as one shop floor operator put it, "B&W was something your father or grandfather did when they worked for Kodak in the good old days. Who wanted to go back in time?"

With morale problems at an all-time low, the community up in arms, and top management under the gun from Wall Street, we began our adventure into the flows. From the vantage point of my newly assigned position as the BWFM flow manager, the future looked terribly out of focus.

Jack : Do you think baby will be quiet long enough to take her picture, mamma?
Mamma : The Kodak will catch her whether she moves or not ; it is as " quick as a wink."

CHAPTER 2

MOTHER KODAK

Nineteen eighty-nine was not the first time I'd experienced fallout from a blast at Kodak Park; 32 years earlier, when I first visited the company, I was nearly run over by a street sweeper cleaning up dust that potentially contained radioactivity bits from atmosphere A-bomb testing. Any of the particles could have fogged the sensitive film.

When George Eastman started the company in 1887, there was, of course, no fallout to contend with. There wasn't "film," either—photographers used glass plates coated with light-sensitive chemicals to capture an image. When Eastman first began taking photographs himself, he used what was known as "wet plates"; prior to taking the picture, he would coat the plates with chemicals, such as silver nitrate, and then expose them to light by opening the

shutter of the camera. This was even more involved than it sounds, because silver nitrate is highly corrosive and had to be handled and stored very carefully. As Eastman described it, "In those days one did not 'take' a camera; one accompanied the outfit of which the camera was only a part. My layout, which included only the essentials, had in it a camera about the size of a soapbox, a tripod, which was strong and heavy enough to support a bungalow, a big plate-holder, a dark tent, a nitrate bath, and a container for water." This was certainly a far cry from the automatic 35-mm cameras that fit into your pocket today!

Despite the rigors (and cost) of taking pictures, Eastman fell in love with the photographic process and, with the monies he saved during his employment as a bookkeeper at Rochester Savings Bank he dedicated his life to making photography less cumbersome, less expensive, and more accessible to the general public. The commercial potential for photography was not lost on him, either.

In the late 1870s, Eastman's dream came far closer to reality when he learned of the discovery of Dr. R. L. Maddox, a British photographer who had found a way to suspend the light-sensitive silver nitrate particles in a gelatin solution. The solution was applied to glass plates and allowed to dry. Most remarkably, the plates would remain light-sensitive for months. This paved the way for photography as we know it today. It also spawned a number of entrepreneurial adventures throughout the United States and England. Eastman himself set up shop in his mother's house, turning her kitchen into a dry-plate laboratory and manufacturing facility. The quality of Eastman's plates became legend in photographic circles, and with a cash infusion of $6,000 from Henry Strong (a Rochester-based buggy maker), Eastman was able to step up his production (he continued to work as a bank clerk by day and plate maker by night). Finally, in 1881, he incorporated the Eastman Dry Plate Company, and could devote himself full-time to the improvement of photographic processes.

In his autobiography, written in 1932, Eastman described his four main goals for the company during the early days: (1) production in large quantities; (2) low price to increase the usefulness of products; (3) foreign as well as domestic distribution; and (4) extensive advertising as well as selling by demonstration. Interestingly, if Eastman were alive today and was asked to summarize his operational principles, they would probably be virtually the same.

In 1883, Eastman and Strong took a major step forward to achieve the first principle by building a four-story factory just north of Rochester (the company had operated out of make-do rented lofts until then). By the mid 1880s, he made great progress in terms of the second goal—the company began offering the forerunner of flexible film. Glass plates provided excellent quality, but had decided disadvantages in terms of weight, bulk, cost, and durability, and the fact that they had to be developed inside a dark tent.

The first "film" actually consisted of paper-negative material that would be coated with castor oil after exposure to light. Despite initial reluctance on the part of purist amateur photographers who found the developing process too cumbersome, Eastman saw the future of film, and his enterprise (renamed the Eastman Dry Plate and Film Company in 1884) continued to refine flexible paper film as well as glass plates. By the end of the 1880s, the company offered a broad variety of flexible films, glass plates, and associated developing products such as chemicals and paper. It also offered cameras that used the new film, making it easier than ever to take pictures.

Despite his success, Eastman felt that a whole new approach would be needed if camera and film were to become mass-market items. In a stroke of genius, he envisioned a new line of cameras that would be small, light, and easy to use. He also realized that for the camera to become accepted by the consuming public, he would

have to create an entirely new package based on a "systems approach." To that end, he invented the name "Kodak," which he chose because it was incapable of being mispronounced, sounded the same in most languages (it also resembled the "click" of a shutter), and could not be "associated with anything in the art except a Kodak."

By today's standards, the first Kodak hardly resembled a camera. Yet, at the time, it was nothing less than revolutionary. The wooden case of the Kodak measured just 6½-by-3¼-by-3¾. Users would pull a string to cock the shutter, turn a key to advance the film roll, then press the button on the side to snap a picture. Photography "reduced to three simple actions," as the company would proudly boast in its advertising. And the cost for this little miracle? A mere $25, which included a roll of film that would capture 100 great personal moments.

The Kodak was innovative, but equally impressive, and perhaps more significant, was Eastman's new concept in film developing. Rather than forcing people to mix chemicals and develop their own film, Kodak customers simply boxed up the camera and sent it to the factory in Rochester. For $10, the company would develop and print the film, then reload the camera and return it to the customer. This new approach—simple device, "no fuss/no muss" processing—truly made photography accessible to anyone with a little money to spend. It also resulted in far greater success than Eastman had ever dreamed possible. To keep up with demand, in 1890, his company purchased land for a new factory, to be called Kodak Park Works. A year later, the first film was rolling off the assembly line.

THE PARK

The original plans for Kodak Park called for a power station, a film factory, and a bromide paper plant (silver bromide is one of the fundamental chemicals of the photographic process). Through the years, the company continually added new buildings to accommodate growing demand and manufacture new products. Today, Kodak Park is one of the largest manufacturing facilities in the United States; 250 separate manufacturing buildings occupy 50 million square feet and sit on 2,200 acres. At its peak in the mid 1980s, the Park employed more than 35,000 people; with the reductions of the late '80s and early '90s, that number is now below 20,000, although the company is still the largest employer in Rochester.

The Park is virtually a self-contained city, with its own railroad system, trucking network, fire department, security network, and health care facilities. It also provides its own electricity through two power stations, and tends to its own water needs through a state-of-the-art water treatment plant that operates independently of the city.

Though the Park certainly has expanded dramatically since the turn of the century, many of the pre-1970s buildings appear unchanged by time. Despite the numerous times that the red bricks must have been repointed, when you enter the Park you get the distinct sense that you've just passed through some kind of time warp. One hint of modernity, though, is the massive network of shiny tubes that connects the buildings. It's almost as if the Park were a great living thing and the miles of piping part of a throbbing circulatory system that brings nourishment to its massive organs. Most of the pipes do, in fact, carry the life-"blood" of the Park— steam, high-purity water, and various chemicals. The pipes transport the chemicals from the manufacturing operations on the east side of the plant to recycling facilities several miles away, where

they are purified and reblended, then sent back for reuse through-out the Park.

Step inside one of the manufacturing buildings, and you'll also notice mazes of piping that carry the steam and substances to the various processing operations. In the dim glow of the manufactur-ing corridors, you'll probably feel as if you've been transported to a stage set for *Alien* or some other sci-fi film.

This eeriness is reinforced by the barracks feel of the hallways and processing rooms, the floors of which are often covered by a damp sheen or shallow puddles (don't worry, just water). You'll see people walk around in bright white "clean suits," creating an other-worldly feel. You'll have to wear safety goggles in most areas, and in some operations where solvents are used, you must wear booties equipped with antistatic strips on the bottom to avoid a spark that could ignite the highly combustible vapors. In the event of an explosion, the walls of the building housing the solvent coating operation are designed to blow outward; fortunately, the design has never been tested.

In addition to the piping and white-garbed workers, you'll probably be struck by the "funkiness" of the areas in which prod-ucts as precise as camera films are created; a fleck of dust or a deviation in film thickness less than a hair can render the film useless. At first blush, many of the areas will seem about as clean as a typical gas station repair bay. In fact, they're virtually dust-free; air is constantly passed through high-efficiency filters, and workers change into fresh white suits when they enter the room through "people cleaners" that blow off any dust particles that might have collected on their "whites." All critical areas also have special dressing rooms and water footbaths that help keep dirt off opera-tors' shoes.

What you'll probably find most remarkable, though, are the operations carried out in different degrees of darkness, to keep the film from fogging. Lighting conditions vary depending on the prod-

ucts being manufactured. You'll notice that some areas are lit with dim red light bulbs, typical of a darkroom in which an amateur photographer would produce black and white prints. Within a few minutes of entering, your pupils would dilate enough to provide reasonable vision.

Other areas, where high-speed films are produced, are totally dark except for the faint glow of small "LED"s (light-emitting diodes) marking exits. The illumination from one of these LEDs would be imperceptible in normal room light conditions—it might take you 20 minutes to "get your eyes," and even then, all you'll see is shadows and silhouettes. Even in these conditions, though, operators learn to navigate the workplace as easily as you make it from your bed to the bathroom in nighttime darkness, guided primarily by sound and feel. The operators who manufacture and package film learn to manipulate valves, levers, controls, and instruments with the same dexterity and grace as they would under normal lighting conditions. (The darkroom conditions provide workers a unique opportunity to have fun with visitors. A common prank when escorting visitors through the dark is to stand them in front of a brick wall while describing, with great pride, a brand-new piece of marvelous equipment. When asked if they liked the new machine, the guests, too embarrassed to admit they didn't see a thing, will invariably nod and mumble something like "Yes, it's quite impressive.")

When moving from one light-sensitive operation to another, you'll find yourself in corridors lit only by faint beads of tiny red or green lights; others are totally dark and to the uninitiated resemble a funhouse at an amusement park (the beads of light will play tricks on your eyes. Sometimes, you'll be certain that you're climbing upward or sloping downward, even though the floor is perfectly level). People wheeling supply carts or rolls of films through the black labyrinth constantly chant "Coming through," "Hey-ya," "Waaaatch-out," "Hey-watch," and similar warnings to other

travelers in the corridors. Everyone in this "mole culture" seems to develop a distinctive "call out" and intonation of his or her own.

The darkened working environment of the Park is all the more amazing given the complexity of the film-making process. To appreciate this, it's worth considering how film is made (you'll also gain an appreciation for the difficulties Kodak had in converting the Park from a functional "stovepipe" organization to a dynamic flow). In a nutshell, the process of making film entails the marrying of chemicals and a support material, then cutting it into the final products for the end customer. The basic "recipe" for creating a batch of film goes like this (the food metaphor is apt, given that some of the chemical-mixing equipment is actually made for the food-processing industry):

Step 1: Create the base. This is the material used to support the light-sensitive chemicals called the "emulsion."

Step 2: Make the emulsion. The emulsion is produced in large kettles with mixing blades. The emulsion, also referred to as the "soup," will have a consistency ranging from cream of mushroom to thin broth, and a color ranging from black to white and just about everything in between. Its odor can be anything from perfectly neutral to perfectly rotten—similar to rotten eggs, that is.

Step 3: Coat the film. Once the emulsion (also called "the melt" at this point) is ready, it is piped to the coating rooms, where the actual "marriage" of the chemicals and support material takes place (in Kodak language, the marriage is called "sensitizing," and refers to the combining of the support with the light-sensitive chemicals).

Step 4: Dry the film. This is done with the equivalent of giant "hair dryers." The drying must be done with great care to avoid damaging the film.

Step 5: Cut and package (i.e., "finish") the film. The rolls of film

must be cut to specific sizes—a challenging task given the hundreds of different possible configurations and packaging options. Once packaged, the film must be shipped for distribution in refrigerated containers that maintain optimum temperature and humidity conditions.

The journey from raw materials to finished film is filled with opportunities for error, which is why stringent quality assurance must be practiced throughout the entire process. And while modern instruments have made the film-making process more precise, the steps have remained essentially unchanged since Eastman introduced the concept of film-based photography. But even with electronic feedback controls, the manufacturing process requires a high degree of expertise and sophistication. This, in turn, requires the kind of dedicated workforce that Kodak has enjoyed for so many years.

BEYOND FILM MAKING: SUPPORTING THE LOCAL COMMUNITY

Since the early days of the company, George Eastman demanded unparalleled levels of quality. In return, he also offered his employees unheard-of benefits. While immigrants were working for deplorable wages and sometimes dying in sweatshops in New York and other large cities, Kodak employees were given profit sharing through the wage dividend and comprehensive health care benefits. And while the policy was unwritten, jobs at Kodak were jobs for life—which is why Kodak was resistant to union organizing attempts for so many years.

But George Eastman's benevolence went far beyond treating

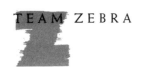

his employees well; his philanthropic tendencies and love of Rochester made the company a cornerstone of the city's economy. Eastman's philanthropic efforts in Rochester totaled well over $100 million during his lifetime, and included the Rochester Dental Dispensary (which treated 48,000 people the first year it opened, 1914), the medical school complex of the University of Rochester and an accompanying hospital, the Eastman School of Music, the Eastman Theater, and numerous other donations that benefited the city's arts, education, and social service functions.

You could write an entire book about Eastman's generosity to local and national causes (he donated $30 million in one day), his gifts to institutions of higher learning, his business ethics (after WWI he wrote a check to the federal government for the amount of profit he calculated his company made as a direct result of the war effort), and his love of children (as an example of his largess, in 1930 Eastman offered all children born in 1918 in the United States a special twelfth birthday gift—a free camera. Also, Eastman's "community chest," which he started in Rochester, grew into the national United Way).

What counts for this story, though, is the fact that Kodak became so entwined in the fabric of the community that going to work for the company was a rite of passage for many young men and women of Rochester. Unlike so many steel and coal mining towns where generation after generation would often continue in the dusty footprints of their fathers because they had no other options, in Rochester, "induction" into Kodak was an honor and a guarantee of fiscal security. And while parents in coal mining and steel mill towns often dreamed "centripetally," hoping their children would spin off into better lives, parents in Rochester dreamed their children would stay close to home and have the opportunity to enjoy good wages and lifelong security. For those entering the workforce, going to work at Kodak did not represent a failure of one generation to go beyond the achievements of the preceding generation;

rather, it was viewed as a wise career decision and validation that the community was blessed with a powerful benefactor (in addition to being called "Mother Kodak," the company was also referred to as the "Yellow Father," yellow being the dominant color of the company's logo).

Not surprisingly, you'll find many second-generation (and some third- and fourth-generation) Kodak workers today, even with the head count reductions of the '80s and '90s. So it is quite understandable why the events of 1989 were so devastating to the community, and why many felt betrayed by Mother Kodak's perceived threats of mass job terminations and wage freezes. It's also understandable why the idea of reorganizing the Park into flows was so difficult to accept—it simply challenged the basic wisdom that had been passed down from parent to offspring. Those who refused to believe that things were as bad as the media implied just assumed that the current troubles would pass. "It ain't broke, so don't fix it" was a commonly heard refrain. The trouble was, it really *was* broke. And it had to be fixed—immediately.

Kodak as you go

The lens sees with you—the autographic record remembers
for you—and the story is complete for all time.
Kodak brings back the trip to your library table.

Autographic Kodaks *$6.50 up*

Eastman Kodak Company, Rochester, N. Y., *The Kodak City*

CHAPTER 3

FLOW IS A GO—
THIS MORNING

Building 26, near the entrance facing the memorial where George Eastman's remains are buried, is one of the more unobtrusive four-story brick structures in Kodak Park; designed for office use only, it lacks the venous network of piping that shrouds so many of the other edifices. Yet, it serves as home to the Park's top executives, and during the flow formation period, it was the site for regular Wednesday-morning staff meetings with Ron Heidke.

At the morning meeting of August 23, 1989, the 25 of us who had been attending the previous sessions assumed that the meeting would run the usual course: 10 minutes or so of recap on our miserable financial performance, another 10 minutes of talk about top management's concerns and action plans, then another 40 minutes of discussion about the flow planning. As expected, Ron

began by reading off a litany of disappointing numbers, confirming that the company was sinking deeper into the abyss. He then told us of Colby Chandler's "Machete Speech," which those of us who knew the gentle-mannered CEO found startling. I looked down at the "aircraft-carrier"-sized walnut conference table and tried unsuccessfully to imagine Colby hacking away at it for effect. Ron delivered the really surprising news, though, when he shifted the meeting to the business of the flows.

"I know this is going to come as a shock for some of you," he said, straightening up in his chair, "but we simply can't wait until the end of the year to start the film flows. I've told Bill Fowble [the senior vice president of worldwide manufacturing at the time] that within two weeks the entire Park will be converted into efficient flows, and that as a result, performance would begin to improve. Bill was pleased, and said he'd pass the news on to Colby."

The silence in the room was palpable, but Ron continued without waiting for a reaction. "We've been planning for two years and we pretty much know what has to be done. Now it's time to hunker down and turn those plans into action." He then apologized for the grief that the rush to flow would cause some people.

After a moment of silence, several people voiced their concerns. "Ron—how could you do that? We haven't decided how to subdivide the emulsion-making operations. How can we possibly go to flow?" someone asked.

"Remember, Ron, the paper flows were so much easier. If your rationale is that the paper flows are the pilot and they're going well, don't forget they're a piece of cake compared to the film flows," added another brave voice.

A healthy debate about the remaining work to be done ensued, but as even the dissenters knew, Ron had "crossed the Genesee" (the river that runs through Rochester), and we were going to flow.

As it became clear that the decision was final, I felt my excitement rise and pulse begin to race. Secretly, I was thrilled at the

prospect of changing to flow immediately, and I later learned that many others in the group felt the same way. Few things were as frustrating at the Park as trying to introduce change. The Kodak method was to study a project or proposal until it was rendered harmless, wait a bit longer to make sure it was really neutered, and then wait some more just to be on the safe side. I honestly believe that it might have taken another year to get the film flows rolling if we didn't have marching orders to begin that very morning. And who knows if there even would have been a Black & White film making operation to reorganize 12 months down the road?

We asked a lot of questions and Ron answered them as best he could. Mostly, we'd be "flying by the seat of our pants on the unresolved issues," as he put it. We also agreed that we'd break the news to our own management teams in a timely, but orderly, way. Of course, within 15 minutes of leaving the meeting the entire Park was buzzing with news that "flow was a go." Several weeks earlier, Ron and the two other top officials at the Park, Ken Hoffman and Vern Dyke, had held a general meeting in the massive auditorium in Building 28 and explained the new structure for the manufacturing organization. Nearly 2,000 people jammed into the auditorium to learn about the company's first real structural overhaul in 100 years. They were relieved to learn that the paper flows were a pilot, and that the conversion to the film flow would happen *gradually* over the next six months.

KODAK AND ME: ROCHESTER WITHOUT KODAK

Ron's decision to go with the flows wasn't the result of a "satori," a blazing flash of insight; planning had actually begun at an off-site meeting held in nearby Geneva on the Lake during January of

1987. The lack of snowfall that month augured well for the rest of the winter, Bob Grose, Tom Fenton, and I agreed as we drove east on Route 104, then south on Route 14 from Rochester to the workshop. What we didn't quite agree on was what Ron had in store for us at the upcoming three-day meeting. Each of us knew that off-site workshops had worked well in the past, and that Ron was a master at leading such sessions. Tom Fenton, who started the same day I did in 1957 and was my counterpart in the rolls finishing division (in 1987, I was responsible for paper and film sheet finishing), was certain that Ron had something big planned for us, while Bob Grose, who was on Ron's staff, guaranteed that we'd be dealing with some interesting "stuff." In any case, off-site workshops had become a useful way for Kodak groups to reexamine their operations, and we were all psyched for an insightful few days.

None of us would have expected that after registering at the 90-year-old resort-mansion and unpacking our bags, we would be treated to a video tape of a movie. The film, *Roger and Me*, chronicled the devastating effects of GM's plant closings on the people of Flint, Michigan (the title derives from the fact that GM's chairman, Roger Smith, steadfastly refused to be interviewed by the producer, Michael Moore; throughout the film, Moore mockingly records his many attempts to track down the elusive GM executive). According to Moore's narrative, at one point "Flint enjoyed a prosperity that working people around the world had never seen before and the city was grateful to the company." After the plant closings, Moore cited the cynical statistic that the rat population of Flint exceeded the human population by 50,000, due to the exodus of people and the fact that the city could only afford to pick up trash every two weeks.

When Ron shut off the VCR machine and the snickering in the room died down, he asked us to imagine what it would be like if Eastman Kodak were the subject of the film. Rochester without

Kodak? That was a sobering thought, and one that some of us found difficult to imagine. Tough competitive battles lay ahead, but Rochester was still "Mother Kodak" in the eyes of the community and was quite highly regarded in the investment world. Nineteen eighty-six had been a good year for the company, and the outlook for the future was rosy. In fact, 1987 and 1988 were two of the best years in Kodak's history.

"I think the comparison is pretty farfetched," Bob Grose (a native of Michigan) commented. "Kodak and GM are as different as night and day. Different industries, different structures, different mind-set."

"Oh, really?" someone snorted. "What about the 35-mm camera business we gave to the Japanese, just like GM gave up a chunk of its market to Honda, Nissan, and Toyota?"

"Whoa," interjected Don Delwiche, the manager of motion picture finishing and a perennial Kodak defender. "We made a strategic decision to focus on low-end, easy-to-use cameras. The decision to 'give up' the high-tech 35-mm market simply led to more demand for film. And we're not about to hand over the core business to anybody. Besides, Kodak has a special dedication to Rochester. We have to be sure it doesn't happen here."

Ron let the spirited debate go on a bit longer, then gently corralled us back to the matter at hand: improving performance at the Park. He reiterated that the point of the video was to "shake us up a bit" so that we'd stay on our toes. To help us appreciate the possibility of a major cultural "revolution" in a massive organization, Ron also showed us a tape of Robert Galvin, CEO of Motorola. In the tape, Galvin explained how Motorola's quality level was inadequate for competing with the Japanese, so the company developed a massive program called Six Sigma, which was designed to dramatically reduce error rates in everything it did, from manufacturing to service. Six Sigma not only landed Motorola the coveted Baldrige Award, the first awarded to an

entire corporation, but gave the company an enjoyable lead over its Japanese competitors in the mobile communication device markets. (Even before Motorola had won a Baldrige Award for its corporate-wide effort, the company had made remarkable strides in getting people to understand that quality was the key to the future.)

In retrospect, Ron's visionary thinking may well have saved the Park and thousands of jobs by getting us to shift into "controlled crisis mode" and to appreciate the kind of change that can happen even on Motorola's scale. For the first time, we began considering seriously alternative organizational structures. True, Kodak would probably never become the subject of a Michael Moore–style film, but had we not been jolted into "thinking about the unthinkable," we might not have been ready with an alternative organizational plan when the crisis of '89 forced drastic and immediate action.

As Ron later mused, a number of "drivers" really led to the development of the flow plan. First, there was the formation of the business units in 1984, which were an attempt to decentralize the entire company into more manageable operations. Ron had led one of the business units and had firsthand knowledge of their operation. "Unfortunately, the alignment of the manufacturing operations and the business units was quite poor, which made it difficult for the business units to be more responsive to customer needs."

Then there was the growing realization that the fiefs and the mountains of inventory necessary to support the company's archaic "stovepipe" organization had to go. As Ron explains the situation, they hampered the material flow and caused the costs of making product to skyrocket. Also, "Kodak Park was the antithesis of the sleek factory that the company needed to operate in order to give the business units the kind of flexibility and support they needed to succeed against the competitors boring into the photographic markets."

Finally, there was Ron's own growing awareness that other large

companies had managed to overcome "barriers to excellence" and achieve outstanding levels of performance. What pushed him into action was a seminar he attended in Chicago in 1983 on kanban (a simple visual system for keeping work flowing along in assembly lines). Two of the originators of kanban, both from Toyota, explained how the system helped transform the Japanese firm from an almost bankrupt truck manufacturer into one the world's premier auto companies. They both spoke through a translator, who presented a coherent and powerful argument for the new approach to manufacturing. Still, many people in the audience thought that "kanban couldn't work here."

"Nonsense!" replied Graham Sperling, another speaker at the seminar. Sperling, who was then head of Mitsubishi Motors in Australia, waxed eloquent on how his company took the Toyota concept and successfully adapted it to a "Western culture."

After returning from the seminar, Ron enthusiastically supported the formation of Kodak's Japan Study Program, which was designed for the company by Professor Michael Yoshino of the Harvard Business School. The program included extensive travel to Japan with on-site visits to some of the country's top manufacturing companies, including Matsushita, TDK, and Nippon Steel. (Several Park managers, including Ron and most of the flow managers, participated in the program.) To say it was an eye-opener would be a vast understatement; it showed us an entirely new way of doing business; we felt that the Japanese companies were very good, but that we could equal or exceed their performance if we did the right things. After all, even though the Park's performance was in desperate need of improvement, we had a lot going for us, such as versatility and a record for high-quality product, not to mention an unbounded supply of creative problem-solving ability.

In addition to stimulating Kodak's interest in adopting Japanese manufacturing techniques and strategies, Ron relentlessly looked

for pockets of excellence on our own shores. Just before the Geneva conference, he had observed self-directed work teams and empowered workforces at companies such as Cummins Engine, in Jamestown, New York, and Tektronics, the circuit board maker in Portland, Oregon. At Tektronics, Ron met the plant manager, Gene Hendrickson, who stressed the importance of bringing people into the running of the company. "To be part of the business," Hendrickson said, "people must see themselves in the future." That idea stuck with Ron for years, and was a significant influence on his decision to go to flows.

A visit to Florida Power and Light, the only American firm to win the coveted Deming Prize for quality, also made a lasting imprint on his thinking. What intrigued Ron the most was how the company embraced "constancy of purpose," as Deming calls it, which boils down to deciding what you're going to do and sticking with it so you enjoy maximum gains. This was a lesson that Kodak desperately needed to take to heart, since it tended to gravitate to many business-management fads.

Finally, there was Preston Trucking, a once ailing transportation company that not only experienced a stunning financial turnaround, but also has become a regular entry in the popular *100 Best Companies to Work for in America*. How did Will Potter, Preston's CEO, bring this about? According to Ron, the company motto on each truck says it all: "Preston people make the difference."

Could Kodak people make a difference? Yes, Ron believed, and the key was to find a new management philosophy that would allow them to give their best. The most promising approach was a hot new concept called "High Performance Work Systems."

In a nutshell, high performance work systems refer to groups or organizations that consistently exceed their competition in terms of efficiency, productivity, and other measures of success. High performance is achieved by improving three elements: the processes through which people communicate information and solve prob-

lems; the systems that are used to inject predictability into the organization, such as feedback, wages, etc.; and the structures or arrangement of people according to their skills and tasks.

Even before the Geneva on the Lake meeting, and the formal introduction of high performance one of Ron's former colleagues, Joe Bourcy, had hired two consultants, Paul Boulian and Tom Kent, to help Kodak managers learn the basics of the technique. Boulian and Kent ran a series of workshops that acquainted us with high performance principles and encouraged us to think about our work in new ways.

"Companies that successfully adopt high performance practices enjoy a variety of benefits, including a tremendous boost in productivity, performance, and quality," Paul Boulian said to us during one seminar. "Improvements are made on a continuous basis. Profitability goes up. Waste goes down. Customer satisfaction rises. Employee satisfaction rises. In short, all stakeholders in the company feel a significant sense of forward motion and improved performance."

All of these benefits could help Kodak Park reverse its steady performance declines, especially in the areas of material flow, waste, customer focus, and communications across the various levels of the organization. To achieve high performance, we knew that we'd have to bring about a major change in our corporate culture. Now, "corporate culture" has become a major buzzword these days; I define it simply as "the way we do things around here." And the way we did things was simply no longer adequate for a fast-paced, changing world. When Eastman Kodak had the market pretty much to itself, efficiency and productivity were less important—quality and product features were really all that counted. In today's global marketplace, with able and aggressive competitors taking bites out of our market share, that kind of thinking could sink us. We saw the need but could we really change our stripes and become a high performance operation?

That was the question we would try to answer at the remainder of the January 1987 Geneva conference. Most of our time was spent in a dark-paneled room with a working fireplace, multipaned picture windows, and exquisite tongue-and-groove floors—an inspiring setting far away from the "snapping alligators" that drained our creative energy and made it difficult to look ahead.

The relaxed atmosphere of the resort made it possible for everyone to speak without feeling defensive, and to see our mistakes as clearly as the swirling ice patterns that had formed on the windows. Most important, it made it possible for us to envision a future that we could shape with our own hands, rather than dealing with one handed to us on a plate.

THE FLOW PLANNING TAKES SHAPE

As we talked about improving our situation during the Geneva conference, the group focused initially on "material flow"—how raw materials were formed into finished products. Not only was this the most obvious sore point in our operation, but it was the most tangible thing for us to change. By the end of the session, "flow" had become synonymous with our entire effort to create a high performance work system within Kodak Park.

On the way back to Rochester, Tom Fenton joked that another record had been set: "Three days in January without any additional snow!" But although the landscape hadn't changed, everyone in the car knew that things would never be the same at Kodak Park. And while you can't change 100 years of history with the wave of a magic wand, the mission was clear: redesign the organization into distinct material flows based on high performance work principles, or suffer at the hands of nimble competitors.

"REENGINEERING" THE PARK

Following the Geneva on the Lake meeting and the decision to pursue flows, we met monthly in two groups, one for film and one for paper. Ron assigned Roger Maddocks the job of pulling together the film flow design and Joe Staudenmayer the task of developing the paper flow. Everyone involved in Ron's flow planning group was excited by the idea, but in typical Kodak fashion, we proceeded slowly and cautiously. Aside from Ron's hypothetical suggestion that Kodak might go the way of GM, we didn't feel any particular sense of urgency to get on with the planning.

In September of 1987, the flow planning team held a workshop at the Pillar & the Post, located in Niagara on the Lake, Canada. While our group continued the flow planning, we also focused on team building and positive reinforcement—an unusual move for us, and one that would have an important impact on our planning and executing the flows. During the workshop, which more than 100 people attended, a variety of success techniques were discussed.

We also focused on the techniques of Dr. Aubrey Daniels, a leading expert on performance management. Daniels's management philosophy called for changing attitudes and work styles by reinforcing the desired behaviors. His approach called for heavy measurement and very visible feedback—two elements sorely lacking in Kodak's culture. Daniels's work had given us insights into how we could bring about some of the necessary cultural changes and a sense of shared purpose. (It would eventually shape the way we treated the people within Team Zebra; from the outside, the number of "R-plus"—positive recognition—celebrations we sponsored must have seemed excessive. But the results were stupendous, and we created one of the most spirited organizations within any manufacturing operation in the country.)

By November of 1987, the flow planning group had begun to realize the complexity of reorganizing the Park from a functional operation into product-oriented flows. It also realized that many of the support groups, such as human resources, engineering, and financial services would require a higher level of alignment into the flows than was previously thought. At an off-site meeting held in April 1988 in Toronto, we invited representatives from the various support functions to join us and help develop a plan for meshing their services into the flow. According to the plan, some operations would simply be in the Black & White flow, such as emulsion coating, finishing, and testing. Other groups, like human resources, financial services, and engineering support, would be "dedicated" to the flow. Yet, other organizations would centrally supply services to a number of the flows, including Black & White. These included utilities, manufacturing, plant services, and engineering.

Not surprisingly, the decisions over assignments to the flows sparked a fair amount of controversy; people don't easily hand over the deed to their fiefs, even if it's for the greater good. In addition to the turf wars, there was a substantial debate about whether we would be able to maintain our functional excellence if we decentralized certain functions into other units. The concept of leaving certain groups with central responsibilities, it seemed, would be a good insurance policy against erosion of the functional know-how. Once we made the decisions about how to support the flows with adequate services, we were much closer to developing a viable plan for the Park.

Throughout 1988 and 1989, our management group conducted numerous workshops to nudge the flow planning along. The paper flows were announced at the end of the year and began operating early in 1989. But it wasn't until the spring of 1989 that we formed organizing committees with the responsibility for determining the actual details of four newly defined film flows: Motion Picture; Consumer (Kodacolor—the film you buy at the drugstore or cam-

era store); Professional (studio photography, photo journalism, and commercial photography); and Black & White (graphic arts, X-ray, aerial, microfiche, and various other specialty films).

The greatest difficulty for the Black & White organizing committee, which Ron had placed under my guidance, was untangling the various manufacturing operations used to create the thousands of Black & White end items. In the past, functional organizations had the responsibilities to create their part of the products for all the different businesses. For example, the film sensitizing organization made films for consumer, graphics, health sciences, motion picture, and other product areas.

The situation was so complex that the planning group decided the only way to develop a flow plan was to start with a clean slate—take everything that we knew about making film, then try to build a visual representation of the manufacturing processes at the Park and their connections to other Kodak plants and business units.

The complexity was increased by the sheer number of products Black & White manufactured each year—250 product families made into 7,000 final products. In addition, the total volumes produced at B&W were staggering. If all of Black & White's annual production were a one-foot-wide strip of film, it would stretch from the earth to the moon and then some.

We started off with "flow mapping," a technique for describing what happened in the Park, independent of the plant's geography. We started with simple block diagrams, but found that they got complicated very quickly. In one summer-of-'89 session of the organizing committee, held in Building 328, Tim Giarrusso, a management services supervisor, and Tony Myers, a staff member of the sheet finishing division, invented what later became known as the "cloud map."

"The problem with this stuff," Tim said, "is that 10 people can look at the same set of functions and see 10 different organizational schemes."

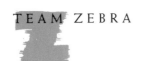

"Kind of like cloud watching," Tony remarked.

"Exactly!" Tim said, as he drew puffy little circles around the main functional processes.

Within an hour, the two had drawn clouds of various sizes to capture all of the various internal processes, suppliers, and customers worldwide. The bigger and puffier the clouds, the more people who were involved. Next, they drew interconnecting lines like a circuit board. By the end of the planning session, the cloud drawing began to resemble what Tony (a native of England) called the "London tube model," or as Tim Giarrusso (of Italian heritage) called it, the "linguine model, with noodles pointing every which way."

Whatever you called the map, its complexity was due in part to the fact that we were dealing with nine buildings, often shared by several organizations. We also had to take into account the flow of materials to and from the Park to other sites worldwide. As part of Kodak's international strategy for becoming more responsive and profitable, the company often shipped huge "master rolls" of film (some a mile long) for final finishing in facilities closer to the markets in which the end products would be sold. So we also had to account for the traffic between the Park and Windsor, Colorado; Harrow, England; Guadalajara, Mexico; Chalon, France; Toronto, Canada; Melbourne, Australia; São Paulo, Brazil; and Yokohama, Japan. Conversely Kodak Park also finished film that was coated in some of these worldwide plants for use in North American markets.

During several sessions held throughout early 1988, we grappled with a plan for efficiently subdividing the existing structures and processes of the Park, and then reorganizing them into one entity focused solely on black and white films. Under the old functional arrangement, a multitude of peoples and operations were devoted to both black and white as well as color films. For instance, in the old organization, it was not unusual for operators to work on professional motion picture films one day and health

science X-ray film the next. Or a person might be finishing color products for studio photography one day and black and white films for astronomical use the next.

Numerous proposals flew across the table for subdividing the work. Some people had the idea that Black & White should be divided into two distinct flows, one specializing in films for the graphics market, the other for films in health sciences. Others suggested that not all of the product lines needed to have their own sensitizing functions; they could receive emulsion coating through one of the other flows.

A bit of thought was given briefly to splitting the flows physically across the Park—transporting equipment to different buildings. But the expense would have been prohibitive and the chaos and downtime catastrophic. Instead, the planning group wound up creating "virtual flows"—no equipment was actually moved, although the Park wound up being completely reorganized in respect to the way materials and finished products were managed.

Placing a beginning point (raw product) and end point (finished product) on the flow map was easy; dealing with everything else in between was a "megachallenge." The further "upstream" we went from the finished product, the more difficult the job of untangling functions. Far and away the most complicated task concerned the emulsion-making operations.

Under the old functional arrangement, there was one large department housed in Buildings 29 and 30, where virtually all of the film products were sensitized. Any given mixing kettle could be used for a variety of color and black and white products. Under flow, the kettles would be assigned to various product lines. Unfortunately, this was not as simple as saying, "These five kettles will be used by Consumer and these five by Professional." The problem is that making film is largely science, but it's part art (you can only get so precise when you're dealing with ingredients made from the bones of cows). If you usually make an emulsion in a 100-gallon

kettle and then decide that tomorrow you'll make it in a 50-gallon kettle, you can't just cut the ingredients in half. Any change requires a surprising amount of painstaking experimentation by the product engineers to determine the correct ingredient mix. So in divvying up the kettles, we had to take into account the disruption and waste that would result from our decision.

In the coating operations, which followed the emulsion making, the situation was a bit less complex, because much of the equipment was specifically designed for certain products. And still further downstream, in finishing, the flows had minimal impact because the various cutting and packaging operations were very closely aligned with the individual end items. Most black and white products were largely finished in sheet formats; color products were finished in rolls, cartridges, or 35-mm cassettes.

In addition to deciding which piece of equipment and which operators would be used for the various flows, we had to deal with the very difficult issue of "attitude." Had the change to flows been gradual and part of a positive campaign to improve performance, the idea would have been widely embraced by most of the people in the Park. But given the 1989 backdrop of the negative press, and fear of job loss, the apparent precipitous change was taken as yet another sign that the company was in trouble, perhaps even desperate.

Worse, the announcement of the flows came soon after a decision to eliminate the fourth shift for the Black & White coating operations, a decision that some compared to the launching of World War III. In the past, sensitizing operated a fourth shift that enabled it to crank out products 24 hours a day, seven days a week. That meant one week in four, people would work weekends—at a significant pay premium (time and a half for Saturday work, double time for Sunday, and triple for holidays). Given the timing of the two announcements, many people associated the flows with the cutback in work hours. This in turn led to another negative associa-

tion; the elimination of the seven-day week would mean that the Black & White sensitizing operations needed 25 percent fewer people. Was the Black & White flow scheme really a smokescreen for reducing head count? Waves of job insecurity inundated the workforce, then turned into whirlpools of anger and resentment. Go with the flow? No way!

Within some specific areas that became integrated within the Black & White flow, job security became a major concern. Take the quality service organizations. In the preflow days, the various line operations purchased their testing services from a central Kodak organization. Each manufacturing department would allocate part of its testing costs on the product bill, so that quality testing represented a very high proportion of the final product cost. So there was some fear that when the manufacturing operations were pressured to cut costs, testing might be seen as a low-value part of the process and positions in that area would be eliminated.

Beyond the concerns for job security, the flows brought with them something that is often feared even during the best of times: *change*. New assignments, possibly in different buildings, meant that longtime employees might suddenly find themselves working amid strangers or performing a new task. That problem was complicated by the fact that work groups at Kodak did not traditionally share information. And to achieve high performance levels, teamwork was essential. Would people in flows continue the tradition of internal competition, or could we teach them how to think of one another as internal suppliers and customers?

Finally, there was the issue of going into Black & White from the color world. Color was the darling of the company, and represented a high degree of status among Kodak employees, so many people saw the move as a career reversal. Also, Black & White seemed to be a hodgepodge of esoteric, small, and old-fashioned products—nothing to get very excited about. We eventually turned that lack of understanding about B&W products to our advantage.

But until people grasped the importance of black and white film products, it represented a career setback to many, perhaps even a dead end; it was no secret that black and white products at the Park were produced in much smaller quantities than the prestigious color films. Would Kodak management eventually move Black & White products to other manufacturing sites and close down the Park's B&W operations altogether?

It was hard for me to completely refuse to acknowledge that the ship was in trouble. The possibility of the whole Black & White manufacturing enterprise going under was driven home on September 7, 1989, when I performed my first official act as the new manager of the B&W film flow: presenting Ron Heidke with suggestions for an official name for the black and white organization. With morale so low, a new name that conveyed the importance of the film products might help in getting people to feel better about their work. (While the "Team Zebra" concept didn't emerge until April of 1990, following a visit to the local zoo, where we learned that zebras, like us, were endangered and could only survive in herds, some people on the organizing committee had already begun to use zebra imagery. For example, we inserted photographs of zebras in the clear front pouch of the three-ring binders we used during committee meetings. To welcome the new Black & White management team, I bought out the Seneca Park Zoo's total inventory of zebra sun visors, which I then handed out to the managers during our first meeting. Later, I found myself compulsively purchasing any zebra knickknack I'd see at local stores, airports, or hotels.)

I always felt at home in Ron's office—it was overflowing with books, magazines, and memorabilia from past jobs at the Park and at corporate headquarters. So I eagerly opened my notebook and began reciting a list of names that I was sure would boggle Ron's mind. He'd be so taken with the choices that he would be forced to make the toughest business decision of his life.

"Vital Imaging Products—VIP." I looked at Ron, waiting for a response. He looked back at me, apparently waiting for another suggestion.

"VIP Films," I said, unflustered by his lack of enthusiasm.

"High Technology Films." No response. I was beginning to suspect that I was losing the ball game.

"Applied Technology Films." Still no response.

"Specialty Technology Films?"

Okay, I thought to myself, this is it. I glanced at my paper, stared Ron straight in the eye, then pitched what I knew was going to be the knockout name: "Vital Imaging Technology!"

I waited for a reaction, and was surprised when Ron got up from his desk and walked to the window. He peered out for a moment and then turned to me, saying, "Steve—be careful about renaming the *Titanic* while it's going down."

CHAPTER 4

STRAIGHT TALK AT THE PARK

On the evening of April 14, 1912, the British luxury liner *Titanic* struck an iceberg off the coast of Newfoundland. The collision tore a 30-foot-wide gash in the starboard side of the hull, causing the ship to quickly fill with frigid seawater. More than 1,500 lives were lost as the ocean liner, thought to be nearly unsinkable, plunged 1,300 feet to the bottom of the Atlantic Ocean. In the aftermath of the tragedy, public outrage on both sides of the Atlantic swelled when it was revealed that warnings of icebergs had been sent to the *Titanic*'s officers but had either been ignored or not received. Another ship, just 10 miles away, might have rescued the victims, except that the vessel's wireless operator had retired for the evening.

The parallels between the Black & White Film flow and the

Titanic, other than Ron Heidke's advice about renaming a doomed ship, are striking. The work lives of 1,500 people were at stake, and those steering the operations at the Park had been shielded from information that might have prevented the painful collision with the realities of the marketplace. From September through November 1989, that information became more public, and the flow management learned just how bad performance at the Park really was; everyone was so accustomed to operating in the dark (literally and figuratively) that the news was staggering. In a way, the performance problems were very much akin to the fateful iceberg that sank the *Titanic*; out-of-sight, deep-rooted, and potentially lethal.

A NEW SHIP AND A NEW CREW

Upon hearing the announcement of the flows, the future managers of Team Zebra scrambled to build internal contacts—many had never worked together before, and were spread throughout Kodak Park. Eventually, most of Zebra's managers would move to Building 2, a three-story brick edifice on the east side of the Park. Our goal was to have a central office in place by Christmas. Until that time, the flow would face the dual challenge of managing a "virtual reorganization" with a "virtual leadership team."

Since the flow lacked a common meeting ground, during September and October of 1989 the management team met in conference rooms of various buildings twice a week to finalize assignments, put together the final pieces of the flow, and assess our needs for new information about performance levels. As the manager of the Black & White flow, I made it a personal goal to talk with the 1,500 people who would make or break the effort. Every single one of them. I first met with a group of

12 key managers, and after breaking the ice described the problems of the Park. We seemed quite compatible and anxious to "get on with it" as we told one another what we brought to the team as individuals. Later, I repeated the exercise with a larger group of managers, who became known as the "Gang of 33."

My goal was to bring about a "paradigm shift," a radical change in the way that people thought about making films in general and the way they did their jobs in particular. To jolt them out of the old way of thinking, I made up a list of performance difficulties common at Kodak Park. Now, most of the people in the Gang of 33 had some sense of the performance problems that were dragging us under. But in true Kodak style, most of the really gory details had been kept close to the vest. At best they were seeing only the tip of the iceberg.

During a special meeting convened one warm day in September, I rattled off my list of performance "shockers" to the Zebra managers. The reaction was generally one of disbelief and anger. "How could we have been kept in the dark so long?" people demanded to know. During my talk, I boiled the issues down to the "killer" problems that deeply eroded profit margins and made us dinosaurs in the marketplace.

"You all know about the waste problems," I said. "But did you know that we can't sell *one-third* of everything we make? We load up 1,000 five-ton dump trucks with wasted product every year."

A whistle of disbelief broke the ensuing silence.

"Imagine a consumer product company or auto manufacturer tossing out one-third of its product—they'd be out of business in no time flat! Can you think of *any* organization that can survive with that level of waste?"

"Yeah, the federal government," someone called out from the back of the room.

That started a spate of laughter, and took the edge off the

meeting; I wanted people to feel concerned, but not personally threatened.

"Great," I answered. "So we're on a par with the government. If that isn't an incentive to change, I don't know what is!"

That comment won a round of applause.

"How about inventory turns [the number of times inventory is completely replenished]? Some of you may know that we operate at two turns a year. That means half of the value of product we make each year sits in inventory, which is about . . ." I pulled a small pad of paper and pen from my shirt pocket, pretended to jot down all kinds of calculations, and faced the audience with a look of surprise. After a pregnant pause, I announced the result. "Well, I just figured that it's even more than the highest paid sports stars make."

More laughter.

"Now think again about other industries. Imagine how much cash your Wegman's supermarket [a large, very successful chain in Rochester] would tie up if it only stocked up on nonperishable items twice a year. Wouldn't be a very good use of cash, would it?"

A unanimous "Uh-uh" registered from around the room.

From there, I discussed new product development. "As you might know, of the 250 product families we sell, about 10 percent have major changes each year. If we're going to stay competitive, we've got to make continuous improvements in product features.

"Unfortunately," I said, "we have a constant pattern of missing development dates and overshooting budgets. In some cases, we've been late by as much as a whole year. And let's face it, this might not be as serious as a car maker missing its fall showing of new models, but it shows weakness, poor performance, and a lack of accountability to our customers."

Heads nodded in unison.

"Here's another shocker to think about—'cycle time' [how long it takes to create a batch of product]. I was surprised to learn that it

takes us an average of 42 days to run a batch of product. To put that in perspective, think about a baseball game. You know how much meaningful action—hits, throws, runs—you'll see in a game? Just seven minutes on the average. That's a pretty low amount, about 5 percent. But in our operation, our value-added percentage within the 42 days is far less—about ONE percent [about 10 hours]! How can we possibly be responsive to the marketplace and compete when we're taking that long to perform the basics of our operation?"

Total silence. This question was apparently a shocker, because most of the people looked around the room somewhat uncomfortably.

"One more outrageous reality before we adjourn—deliveries. Any idea of how often we get the right amount of product to the right place at the right time?"

"Eighty percent of the time?" a voice rang out.

"Seventy-five?" someone else offered.

"How about 66 percent?" I answered.

That one brought the house down.

"How the hell have we managed to stay afloat so long?" one of the managers asked angrily.

I stole a page from Ron Heidke's book and walked to the window without saying anything. I looked out for a moment, then turned and said, "Let's not push our luck."

LUNATIC ON A SOAPBOX

For the next few months, the Gang of 33 met regularly to discuss how we could improve our performance. At the same time, I felt it was time to move closer to the shop floor and talk with the other people in the flow. I had planned to run through my list of shockers

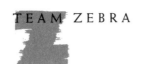
during a series of "town meetings," thinking that people would only be able to improve if they knew what the score was.

Before the first meeting in late September of 1989, I envisioned two possible scenarios: "better" and "terrible." In the "better" scenario, the people in the meeting would give me a chance and listen, and would understand there was good reason to have faith that we could all turn the flow around. They would acknowledge that flows make sense, and agree with me that there was a significant performance gap to close. Most hopefully, they would see themselves as part of the problem.

In the "terrible" scenario, people would be so intent on venting their anger that they wouldn't hear my message. They'd consider me a know-nothing from finishing who was unqualified to lead the film flow, and who would only make things worse. Also, they'd see the situation as desperate and unsalvageable, while blaming everything on others and accepting no personal accountability. Finally, they'd all want out—to anywhere.

The first of the town meetings was closer to the terrible end of the spectrum than I would have hoped. Although I had steeled myself for the worst, I was still taken by surprise by the amount of anger and hostility that erupted like a furious volcano. At the top of the complaint list was the precipitous announcement that the fourth shift of a seven-day rotation had been canceled. For some people, the change in working hours meant a substantial drop in pay, and a great deal of the resentment had to do with the fact that no one had time to prepare for it. As one shop floor worker put it (and shop floor workers tell you exactly what they're thinking), "Hey, man, how would you like it if you found out your paycheck was getting axed by 25 percent? Tell that one to your mortgage company!"

While I tried to explain how the opportunities for overtime would compensate for the change in the work schedules, my logic fell on deaf ears. In hindsight, my straight talk sessions were the

first opportunity for the shop floor folks to speak their minds since the company began taking a battering in the spring. Many were suspicious and completely distrustful of another desperate attempt on management's part to save the company. Some were convinced that they were going to be the scapegoats for top management's poor judgment. So for the first month of straight talks I just resigned myself to getting skinned alive as I tried to sell flow and the improvements it would bring. After the meetings, I was later told that people made comments like:

"The dude is nuts."

"What's he been smoking?"

"Turnaround? He probably can't even parallel park."

"This guy probably doesn't know how to turn off the lights in his bedroom—what's he know about working in the dark?"

"Does he think we're dumb or something?"

"What's this 'fun' crap he keeps talking about? Glad I don't have to spend *my* time off with him."

The list could go on for more pages than I'd like to admit. But by the second round of talks, the tone began to change. There were no massive layoffs. Overtime opportunities did become available. It was clear from the ongoing department meetings that we were serious about opening up a real channel of communication and a continuing dialogue. People were stunned when we made our performance information generally available to them. And they were perhaps most surprised to learn that their jobs were vitally important to the company and its customers.

During the town meetings, I launched into a rundown of how Black & White Film products were actually used by our customers. At one meeting I said, "We might not be doing the high-volume runs that our friends in color are doing, but, you know, even with our performance problems, we produce some of the most highly profitable and versatile products in the entire company. We also make some of the most important photographic products in the

world. Yeah, they don't have the pizzazz of Kodacolor, but without them, your lives would be very different."

I then mentioned a few of the uses for some of our more esoteric products. For instance, in the past, "XRT-234" was just alphanumeric soup; the people who made it got a new appreciation of the importance of their work when they learned that it was used during cardiac surgery. "I never realized that I was helping to save lives," one person from sensitizing reported during a town meeting.

Such revelations demonstrated that we were heading in the right direction; attitudes and morale can't change unless people believe that what they're doing has intrinsic worth to the mar-ketplace, and makes a contribution to other people's lives. Abstract numbers are meaningless. But helping save lives—that was worth getting up for every workday morning.

Once people started focusing on the importance of the prod-ucts, I introduced the theme of "extended families." I wanted people to understand that it wasn't just 1,500 livelihoods at stake, but that suppliers and customers depended on our timely shipment of quality product. "When you put the whole 'family tree' together," I said, "you have as many as 10,000 people who are affected by our actions. That's about the size of my hometown!"

OPEN OFFICES FOR AN OPEN CULTURE

Like most American companies, acquiring a private office at Kodak was a rite of passage and a sign of personal career advancement. So when the flow management team sat down to design the central offices for the black and white flow in Building 2, I expected that we'd continue the tradition of enclosed offices for each manager and secretary. Tim Giarrusso, our management services unit direc-

tor, Ken Lamport, also with the management services division, and Dennis Morgan, our facilities manager, had different ideas.

"I think we'd send a strong message to everyone if we got rid of the walls and used partitions instead," Tim said during one of our planning sessions. "We've been talking about a cross-functional team—why not make the office a symbol of an organization 'without walls'?"

Ken and Dennis enthusiastically agreed.

"Well, what about privacy?" I asked, feeling a bit guilty for tossing cold water on an idea that I knew had merit.

"You get used to it," Tim replied. "I've seen it work at other companies. The partitions keep your conversations from floating all over the building. If you need to make a personal call when someone is standing in your area, you just say, 'Can't talk to you now, I need to make a call.' People catch on. We can always enclose a conference room when group meetings might disturb other people or involve sensitive information."

What could I say? A week later, we met again and Tim presented the floor plan. I could only focus on one small portion: my partition, which faced a wall.

"I'll go with an open office," I said with a grin, "but I've got to have a window. It took me 25 years to get one and I'm not about to stare at a wall now!"

Tim laughed and understood—so much of Kodak Park operates in the dark that windows carry a high premium. I did get my window, with a view of the entrance to Kodak Park, complete with the flagpole and George Eastman's Memorial. Just after New Year's Day, 1990, the renovation was complete and 12 of us moved into our new quarters. (In the new style of cost-consciousness, we managed the entire renovation for a mere $13,000—probably 25 percent of what the traditional route would have cost—largely because of the used partitions and furniture we found sitting in storage.)

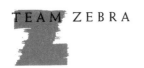
Initially, there was some concern over the privacy issues. But within two weeks, everyone who had worked in a traditional office setting wondered why they'd made such a big fuss over the perceived problem. The secretaries, Jean and Beth, were also in for a surprise; they were invited to attend all meetings held in the conference rooms, not to transcribe notes, but so they would be up to speed and contribute to our discussions.

As a complement to our open office, we created an upside-down organizational chart, with top management on the bottom. We posted it by the door to our office area and on the bulletin boards of the various manufacturing buildings. Initially, when people saw it, they would instinctively remove the thumbtacks and turn it upside down, until they noticed that the type would then be inverted. Some people thought it was just a symbolic gesture. But that's exactly what I was looking for at this stage—signals that we were very serious about turning things upside down and creating a new way of doing business.

STRAIGHT NUMBERS AT B&W

If you really want to change, you have to know where you stand; as the old saying in business goes, nothing gets better unless you measure it. Unfortunately, Kodak had long operated under the military approach of marshaling information, sharing things strictly on a "need-to-know" basis. Many times in my 34 years with Kodak, I almost had to beg for information I needed from the "keepers of the numbers."

Another information flow problem concerned the "silver curtain"; people in functional areas simply didn't exchange information with one another. The "curtain" began with a legitimate need for guarding our proprietary emulsion formulas—the recipes for

making emulsion would have been a delicious plum for our competitors. Unfortunately, people began applying this line of thinking to virtually all of our processes, creating an information blackout that worked against teamwork and openness.

There would be no silver curtains in the black and white flow, we pledged; information would move freely from operation to operation, including the once highly guarded data related to performance. The latter was particularly important, because Ron Heidke had made it clear that we would be using hard numbers to evaluate our progress. During the past two years, we'd learned about performance matrices, while studying performance management techniques. Our first step in using the matrices was to establish a good set of baseline numbers for productivity, inventory waste, quality measures, and conformance to specifications, etc. One of our team members, Bob McKinley, who headed our financial group nicknamed "Team McZebra," had the thankless job of pulling those numbers together from thin air (there was little to go on from the old organization). McKinley's task was complicated by the fact that the accounting system was largely set up to serve the financial accounting needs of the shareholders and the IRS. To make the challenge even more difficult, the numbers were organized purely by functional area, making it very troublesome to obtain flow data. The Park, treated as a cost center, had little information that was actually useful in bringing about improvements in flow operational performance. In fact, the systems were designed to be separate for Kodak's security.

Once Bob with the help of Chip Wagner, our quality and administration manager, had extracted out the necessary numbers, we created a performance matrix that consisted of a scale of 1 to 10 on the bottom, and the individual measures (e.g., productivity, conformance, delivery, inventory, and capital) on the left-hand side. Initially, Ron established the target levels for each of the flows (by the start of 1990, he entrusted us to select our own numbers). The

targets were tied to budgetary concerns, marketing strategies, special customer needs, and other factors. If we achieved the same level as the previous year, we'd receive a rating of 300; if we hit the target on all measures, our score would be 700. A score of 1,000 would mean hitting the jackpot.

"It's hard to imagine that we could hit 700 in one year," Bob Brookhouse, who was responsible for Team Zebra's health sciences stream, commented during an informal gathering in my office to review the performance matrix.

"Yeah, but that's what Ron expects us to do," said Bob McKinley.

"Not just Ron," I interjected. "That's what the business needs to survive."

"Seven hundred or bust," cried Chip, raising a clenched fist.

I raised a fist, too, although in my mind I was quite skeptical that we'd even come close in just one short year.

Despite my doubts about hitting the targets, I knew that the performance matrices were crucial to the success of the flows. Like the straight talk sessions we held at the town meetings, the matrices said it all—no cover-ups. For many people, this was a radical new way for the company to use information. In the past, information was wielded as a hammer when performance was worse than usual. And to add salt to the wound, since information was rarely current, people would often find themselves getting clobbered for ancient history. (Read any animal training book and you'll learn that the quickest way to create a disgruntled and neurotic pet is to punish it for misbehaving several days ago. Humans react equally poorly to "after-the-fact" negative reinforcement.)

During one of our town meetings in October of 1989, I got up on my soapbox and asked, "Can you imagine going to a football game with no scoreboard? It'd be pretty confusing. Well, it's pretty confusing here, too. When we start using performance matrices, we're going to figure out what we need to do to become winners.

And when we win, our customers will reap the benefits of reduced cycle times and prompt deliveries, and much shorter development times for new products. In other words, it's win-win all the way down the line—except for our competitors!"

A key benefit of the performance matrices was that they forced the three individual streams (subsets of the flow) to meet with the business units and learn if we were satisfying our "external" customers. The "score" varied by stream. For example, in the case of the graphics stream, quality wasn't an issue at all; customers were quite satisfied with the level of quality of Kodak's products. But there was tremendous pressure to reduce costs because of the competition. In the health sciences stream, the opposite situation existed. Cost was an issue, but, more important, the nature of the applications for which the products were used demanded perfection. By feeding those differing needs into the matrices, the streams could, for the first time, define and establish the performance targets that would be necessary for the company to remain competitive.

In addition to tearing down the barriers to secrecy, the matrices provided feedback that enabled us to see at a glance how we were doing. Finally, we were playing in a major league stadium with a highly visible scoreboard. As painful as the numbers were, we saw them every day, in black and white.

Kodak
Simplicity

has made the
Kodak way
the sure way
in picture
taking.

$5.00 to $75.00

**EASTMAN
KODAK CO.**

Rochester, N.Y.

*Catalog free at the
dealers' or by mail.*

BANDAGES AND TOURNIQUETS FOR A BLEEDING ZEBRA

QUESTION. What's black and white and red all over?

ANSWER. A dead zebra.

I overheard this joke on my way through Building 29, where two shop floor operators were taking a coffee break and sharing their feelings about the situation in Black & White. I repeated the joke to a group of managers who had gathered in my office for a late-afternoon staff meeting in October of 1989. The last traces of daylight had just succumbed to a heavily armored platoon of storm clouds that portended an early taste of winter. Inside, our own storm clouds appeared on the horizon in the form of monthly performance reports. Everyone on the management team put on

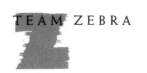

an optimistic air when talking to others in the organization. But in private, with each month's declining performance numbers, it was easy to get discouraged.

"Well, the Zebra may not be dead, but it's sure bleeding from the neck," said Bob McKinley, our financial manager. "We've had another month of poor financials."

"Oh, great," said Bob Brookhouse. "I saw the inventory bill and it was sky-high. We're talking change, but the numbers sure look like business as usual. And speaking of business, the business units are going to be all over us like Turkish rugs."

A moment passed in silence, then Marty Britt, our human resources strategic partner, added her own concerns, "Another round of bad news sure isn't going to help morale. People are still reeling from the change to a five-day shift, and they blame it on the Black & White flow. In the last week, 23 people begged me to get them out of B&W. 'Where would you like to go?' I asked them. 'Anywhere but here' was a pretty typical response."

Marty's observations were especially painful; it would take fully committed people to turn Black & White around, and it was clear that a lot of people had already cast their vote with their feet. Throughout September, a number of supervisors in other flows had called to tell me that they'd been besieged with pleas for transfer from their people who'd been assigned to Black & White. "I think you're in trouble, Steve," one supervisor told me. "You'd better have some strong medicine in your bag."

TRIAGE AND FIRST AID

In a sense, the flow had a chicken and egg problem. It needed people's commitment to turn around B&W's performance, but it couldn't get that commitment unless performance improved and

showed signs that Black & White was going to be around for the long haul. The first opportunity to break the cycle of decline came in early 1990, when it became clear that overtime was needed to meet the demand for film products—So many people had accepted voluntary retirement offers that we actually faced a shortage of qualified operators. In addition to bringing in supplemental workers, overtime would be necessary. Instead of formulating a policy and decreeing mandatory overtime, the flow management agreed to let the operators decide how they'd want to handle the situation. This, of course, was a radical departure from prior practice. When overtime was called for in the past, management just declared who was going to do it. Simple as that.

Rich Malloy, our graphics stream manager, with the help of Marty Britt and Tim Giarrusso, spearheaded the effort of organizing our "preference meetings." This was no small effort, because hundreds of people were affected by the decision. Rich, Marty, and Tim ran different meetings for each shift, and explained the situation. They also recruited 18 to 20 sensitizing operators to meet with others who couldn't make the meetings. Despite our good intentions, the entire effort was met with suspicion and raised eyebrows—the same kind that I'd encountered earlier during my first straight talk meetings. (One of the angry operators cynically threw a worthless wooden nickel at Tim during one of the discussion sessions.)

At the end of the preference discussions, everyone completed a survey, and the results were examined. By a very narrow percentage, the crews preferred a voluntary overtime policy—they'd determined that enough people were eager to work overtime that the company could depend on them to achieve the necessary volumes. As a sign of what was to come, one operator declared to Rich, Marty, and Tim, "Trust us, we'll come through." In fact, people quickly discovered that with voluntary overtime, they could recoup some of the income losses that resulted from the elimination of the seven-

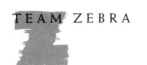

day schedule. It was also an important win for the company, because it turned out to be a very efficient way to meet product demand.

The preference meetings were our first attempt to create an empowering environment (that's "empowering environment" rather than "an attempt to empower people"—all of us learned early on that you can only set the stage for empowerment, *people have to empower themselves*). And the meetings were also the first demonstration of how our new management approach could lead to a win-win situation for the company and the people in the flow. Most important, the unprecedented act of letting people determine their own fate helped create a foundation for rebuilding the trust that had been so badly eroded during the preceding six months.

The feedback from the surveys circulated during the preference meetings was so enlightening that the flow management team realized the need for a similar action at the supervisory level. This led to the idea for the "Breakfast Club," which gave top flow managers the opportunity to have face-to-face contact with all the supervisors.

Starting in early November 1989, we met in Building 28 every few weeks for an early-morning gathering of first-line supervisors, in groups of 10 to 12. It was clear that the idea was going to be an immediate success—supervisors are naturally an outgoing and curious lot, and ours were excited to tap into a new information source. To enhance the value of the breakfasts, Marty took detailed notes about the issues, problems, and solutions discussed, and distributed them by E-mail. In this way, the breakfast topics quickly reached the entire cadre of supervisors.

Typically, the Club proved to be an opportunity for supervisors to ask tough questions about company policy, HR, and pay issues. For instance, one morning session went like this:

Q. HOW LONG will this pay freeze "thing" last? We have people who deserve more money since they're doing such responsible work.

A. WE HOPE to get exemptions for the pay freeze for extreme situations. [We did succeed in doing so for several people.]

Q. WHEN WILL WE GET to hire more people? We're short and working overtime, and that doesn't make sense.

A. WE WILL BE hiring temporary people and putting them in beginning-type jobs. In time, we'll be selecting the best of these for permanent jobs.

Q. HOW WILL our best people in finishing have a shot at the higher-paying jobs in sensitizing now that we're all part of the same flow?

A. WE'RE PLANNING to have job exchange programs between various parts of the flow so that our best people can progress, should they want to. You can help by encouraging capable, flexible people to give it a try.

Occasionally, I would use the Breakfast Club as an opportunity to mention something successful I'd seen in one part of the flow, such as safety training in solvent coating, or a packaging break-through in plate manufacturing.

I'd also spout off a few of my management ideas. Early in the game, I gave a little speech about how the role of the supervisor was changing, and that for flow to work, supervisors would have to become coaches, facilitators, and cheerleaders. To my surprise, this was extremely upsetting to one of the Club attendees.

"I just can't see myself doing it," he told Marty. "It's not in my blood. Supervisors get people on the line to toe the line. I really can't imagine any other way of getting things done." The admission was bemusing, because I'd heard that this individual was top-notch and would have no trouble adapting to the new style. Eventually,

at his request, human resources helped him transfer to a nonsupervisory position within the flow.

By December of 1989, I soon began to feel that things had the potential for getting on the right track; the preference meetings were an unequivocal sign that flow management was serious about doing business differently. And for many supervisors, the Breakfast Club had become one of the most exciting aspects of the flow. But Team Zebra still needed some kind of "glue" that would bind the flow together and create a sense of strong feeling of unity. That "glue" came in the form of a shared vision and the articulation of a set of values and principles to live and work by.

IN SEARCH OF THE WILD MONGOOSE

Every management guru I've ever read or heard says that leaders need a vision for their organization. So as the manager of the Black & White flow, I thought we needed a vision that everyone in the management team could share and refine into something that would serve as an inspiration to the entire operation.

Now, I wasn't quite sure how you go about "inventing" a vision, so on December 1, 1989, I sat back and looked out my window at the light coating of snow that had enveloped the Park, and asked myself, "What might the Black & White film-making organization look like in four years?" The answer led to the creation of what I called my "starter vision," which depicted a highly efficient and productive manufacturing operation. In this future vision, our internal suppliers and customers were working in concert and our customers could count on receiving the right product at the right time. New products rolled out of the plant on schedule, and Team Zebra had become a model for all other manufacturing units at Kodak. Wishful thinking? No—we could get there if everyone shared the same goals.

My starter vision made its debut to the Gang of 33 during one

of our regular Team Zebra management meetings held in December of 1989. At the same meeting, everyone tried an exercise designed to foster individual visions for the Black & White Film operation. Each person was encouraged to illustrate his or her current feelings about Team Zebra and where the flow could be heading in the future, using colors and animals. Tim Giarrusso supplied plenty of large sheets of paper, markers, and crayons for every person at the meeting, and asked the participants to take 20 minutes or so to express their thoughts and feelings.

Since the exercise was my idea, I thought I should embarrass myself first with my crude crayon scribbles.

"Well, as you can see, there are two faces here—a blue frowning guy, me, and the words 'sad' and 'low morale.' Notice the arrow pointing to Mr. Green Face. He's a happy go-getter." (Near the face I'd written, in green, "Go, Green Light" and "Go, Money.")

"Now, you're probably wondering about the five black and white fish on the bottom of the picture. They're killer whales [I'd recently been to Marineland near Niagara Falls with my granddaughter]. The killer whales are holding each other's fins instead of hands. Each of the killer whales has a ball on its nose. These balls represent customer needs, the business units we work with, the other flows and plants, our goals and strategies, and 'Can do!' "

After a round of applause, I said, "Gee, someone must have a better one than this." Fortunately, Marty Britt, stepped up to the plate and revealed her masterpiece. "Why, it's a baseball game, as you can see," she said. "First of all, it's supposed to represent something fun—who doesn't want to go to a baseball game? Second, it's a team—everyone has a role. The utility players might be thought of as the line managers, and the niche players are the specialists, but you need each one to win. There's also a scoreboard, so you'll know how you're doing. We're winning, as you can see by

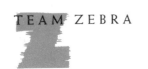

the evidence of a planned celebration outside the stadium—a beer tent outside the park. By the way, you know who's out there in the bleachers cheering us on? Our teammates and our customers."

This led to a round of applause for Marty.

Next Bob Brookhouse was inspired to show his wares.

"Anyone know what this is?" he asked with a grin on his face.

"A weasel?" someone replied from the back of the room.

"Close."

"Otter?"

"Nope."

"Mink?"

"A mongoose," Bob announced pleased that he'd stumped us. "One of their claims to fame is being able to defeat and devour poisonous snakes. In fact, I've drawn a few of our competitors down here . . . those snakes in the corner." He then went on to say that the mongoose is extremely quick—just like we wanted to be. "They're tenacious, too," he said. "They just keep chipping away at whatever they're 'working on,' just like us."

Bob's snake comment drew a round of belly laughs from the rest of the people at the meeting. One by one, each of the other members of the Gang of 33 stood up and presented his or her own visual renditions of a vision. People presented everything from ferocious beasts to happy clowns. A number of common themes were also evident, such as becoming more aggressive and nimble-footed in the marketplace, becoming more internally efficient, and using everyone's creativity. The vision drawings were so popular that we decided to post them on a prominent wall so that people could visit them as often as they liked, kind of an "art museum" of thinking on flow.

Probably the best result of the exercise was the enthusiasm it generated on the part of the managers. The Gang of 33 agreed to use this "visioning" experience with others. As the common themes were shared and internalized in many different ways, it would

ideally lead to a series of visions that were all "holograms" of our larger vision for a strong and flexible Black & White Film Manufacturing flow.

Over the course of several months, various operations developed visions of their own, based on their unique needs. For example, the major cycle time reduction project (called Sensi-X, short for "sensitizing excellence") had a vision of cutting cycle time from 42 days to 21 days in one year, then down to 10 the second year and 5 by the third year, and, someday, down to a single day. Originally, the cycle time reduction team was given a lengthy and very wordy vision from Rich Malloy and the other managers involved. But the team cut it back to two powerful words: "One day." The use and power of visioning was a distinct shift in capability for many. "Starting with the end in mind" is a powerful way to align people toward a common goal.

Those working on developing new products had a vision of their own for cutting their development time in half. And in the human resources area, Marty Britt developed a vision for the "people side" of the business, stating how people would be treated in the future, how everyone would be accountable for his or her own career development, and how people would have the opportunity to enhance their capabilities.

Regardless of whether people talked about the vision with a capital *V*—the shared vision, or individual vision (small *v*), the common themes served as a "transparent glue"; for the first time, many saw a purpose and a future for their work. And the discovery that our mind-set and thinking were consistent with others around us added power to the vision. More and more, I'd hear people talking about their "vision" for a particular project or improvement effort. As I wandered the halls in search of "minivisions," I was thrilled to learn of great scheming and plotting to make things happen. Over in Building 6, where film testing takes place, for example, I learned all about a project called RASP (rapid access

sensitometric processing). The idea behind RASP was that we'd have "real time" testing, rather than keeping product in limbo for as long as a week before it was released for "downstream" operations.

The changes in the air were clearly positive, although there were many rumblings of discontent. There were plenty of fears about the future, too. Some of the fears were vague apprehensions of what the future might or might not bring. Other fears were more related to the abrupt change in the way people did their jobs, from adjusting to new employees to sizing up new supervisors. What most people didn't realize, though, was that late in 1989, the flow was visited by a very real threat that, thanks to the fancy footwork of Rich Malloy and his team, transformed itself into a great opportunity to enhance Team Zebra's personal ownership and commitment.

MALLOY'S MAGIC NUMBERS: WHY A SQUARE FOOT IS NOT ALWAYS A SQUARE FOOT

Following the creation of the 1990 budget in the fall of 1989, Kodak's worldwide manufacturing management team (called the "sensitized goods manufacturing managers" or "SGMM") conducted what was known as the "strategic quantification" or "SQ" process. As the name implies, the idea behind SQ was to develop manufacturing strategies for the company. The strategies were based on the production volumes that each Kodak unit was expected to manufacture over a five-year planning horizon. SGMM's recommendations carried a great deal of clout, because the group directly advised Dick Bourns, Kodak's newly appointed vice president for worldwide manufacturing.

The material planners informed us that SGMM had decided to

advise Bourns to transfer large amounts of black and white film volume to other Kodak plants with newer equipment that was not being fully utilized. If black and white products were to be transferred to other sites outside the Park, the repercussions to Team Zebra would have been devastating. First, it could have resulted in significant job losses—part of the flow would be shut down. Second, it would telegraph a signal that B&W in Rochester was going to be cut back. This would quickly erode the trust we were beginning to build and once again send morale spiraling down into the abyss.

The maneuver would have been a bad one for the company, too, largely because of a misconception on the part of the planners—SGMM was considering black and white products in total. And on a total basis, it would appear that moving some of the products to other facilities made a lot of sense. When you looked at the detail, however, it was clear that the total was generally made up of many small product runs. And those were best done in Rochester. Although our equipment might not have been as modern as that of other Kodak manufacturing sites, no one had our versatility, experience, testing facilities, or proximity to the R&D community.

In addition, the other facilities would have found the short black and white product runs difficult to work into the massive longer runs for color that often took as much as two days to complete. In contrast, 80 percent of the Rochester-produced black and white runs took less than six hours to coat, compared with the longer-running products that could be on the coating machinery for days. This means that the longer runs would have suffered from interruptions or, more likely, the black and white products would have to be queued behind the long-run items—which was the worst thing that could have happened to B&W and its customers, given our miserable delivery history.

Finally, the transfer would have created unbelievable turmoil at

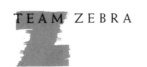

the recipient plants—you can't just move a product from one facility to another plant and say, "Here's the recipe—go make it." The transfer requires design changes in the formulas as well as time-intensive quality checks before the product can be "accredited" in the new location.

In short, the transfer idea was lose-lose for everyone, and Rich Malloy took it upon himself to "work up the numbers," in an effort to demonstrate that our products were best produced by the B&W coating machines. Rich and I then approached Ron Heidke with an "airtight" case for keeping B&W products in Rochester—Rich and his team had done a fabulous job pulling numbers that supported our point. The numbers clearly showed how much lower production costs would be if Black & White didn't have to accommodate the smaller runs, making for a much fairer comparison.

On a particularly blustery day in early January 1990, Rich and I walked from Building 2 through the "Ho Chi Minh" trail, a network of passageways connecting the facilities, to Building 26, where Ron's office was located. The trail saved us from a long trek out in the cold.

"How can the company think of doing this?" I demanded to know, as we discussed the ramifications of the proposed plans. "It's not good for us or the other plants. We've got the staff, technical knowledge, and facilities necessary to make B&W work the way it should."

Ron scratched his chin and then said, "You make a compelling case, Steve. But we're still going to have to convince SGMM. Let's have Rich present his data to the next NAS group meeting. We could sure use NAS's support." (NAS, Kodak's North American sensitizing management group, included top managers from Rochester, Colorado, Canada, and Mexico.)

On Groundhog Day, Rich presented his report, entitled "When a Square Foot Is Not a Square Foot," to NAS. (The planning was done on a square-footage basis, for the aggregate products rather

than the individual items. As Rich demonstrated, the short-run products in the aggregate were not equivalent to the individual parts—hence the report title.) The NAS members concurred and empathized with our position, and urged Ron to present the report at the next SGMM meeting—with their full endorsement. Ron did just that, and in March, the SGMM managers unanimously decided on the spot to keep the Black & White products in Rochester.

SGMM's decision not only saved jobs, but also validated BWFM's mission as the company's "job shop" (at Kodak, "job shop" refers to an operation that produces specialty products, generally produced in short runs). The decision also confirmed that Team Zebra would be an active partner in commercializing new versions of Black & White Film products. Of course, everyone was jubilant over the decision. The flow came into the "SQ crisis," as it had been dubbed, with a "hit on the head" and came out with the affirmation that our corner of the Park could do specialty and new black and white film manufacturing better than anyone else.

The news of SGMM's reversal was met with great cheers at a regular Wednesday-afternoon staff meeting that quickly turned into a victory celebration in honor of the flow and the company as a whole. "Everyone's better off for it," Brookhouse commented. "Black & White gets to make the products it should, and the other plants won't be burdened by product runs that they're not set up to handle."

Bob, Tim Giarrusso, and Rich Malloy then performed a skit for us, *Mr. High Volume*, which by popular request was repeated during numerous meetings over the course of the next two months. Tim played "Captain Corporate," a three-piece-suit type who could bestow Black & White's volume upon other plants in the company. Bob assumed the role of "Mr. High Volume," who in turn represented the plants outside Rochester that coveted the Black &

White products. And Rich played "Mr. Job Shop"—dressed in grubby clothes and decked out with a Zebra hat. In the end, Mr. High Volume's enthusiasm soured when he learned what would happen if he acquired the B&W products. Mr. Job Shop, by contrast, became happier as Mr. High Volume's spirits initially sagged. In the end, Mr. Job Shop emerged as an important character with a high level of self-esteem, and Mr. High Volume saw he, too, benefited by letting Mr. Job Shop retain the short run products. Both came out winners.

People in the flow not only found the skit great entertainment, but also an important morale booster. It reaffirmed that black and white products were a source of pride, and that people in the Team Zebra flow had an undeniably important role at Kodak Park. And a future, too.

OF BUSINESS PRINCIPLES

With Black & White products firmly established at Kodak Park, the Gang of 33 could turn its attention back to the issue of rebuilding morale and boosting performance. In a sense, we were working on two levels at the same time—developing stopgap measures to staunch the bleeding, and creating long-term strategies that would enable Black & White operations to achieve its future goals (as of September 1989, the flow was formally named BWFM—Black & White Film Manufacturing). As I asked people what kind of organization they wanted BWFM to become, everyone agreed that they sought a principle-driven, not a rule-driven, organization.

Now, it wasn't as if values and principles were completely new—the flow had inherited values from the sensitizing, finishing, and testing groups. Our task was to select and consolidate the best from each organization. This turned out to be a much more compli-

cated task than anyone had imagined. For example, the *f* word ("fun") was highly controversial; instead, we wound up using "enjoyable."

"Fun and work simply don't belong on the same combo plate," someone commented during one of our meetings. "Besides—it just doesn't sound dignified. I don't think anyone's going to take us seriously if they heard about 'fun.' "

This bothered me, but rather than get into a fundamental discussion about the nature of work, I bit my tongue and agreed that the flow would use "enjoyable" instead of "fun."

Then there was the issue of customer satisfaction, which eventually become known as "customer delight" (nothing pleased Colby Chandler more than to learn that our products and people provided "customer delight," as he put it). We talked about people values, too; one of our values was to develop a safe and participative environment. Finally, there were values concerning the flow itself—to operate as a set of linked internal customers, to use facts rather than emotion, and to strive for continuous improvement.

On the one hand, this might seem like a matter of semantics and splitting hairs over shades of meaning. On the other hand, the words did provide windows into strong emotions and beliefs. By listening to what people had to say and discussing alternative wording, we were able to build a strong consensus among the management team.

But would all of this thinking about values and principles really translate into action on the shop floor level? To find out, I often toured the manufacturing buildings and asked people what they thought of our ideas for Team Zebra. I got some nods of approval, along with some skeptical comments. But far and away the most interesting insight was offered by Johnny Johnson, an X-ray film finishing operator in Building 313. After reading Johnson our list of values, he smiled at me and said,

"Steve, it doesn't matter what you call these things. It just matters whether you *mean* them."

IMMORTALIZING THE MISSION

Johnny Johnson put his finger right on the issue as only someone so close to the work can do. The management team did mean the words, and one way to show people that was to print them and display them with a unique BWFM logo in every office. We had the words, but we needed a logo. What better way to show our intent of listening to people than to sponsor a logo contest open to everyone in the flow? Besides, if the logo was to truly represent the spirit of our team, the inspiration should come from within the flow, rather than from the mind of a graphic artist. So the flow management team sponsored an official BWFM logo contest, and offered a $100 reward for the best phrase and design. Within hours after posting contest announcements on bulletin boards throughout the manufacturing buildings, ideas began flowing in from all corners of the Park. Some came on the back of napkins, others more formally on large sheets of film wrapping paper.

At the end of two weeks, a formidable mountain of logo ideas gobbled up every square inch of the conference table outside our offices. Deborah Norton, one of the secretaries in the flow office, spearheaded the process of narrowing down the entries during a special management team meeting. At one point during a hot debate, Deborah Norton threw up her arms in desperation and cried out, "Bond with me for a minute!" That comment broke the crossfire long enough for people to calmly discuss the entries that Norton read aloud:

"The Team Shines Bright in Black & White" (the logo included a flashlight).

"Too corny!" someone snorted.

"BWFM: Focused on Performance" (the logo included a series of lenses).

"Not bad," another offered.

"The Winning Edge" (the logo featured a black and white checkered flag and racing car).

"Too sporty," someone remarked.

"All's Right in Black and White" (the logo included a fuzzy black and white disk).

"Too frivolous," commented one of the managers. "Besides, the logo looks like a hairball that got run over by one of our supply trucks."

"Images of Excellence" (the logo included a black diamond on one edge with white lines passing through it).

"Yes!" The affirmation resounded throughout the room.

The originator of the idea, Bob Gill, from the health science products staff in Building 29, was shocked that he'd won the contest. For his efforts, he won a $100 certificate to spend at the shopping mall of his choice. Long after Bob had spent his windfall, his logo would live on in Black & White Film Manufacturing. Deborah Norton had contracted with a professional graphic artist to tighten up Bob's logo. She then ordered 100 copies of the logo, with our mission statement, values, and principles, printed on two-foot-by-three-foot black matte stock. Not only did the logo grace the hallways of every building connected with BWFM, but it also began appearing on coffee mugs, sweatshirts, T-shirts, stationery, and the like.

One manager, Scott Snyder, was so excited by the logo and mission poster that he had a special one made up for his office, where it hung from the ceiling. No one could help but be impressed by the five-foot-by-eight-foot piece that seemed to float in space and remind us of what we could be when we grew up.

BITING THE SILVER BULLETS

Equipped with a vision and our own logo to prove it, the flow management devoted most of its energy to making improvements that would eventually renew BWFM. Each of the three streams making up the flow (graphics, health sciences, solvent coating) had its own unique improvement plans. For example, the graphics stream had its own "thrust" program, designed to help everyone improve his or her productivity by focusing on a unique "thrust" or major challenge, such as waste reduction, material usage, delivery, performance, commercialization of new products, and expense management.

One of the most pressing thrust areas was the reduction of the high-cost ingredients used in the film-making process. The most expensive ingredient was silver. Even though the price of silver had steadily fallen since its heyday in the '70s, it still cost us around $4 to $5 per ounce in the late '80s and early '90s.

Gene Salesin, a chemical engineer and leader of our graphics film quality assurance group, spearheaded the effort of the "Silver Bullet Team" to redesign the film-making process to reduce the use of silver. (Kodak is the world's largest user of silver; worldwide, the company uses about 50 million ounces of silver a year—enough to produce all the silver dollars that the U.S. Mint made in a 12-month period during the big silver dollar production years of the '20s and '30s.) Reducing the amount of silver used in the production process is much more complicated than simply adding less to the coating kettles. Silver halide is the essential stuff of photography, and enables the film to form an image. If you don't use enough silver, you won't get a very good picture. So Gene's challenge, as both the quality guardian and the leader of this effort, was to find new formulations that would use less silver without losing image quality.

Although the search for "silver bullets" continues today, it has already saved millions of dollars.

While Gene's group was battling with the silver issue, Tony Myers, then on the graphics stream staff, was deputized to wage war against waste in graphics. Remember, the graphics stream manufactured some 5,000 off-the-shelf products. This meant that every giant roll could be cut up into thousands of different configurations. And the goal was to minimize the amount of waste. Tony's waste reduction group took the planning to new heights, and began rethinking virtually every step of the manufacturing process, in search of hidden opportunities. Tony and his team were so successful at tackling the waste in graphics that I asked them to help their counterparts in the other two streams to take the same approach. So while some of the tactics were "stream-specific," others were more generic approaches that could be applied throughout the flow.

To facilitate the sharing of information, I assigned the role of "gatekeeper" to various key people. The gatekeepers reported on actions in various parts of the flow, and provided people with facts, figures, and strategies for improving performance.

One of the more educational tools was the short skit, exemplified by financial gatekeeper Bob McKinley's *Eat at Joe's* skit. In this off-off-off-off-Broadway comedy about selling peanuts, based on an actual case study, Bob explained to Jack Stewart, department manager of X-ray and dental finishing, the fine points of cost accounting and how the "perfect" cost accounting system could lead to the wrong economic decisions. Whatever the format—skits, games, or presentations—the gatekeepers did a fabulous job of raising awareness, especially in the areas of inventory, delivery, and conformance.

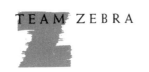

MOVING MOUNTAINS: INVENTORY AND DELIVERY

When I first started at Kodak in 1957, inventory was managed and tracked at a very high level in the company—inventory figures never appeared in divisional budgets. In the 1980s, there was an effort to give organizations within the Park more responsibility for managing their own inventories. And when the Park was reorganized into flows, the concept took on great significance; in order to meet Ron Heidke's performance ultimatum, each stream would have to become master of its own inventories. This in turn meant a whole new way of doing business.

Our gatekeeper for inventory and material flow, Bill Poole, took on the challenge of cutting inventory with great relish, and within two weeks had undertaken a major educational initiative.

He figured that the first step was to get people to understand the causes and consequences of sky-high inventory. One learning device he created was the "Poole Inventory Quiz," which he first "administered" to the Gang of 33 in December of 1989. The quiz asked such questions as "What's the value of the materials and finished goods that the company has tied up in inventories?" "How much does B&W have tied up in inventories?" Most people were astounded to learn that, worldwide, Kodak had *nearly $3 billion* invested in inventory. Black & White's inventory was a significant portion of that amount.

Then there was the issue of carrying costs—the tab for storing and warehousing inventory, the cost of replacing damaged goods, and the cost of the money that was tied up in the stock. (Yet most annual reports count inventory as an asset! It should be a *liability*.) At one "Poole Hall" session held in March, Bill asked people to guess the carrying costs of B&W's inventory.

"Ten percent?" a voice rang out.

"Nope," Poole answered.

"Fifteen. And not a point more," said one of the jokers in the crowd.

"Keep on going," Poole said with a laugh.

When the number hit 25 percent, no one believed it could go any higher.

"How 'bout 30 percent!" Poole exclaimed.

When the buzz in the room died down, he asked a final bombshell question: "How much inventory do we carry as a company compared to our competitors?"

No one ventured a guess, so Bill revealed that compared to competitors, Kodak had twice the amount of inventory relative to its sales (based on his study of annual reports).

The numbers were a real eye-opener for most of the Gang of 33. And to make them all the more real, Bill encouraged exercises in which people "walked the material flow." This involved guided tours of the route that all the materials took as they made their way to final manufacturing sites. At various stopping points, the inventory piled up into gargantuan mountains, which drove home the point that the situation was far from acceptable. "It's one thing to read about the numbers on paper," chuckled Bill. "It's another thing to see it in front of you like the Rock of Gibraltar."

Once the managers in the Gang of 33 had walked the route and experienced the bloated inventories firsthand, they passed the message along to others, in some cases recreating the outings (some of the materials started in locations more than three miles away from the sites where they were eventually used).

(An interesting variation on the "walk the material flow" exercise was Bob Brookhouse's "Skeleton in the Closet" exercise. During these excursions, Brookhouse would personally take people on an expedition into the refrigerated storage area in search of the roll of film that had been hanging around the longest time—a three-year-old support roll set the record! Talk about tying up cash! Bob then

staged a "birthday party" for the roll, complete with refreshments. This offered an opportunity for people to discuss how the roll stayed there so long, the ramifications, and what people could do about it.)

Once people had become personally aware of the severity (and absurdity) of the inventory situation, Bill called for general suggestions from everyone in the flow for ideas that could help hack down the inventory levels.

A number of B&W material planners came forward with ideas for cutting back the amount of safety stock. This was certainly a big "Aha!" for us; it revealed that the material planners knew they were operating with excessive "just-in-case" inventory, but never had an incentive to do anything about it (in fact, there was a disincentive— no one ever got rewarded for running out of stock).

Other people suggested capitalizing on the partnerships that Kodak had established with suppliers to provide fully tested materials. Even though the supplier partnerships had taken hold, Black & White had not been successful in eliminating much of the duplicate quality testing.

Still others focused on the shipments Kodak Park to company plants located throughout the world. People offered great suggestions for cutting customs red tape and streamlining bureaucracy, so that master rolls didn't languish for weeks in Kodak warehouses.

In addition to helping people think about practical ways of reducing inventory, Bill's gatekeeping duties involved improving B&W's abysmal delivery performance. Bill was instrumental in helping us think of delivery in terms of the flow, which in turn meant getting people to focus on their internal customers. Everyone could relate to external customers, but the idea of serving and being serviced by others in the company was still new to us.

One immediate effect of the new thinking was a shift from monthly to weekly schedules. "Our ultimate vision," says Bill, "was

to plan on a daily basis so that we could know exactly what the chain of internal customers would have to do to get product out the door at the right time."

TO CONFORM OR NOT TO CONFORM, THAT WAS THE QUESTION

While Bill Poole was inspiring people to slash inventory and improve deliveries, Chip Wagner, manager of quality and administration for the flow, was keeping his eye on the big picture numbers. Chip was responsible for monitoring overall performance with respect to the matrix that Ron had set up for us. He was also the gatekeeper for the conformance measures, one of our quality parameters. Like Bill Poole, he used education as a primary tool for attacking the problem.

"Conformance doesn't just mean meeting customer specs," he explained at one of our managers' meetings in late December of 1989. "We're conforming to a set of *internal* customer specifications throughout the internal flow. Unfortunately, there's a multiplier effect here. So if we have five operations all performing at 98 percent, what's our overall conformance?"

"Ninety-eight?" someone ventured.

"Nope. Ninety—it's the product of the conformance levels of each step." Chip went to the board and wrote: $.98 \times .98 \times .98 \times .98 \times .98 = .90$. He said; "So you're really not conforming 10 percent of the time. Now, what if you have four operations at 100 percent and one at 70? What's the best conformance you can expect?"

"Less then 70," one of the managers offered.

"Give that partner a Zebra pin! You've got it. The lowest conforming operation is the weakest link in the flow."

By the end of the session, our people had a good understanding that the internal conformance numbers were symbolic of our inefficiencies. And they understood that even though quality remained high through the years, the cost of achieving it through product control was simply unacceptable. I thought about repeating the joke I'd heard earlier about the dead zebra, with a slight well-worn twist. What's black and white and red all over? The newspaper—and the big news is that Team Zebra had the tools and understanding to keep Black & White from becoming an endangered species.

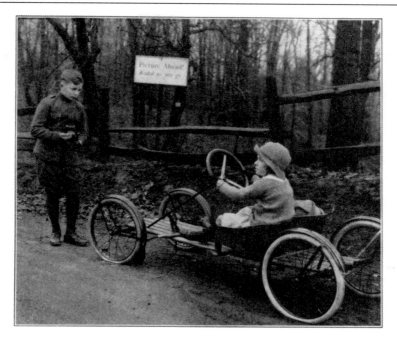

Every sport is even more sport with a

KODAK

Your album filled with pictures of good times will be the book you like the best. Whether it's riding or fishing, tramping or camping, Kodak as you go.

There's a Kodak dealer right around the corner. Ask him to show you how easy picture-making is the Kodak way.

Autographic Kodaks *$6.50 up*—Brownies *$2.00 up*

Eastman Kodak Co., Rochester, N. Y. *The Kodak City*

CHAPTER 6

RACING DOWN THE DATA
HIGHWAY AND OTHER ACTS
OF EMPOWERMENT

"Ready?" Paul Lux asked as he placed his finger on the power switch of the computer monitor sitting on the workbench in his office. Amid the old wooden furniture, the massive video display, clad in a protective metal shell, looked strangely out of place, as if it had been left behind by an advanced civilization that had abandoned the darkened hallways of Building 29 long ago.

Jimmy Culmone, from sensitizing maintenance, answered Paul with a nod, as did Pat Fagbayi, their coach. Paul flipped the switch and the screen came to life as a green blip flashed in the lower-right-hand corner. A moment later, a red blip appeared half an inch above the green one. Several more bursts of green light then lit up the screen, until the entire monitor was alive with flashes of color that punctuated the semidarkened room like a miniature fireworks display.

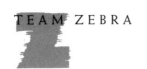

Jimmy whistled softly under his breath. Pat said nothing, although a tear began rolling down her cheek. "Looks like Christmas." Paul chuckled with the glee of a child who had just discovered Saint Nick's handiwork.

In a way, it *was* Christmas; Lux, Culmone, and several "commandos" ("fix-it" people with the reputation of being able to repair any piece of sensitizing equipment) had given Kodak a remarkable gift—its first "real time" glimpse into the processes taking place in the sealed melting kettles simmering away on the other side of the wall. Without valid "inside" information, the operators could never be exactly sure that a particular film emulsion melt would be properly "cooked" until after it was completed. As a result, the company often wound up wasting time, energy, and money on emulsion that couldn't be used to make salable product. The batches of emulsion are relatively expensive, and some incorporate exotic ingredients costing as much as $2,000 per ounce. While the silver could be recovered from a bad batch, the rest of the ingredients had to be pitched. A bad melt also fouled up the schedule; if melted emulsion wasn't ready for the coating operation, the people in the other operations would be idle. The entire "alley" could be down anywhere from two to five hours.

The "data highway," as Paul called it, went a long way to reducing the number of bad emulsion batches. The feedback from the highway (obtained from sensors in the kettles and transmitted to the computer), generated a "melt profile" that provided accurate information about the state of the melt. Operators could then fine-tune the amounts of water and steam entering the kettles (a fraction of a degree off in either direction could mean the difference between a successful batch of emulsion or worthless glop).

While the technology of the data highway wasn't groundbreaking—it consisted of sensing devices called programmable logic controls (PLCs) linked to a personal computer—the way Paul,

Jimmy, and their commando buddies went about creating the system on their own was remarkable for a company that traditionally fostered the attitude of everyone "sticking to their knitting." And it exemplified the kind of empowered thinking that was starting to take place throughout Team Zebra. For me, these self-initiated acts validated the basic premise of our leadership approach—if you manage people as if they're part of a herd of cattle, they'll simply do what's asked of them and no more. But if you create an environment in which people can empower themselves to do great things, they'll go far beyond the duties outlined in their job descriptions.

ONE ORGANIZATION'S TRASH IS ANOTHER'S TREASURE

Normally, when a group at Kodak needs additional equipment or wants to enhance existing gear, it submits a proposal and cost justification through management channels. If the return on the investment is high enough and fast enough, the group has a good shot at getting the requested funds, and management will assign engineers the job of scoping out the project, designing the gear, and overseeing the installation. "I doubt we could have gotten to first base," Lux admits. "We knew that we needed something to get better feedback on the melts, but we didn't know *exactly* what kind of system we wanted—there was no way we could prove the system on paper."

Besides, the "commandos" (or process analysts) usually didn't go about writing proposals and cost justifications for new hardware systems—that was reserved for professionally educated and highly trained engineers. The analysts' job was to assess the progress of an emulsion batch and ensure that it was statistically under control. A

feedback system such as the data highway would have been the domain of degreed engineers. Still, Paul knew what he needed to get better statistical information about the melts. And as a member of the flow, he'd been encouraged to become a problem solver. So he "conspired" with Jimmy Culmone and Bill Zinner, also from sensitizing maintenance, to build a system that would cost the company next to nothing.

Bill had learned that another coating room had just updated its aging T30 Allen Bradley terminals. The ones that wouldn't be used elsewhere in the flow would probably be earmarked for the trash. "Let's grab one!" Paul exclaimed. Jimmy then collected wire left over from other jobs and spent his lunch hours for the next two months making connections from the PLCs in the kettles to a small personal computer and the T30 terminal. Bill and several of the commandos took care of the programming and software side of the project. After two months of "noodling," the data highway was ready for "opening night" in the process analysts' room.

Could the data highway have been built in the preflow days? "No way," insists Paul. "First of all, we were all working under the old 'Kodabucks' mentality—'it's just funny money.' Second, you never got any encouragement to do anything but what your job called for. After you got shot down a few times, you just stopped coming up with ideas.

"In the old days, there also wasn't much real interaction between the people on the shop floors and the product engineers. When you needed a repair or a modification, you called MEMO [the Manufacturing Engineering and Maintenance Organization], and they came and fixed it. No one ever encouraged you to figure out ways to solve problems yourself.

"Since you weren't encouraged to voice your opinion, you didn't care as much. One of the things that irked me was that you'd have 'programs of the month.' All of a sudden, you'd have an edict that said, 'We'll have quality around here.' But there wasn't a chance to

really do much—you could only think of quality in terms of your little corner of the world, which doesn't work. You also couldn't see any improvement. Either we did good or didn't. The managers kept saying we had to improve, but there was no measure, no way of seeing that you made a difference."

For Paul, flow meant a radical change from the previous 27 years he'd spent at Kodak. He'd started out as a floor scrubbing machine operator, then trained to work on various film processing operations. About the time that the flows were formed, Kodak invented the position of process analyst. It meant going back to school and learning statistics—something that Paul wasn't thrilled about. But it also meant an opportunity to learn new things and work at a higher level. And with the new "flow mentality," as he calls it, he felt motivated to do more than just control and troubleshoot the melting process, which is what he was paid to do. He soon found himself engrossed with the idea of a "real time" feedback system that would allow him to pinpoint problems with a melt before it was too late. "Kind of like the difference in treating diseases when they happen and taking a preventive approach," he says.

Paul recalls how one of the turning points for him was the formation of a cross-functional team designed to solve a production problem with a medical imaging film family called S0-132. The S0-132 family was an extremely innovative family of X-ray films, one of the new hybrids that spanned the domains of chemical and electronic photography. The S0-132 films had tremendous marketplace potential, and were especially attractive to Kodak; rather than supplanting an existing product family, they were meant for use in an electronic imaging device made by another company. There was only one problem: the films were extremely difficult to manufacture, and a high percentage (in some cases 100 percent) of the product went to waste. To solve the problem, Bob Brookhouse, who was in charge of the health

sciences stream, assembled a team of operators and engineers from melting, coating, and testing. Paul was included on the team because of his expertise in melting.

This was a critically important first for Black & White. Never before had everyone involved in a film-making process sat down and looked at the whole picture; in the old days, the fiefs and the "silver curtain" made such a "summit meeting" impossible. The collective brainpower, knowledge, and experience of the SO-132 crossfunctional team was truly impressive. Group members stepped out of the confines of their "normal" jobs and were able to develop a solution that never would have evolved if the problem had been tackled piecemeal by isolated individual groups.

"It was a great triumph for a lot of reasons," Brookhouse crows. "We slashed waste down to acceptable levels. But, equally important, we had a symbolic victory. We demonstrated that internal customers can focus their energy on a common problem."

The S0-132 experience probably gave Paul and his peers the confidence that the company was willing to take their ideas for the data highway seriously. The engineers certainly did; once they saw the data, they were truly stunned. "It was amazingly simple and fast," commented Bob Hart, a health sciences product engineer. "It gave us excellent preliminary data and proved itself beautifully." The effectiveness of the data highway made it possible for the engineering staff to propose a $600,000 state-of-the-art, dedicated computer system for monitoring kettles throughout the black and white flow. With an annual payback of $300,000 per year, the new system was readily approved.

"We had two cans and a string by comparison to the new system." Paul laughs. "But they never would have thought to design a system if it wasn't for the old data highway. I feel like we were pioneers on the frontier—we opened a path to the future."

TIME BUSTERS

In the fall of 1989, Rich Malloy began zeroing in on one of the big obstacles to improved performance: cycle time, which averaged 42 days and was as high as 120 days for some products ("cycle time" refers to how long it takes from the beginning of the manufacturing process to the time that a product is ready for finishing into final customer products). Rich called for a 50 percent cycle time reduction, which seemed too extreme to many people in the flow. Yet, the cycle time was so bloated with unnecessary steps that in reality, 50 percent was quite attainable. By November, we'd established a project known as "Sensi-X," which stands for "sensitizing excellence."

To give people an understanding of the importance of cycle time reduction and how it would benefit performance, Rich bought copies of George Stalk and Thomas Hout's *Competing Against Time* for all of the product engineers and managers involved with Sensi-X. Stalk and Hout determined that halving cycle time, yields a net productivity improvement of 20 to 80 percent. This greatly appealed to us, as we would also experience a dramatic drop in work-in-process inventory, which tied up valuable cash.

Recalls Keith LaFleur, a film formulation engineer with the graphic arts stream and a 19-year veteran of the company, "One of the major obstacles to reducing cycle time was the mind-set. People at Kodak had a paradigm of 'playing it safe.' That meant running every test they could before final coating, so if the coating didn't come out okay, they could sit down with their bosses, point to the data, and say, 'Hey—I did everything by the book.'

"There are two types of processes," he continued, "transformations and transactions. A transformation is any activity that adds value to the product. For example, cooking the emulsion adds

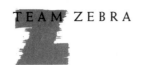

value. But moving the emulsion from 'A' to 'B' doesn't. Running a test doesn't add value, nor does planning for a film run or storing film. In total, black and white film production contained a lot more transactions than transformations. And the transactions were costing a lot of time and money."

Keith believed that there were so many unnecessary "transactions" in the sensitizing process that the cycle time could be slashed significantly without any problems. To prove this, he and his team performed a bold experiment with one of his products. "Normally," he explains, "we'd first coat a 200-foot-long strip, about seven inches wide. We'd do this in what was called the 'FW' machine. We'd then analyze the strip. If it was okay, we'd run a pilot, then do another analysis, which took about a week (we'd call the time lag a 'skip week'). Finally, we'd coat the jumbo rolls. After looking at a lot of test data, it seemed to me that by and large the pretesting was unnecessary, at least for many products. So I took in a gulp of air and approached Steve and Rich with the idea of routing the emulsion directly from the kettles and bypassing the FW, skip week, and pilot. I said we'd cut cycle time to . . . ONE DAY! Their eyebrows went up, but they said, 'Try it!' "

Which is exactly what Keith and his team did in February of 1991. Successfully! He then issued the following E-mail report so that others in the flow could share his findings:

```
After finishing a batch, the emulsion was drawn
down into two of our largest melt kettles and
transported directly to the melting room. About
three hours after the emulsion was finished the
melts were being coated as product code S0-218.
With on-line RASP data [real time testing], we
could see the results almost immediately. Ap-
proximately 40,000 linear feet were produced
```

```
with excellent physical and sensitometric [reac-
tion to light] quality.
```

This was truly a first in Kodak's black and white film-making history, and to this day, SO-218 is made on the one-day basis. The success of Keith and his colleagues inspired experiments with other products, which in turn inspired others in the streams to find ways to cut their cycle times, too. By the time I'd left the flow, many of the 42-day cycle times had been cut in half, and today a number are even lower. Because of formulation and testing needs, not every product cycle time can be cut to one day; but the remarkable demonstration by Keith's team showed what could happen if people were willing to forgo business as usual.

"In the preflow days, I'd never have tried such a thing," Keith admits. "The last thing anyone would want is to have their name written all over a batch of bad emulsion . . . it would not be a career-enhancing move. In [Team Zebra], though, you're encouraged to take risks and step out of your comfort zone, instead of just covering your tail. . . . Under flow, we had the opportunity to redefine our jobs and how we did our work. In the past, I'd say, 'My job as an engineer is to solve problems and get product out the door.' Today I say, 'My job is to figure out how to *eliminate* my job . . . create ways to do the work with fewer engineering and technical problems.' "

This kind of thinking was a radical departure for the product engineers. And it led to some radical ideas, too, like the LASER "Company," a "quasi-organization" in the film flow. LASER stands for "Let's All Support Express Routing," and the "Company" was actually a manufacturing support group that helped members find ways to make product more efficiently. By spring, the LASER Company had acquired a reputation for being a key "unofficial" resource that anyone could turn to to help improve their performance. It

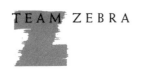

also stimulated the formation of a communications support group, the "PULSERS" (People United Listening, Supporting, Educating, Responding, and Sensing), which spread the word about Sensi-X throughout the flow.

A fellow product engineer, Bill Baum, once asked Keith, "How do I join the LASER Company?" Keith smiled and said, "You just did."

CHOLACH'S CHARIOT

Imagine a film product so sensitive to dust that the slightest fleck would ruin it. You'd certainly be thinking of Accumax (among others), which was used in the manufacture of printed circuit boards. The boards were etched from photographic negatives made with the film, so any dust on the film would translate into a broken wire on the circuit board. And a printed circuit board with a broken wire is worthless.

The rolls of Accumax were finished and slit into finished products in a high-tech clean room. The plastic boards used to "sandwich" the film while it was being slit were also perfectly clean. Unfortunately, the supply cart used to transport the film to a storage area was not dust-free. As slitter operator Bob Cholach put it, "It was self-defeating. We'd make product under clean conditions, put it in the cab, then move it across the buildings. As the cart bounced along, the doors would rattle. If the doors could rattle, there was space for dust to get inside." The solution? For Bob, it was easy: an airtight cab. So Bob talked with the engineer for Accumax, Fred Yacoby, who encouraged him to develop the project.

"I had some drafting in high school, but that was 30 years ago," Bob recalls. "I was definitely rusty."

Nevertheless, Bob began doodling in the evenings, and a month later, he presented his sketch to Fred. Fred was excited and passed the drawing on to the finishing department manager for the graphics stream, Neil Tornes. Neil enthusiastically endorsed the project and approved funding. The cab was to be built in the metal shops of Kodak Park, with Bob serving as the construction adviser. The only problem was that the supervisor of the metal shop laughed when they were given the specs: "Airtight metal cab light enough for anyone to push? When are the people from NASA going to beam down to Rochester to build it for us?"

Fortunately, Bob didn't have enough knowledge of metalworking to realize that his cab couldn't be built. So he and one of the shop workers persisted, solving every problem they encountered. "One of the trickiest parts was the door to the cab," Bob recalls. "Originally, I wanted something like a garage door, but we couldn't make it airtight. We experimented and finally came up with a set of double doors, actually a door within a door, like an airlock. The idea was that if someone rammed into the cart with another piece of equipment while walking around in the dark, the cab would maintain its clean integrity."

Four months later, Bob's "dream machine" was finished, complete with front wheels that would enable someone to easily do a "360." The interior was thoroughly cleaned to eliminate metal filings, and the cab was ready to be pressed into service— to the chagrin and congratulations of the metalworkers in the shop.

For Bob, this was the first opportunity he'd had in 26 years at Kodak to do something on his own, and something he knew would make an important difference. "It was an incredible experience," he said. "In the old days I'd have been told, 'That's not your job— don't worry about it.' But here I was given the power and finances to design and build something that would help my teammates. It

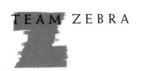

wasn't like dropping a piece of paper into a suggestion box, either. They let me run with it from start to finish. I know that cab is going to be in use long after I retire, and that's the big payoff for me."

HAVE IT YOUR WAY

JOB DESCRIPTION: Place sheets of film in a paper folder—expected to complete 5,000 units per workday. Work in near-darkness. Sit at tables likely to be improperly sized for your body. Get frequent headaches and backaches.

Sound awful? The "interleaving" job (separating film sheets with paper sheets) in B&W, as it was called, certainly was one of the least desirable in the Park. Not surprisingly, it had one of the highest turnover rates in the flow. If the boredom didn't drive you nuts, the backaches would. The tables where you did your work came in two sizes, small and large, and if you happened to be in between, you were in for a sore neck or back. To add salt to the wound, the job was also near the bottom of the Kodak pay bracket scale.

"We practically hired people off the streets to fill the interleaving jobs," laments Jack Stewart, the department manager of health sciences finishing. "As soon as there was an opening somewhere else in the company, they'd request a transfer. Then we'd be out scrounging for people again."

One frustrating day, after losing another interleaver, Stewart and system manager Terry Berbert headed out to Casey Jones, a local watering hole, to figure out what they could do to make the job more appealing.

"There's no way we can automate the interleaving," Berbert said. "It would never warrant the $500,000."

"You're right," Stewart concurred. "I hear that automated interleavers haven't worked all that well, anyway, even after lots of trying. If we're going to get interleaving running smoothly, we've got to somehow make the people part more desirable."

But how can you make a repetitive and uncomfortable job more appealing? The pay scale was very low and the job was what it was—boring. But then Stewart and Berbert had a brainstorm.

"Why not let people create their own workplace—modify it to fit their needs?" Stewart asked. "We'll redo the tables and shelving to fit their body heights. And we'll let them come in whenever they want—who cares what time they arrive as long as they produce the work?"

Berbert agreed with Stewart, and within a week, the news was out that interleaving was offering the ultimate in flexible scheduling—work for eight hours at ANY time you liked. "This was an immediate hit with the people in interleaving, and maybe the first bright spot they've ever had in their jobs," Stewart says proudly. "Some decided to come in at five o'clock in the morning and go home at one in the afternoon. That way their spouses would get the kids off to school, but they'd be there when the kids came home. That also cut out the need for afternoon day care, and gave the operators a chance to have a more normal family life. Other people went to school in the morning and worked in the afternoon. There were all kinds of 'crazy' arrangements—crazy on the surface, but making perfectly good sense for the individuals doing the job."

Stewart recalls how people soon started taking pride in the fact that they could plan their own work. Part of that planning meant that they took responsibility for the stock of interleaved film at the end of the shift. If there weren't enough "ready packs" of X-ray film when they were winding down for the day (or morning or evening), the operators would often call the people on the next shift and ask if they could come in earlier to ensure that the films were ready for promised shipment. And they'd always agree—there was a real

sense of accomplishment in feeling that they were part of a team whose mission it was to keep customers supplied with critical X-ray films.

As part of the "self-governing" approach, the interleavers were also asked to participate in a redesign of their work area, not only so that they'd suffer less back strain, but so they could improve the way they serviced their internal customers, the packagers. Jack received authorization to spend $30,000 on physically remodeling the interleaving and packaging areas, so that work would flow more efficiently—all with the input from the people who worked there every day. The result wasn't just higher employee satisfaction from being part of the planning process, but a 50 percent reduction in operational costs. As a team, the people in the work areas were able to pinpoint inefficiencies and revamp the work flow. Once managers let go of the need to control the decision-making process, these people empowered themselves to make important changes that boosted the quality of their lives, cut costs for the company, and ultimately resulted in "customer delight."

Like many of the managers in the flow, Jack Stewart found tremendous satisfaction in creating an environment in which people could seize the opportunity to have a hand in redefining their work. "I hold a degree from 'Kodak University,' " Stuart beams. "I graduated from high school on a Sunday and began working at the Park on Monday. I've held just about every job from cleaning and delivery to finishing and planning, and I've run every piece of equipment in the X-ray finishing department. I'm proud to have ended up as the manager of this department. But I have to say that working in the flow has been the most satisfying experience in my 38 years at the company. I was able to give people a chance to make important decisions that affected their lives. And by doing that, we took the worst job in the place and made it one of the most prized—we now have a long waiting list for people who want to interleave. I think that says it all."

RANDOM ACTS OF EMPOWERMENT

It would be easy to fill an entire book of stories like those told by Paul Lux, Keith LaFleur, Bob Cholach, and Jack Stewart; as the empowerment concept took hold, more and more managers were encouraging people to take risks and as Keith LaFleur so beautifully put it, step outside their "comfort zone." "Nothing risked, nothing gained" was a phrase I began hearing down the corridors of the Team Zebra buildings.

By the spring of 1990, it was not uncommon to hear anecdotes about people who simply took it upon themselves to do things that improved administrative or manufacturing process, helped customers out of a bind, or fostered customer delight.

Take Deborah Norton, who served as a secretary in the flow when Beth DeCiantis moved to another job. After a short period of time in BWFM, it was clear that secretaries in the flow were not realizing their full potential as partners. "The secretaries were somewhat timid," she recalls, "and not in touch with their ability to get things done or contribute. As a group, our ability to support or initiate flow-wide projects was hampered by our geographic separation—14 different office locations! The question became, 'What can the BW secretaries do to bridge the gaps, create unity, and have a positive impact on the flow as a group?' "

Norton answered her own question by working with Jean Kohler, her colleague, to create the "Secretarial Tours." The idea was to enable the secretaries to become more familiar with the B&W flow operations by taking tours and to understand the critical improvement projects, such as MRP II (for scheduling manufacturing operations) and ISO 9000 (the quality management process).

Each of the tours was a well-orchestrated event, complete with tour guides, supporting documentation, mementos, and certificates

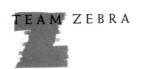

of appreciation. "The tours raised the profile of secretaries in the flow," Norton states proudly. "People learned that secretaries wanted to be part of the team, and to be included in the planning and brainstorming going on around them. It was a major achievement that ensured ALL resources in the flow would be tapped for their creative potential."

While Deborah was energizing the secretaries in the flow, Mary Cutcliffe, an emulsion-making operator, was firing up the flow's marketing department to recapture an important group of customers whose needs were not being met by Kodak. Cutcliffe lived in Bethany, a small town 40 miles west of Rochester. When her foot had to be X-rayed, she visited her local doctor and asked, "Whose film are you using?" She had expected him to say "Kodak," at which point she would have proudly said that she probably helped make the batch of film that was about to be used to image her sore foot. But to her dismay, she learned that the office used the film of a competitor.

"What would a company the size of Kodak care about a small-town doctor like me?" he asked.

Mary cared, and when she returned to work, she began asking, "Why don't we care about small-town doctors' labs?" With Bob Brookhouse's help, her question went straight to the marketing wing of the business unit, and ultimately helped stimulate a plan that would aggressively focus on doctors with in-house labs.

Zack Potter also cared. A shop floor operator, Zack had traveled to Boston for a family event. Zack was shocked when he overheard the photographer quip about the poor service from Kodak: "They never return my calls for technical advice," the photographer complained. Zack got up the gumption to introduce himself as a Kodak employee (and hence ambassador), and asked how he might be able to help the photographer. He then guaranteed that someone from Kodak would be in touch the following week with the answers the photographer was seeking.

When Zack returned, he spent his morning break and lunch hour digging through the various organizations until he found the person who could help the Boston customer. That afternoon, the photographer, to his utter amazement, received a call and the information he sought.

I'll bet Kodak won a customer for life.

Let Kodak save the day

Particularly at vacation time, there's so much you
want to remember—and pictures won't let you
forget. Kodak saves the day—for the years.

Autographic Kodaks $6.50 up

Eastman Kodak Company, Rochester, N. Y., *The Kodak City*

CHAPTER 7

THE ZEBRA LIVES

Most managers at Kodak took Secretaries' Week very seriously—
they knew who really kept the company running. Secretaries could
count on a nice lunch out or a lovely bouquet. In 1990, the B&W
flow managers honored our secretaries, Jean Kohler and Beth
DeCiantis, with hot dogs and fries—at the Seneca Park Zoo. Now,
this isn't as tacky as it sounds. That day in April happened to be the
first real taste of Spring, and we decided to celebrate by walking
through Maplewood Park and across the new footbridge spanning
the Genesee River. Save for a broken high heel, the 30-minute trek
was greatly uplifting.

I'd arranged for Tom LaRock, the Zoo Society director, to meet
our group at the zebra corral after lunch and tell us something
about the animal that had evolved into the official mascot of the

Black & White Film Manufacturing flow. (I got to know Tom while buying out the zoo's entire stock of zebra paraphernalia.) Although flow management never had a formal meeting about the adoption of the zebra, people throughout the operation had a growing relationship with the animal, which took on greater significance throughout the next two years. Our passion for the zebra would eventually become synonymous with our pride in being associated with Black & White Film. By the time we visited the zoo on Secretaries' Day, people had begun purchasing and comparing the zebra-related goodies they'd found in all corners of the world.

As we admired the two stately adult zebras and a newborn, Tom gave us some general figures about zebras average size, weight, life span, and so on, then told us about some characteristics that seemed particularly relevant to Team Zebra.

"Every zebra is unique," Tom explained. "No two zebras' stripes are the same—kind of like fingerprints. They also run in herds. Being animals that are preyed upon, they understand that to the extent they can stay together, they can defend themselves from lions and other predators. In fact, predators probably have a hard time distinguishing the individuals from the mass of black and white stripes."

"This is kind of like our own 'zebra,' " Tim Giarrusso commented when Tom had finished his little lesson. "Each zebra, like our partners, brings unique attributes to the herd. We also need to band together as part of a team—when we're operating in synch, we 'baffle the competition'!"

Tim's analogies prompted a round of applause as well as a renewed interest in adding "zebra" to the flow's name.

"The Kodak Zebras," someone suggested.

"The Zebra Herd," said another.

"How about Zebra Team?" yet another offered.

"Team Zebra," Tim said definitively.

I looked at Tim and smiled; we would forever be Team Zebra.

THE ZEBRA BEGINS TO EARN ITS KEEP

Thirty managers sat in the front row waiting for the show to begin. First, Banker Bob (aka Bob Brookhouse) walked onto the stage (an area at the front of the conference room) and sat down at a desk. Next, Banker Bob's secretary, Ms. Ery (pronounce that "misery"), played by Jean Kohler, took her seat next to the boss's desk. Ms. Ery was not only secretary, she served as Banker Bob's loyal protector (compared with Ms. Ery, Cerberus, the three-headed dog of Greek mythology who guarded the gates of Hades, was a harmless pup). Finally, I strode up to the stage and announced myself as manager of the Black & White Film Manufacturing flow.

"I'd like to see Banker Bob," I said.

Ms. Ery nodded politely and pointed toward the pin-striped banker sitting beside her.

"We need a loan of $600,000 to cover our costs. No problem making it up next month. Can you float us for 30 days?"

Banker Bob studied the sheaf of papers I handed him, then nodded his approval.

I left the "office" and returned shortly. "I'd like to see Banker Bob again," I said to Ms. Ery. She narrowed her eyes and pointed the way to his desk.

"Banker Bob, we don't have the money to pay off the $600,000 loan, but, in fact, we've developed a great vision and mission for the future. We also have a terrific set of operating principles. All we need is another . . . $3.5 million to cover our operating costs. You'll definitely have the $4.1 million next month. Count on it."

Banker Bob looked over the numbers on the papers I handed him and nodded as he had the first time.

The third month I returned and told Ms. Ery I had to see Banker Bob again. This time, it was only after Banker Bob and Ms. Ery conferred in hushed tones that I was granted an audience and

allowed to state my case. On the basis of the great people in the flow, I garnered another million.

I repeated the cycle three more times, Ms. Ery getting more and more aggressive about shielding Banker Bob each time I came back. By the sixth time, I'd borrowed another $2.5 million, and it took all the pleading I could muster to get by her. On visit number seven, she told me that Banker Bob didn't want to see me—I had no credibility until I began repaying the loan. In fact, I had a check in hand for Banker Bob, the first black ink the flow had seen. Even Ms. Ery cracked a smile, and Banker Bob showed his first sign of emotion.

In reality, the amounts I borrowed corresponded to the variances (our form of "red ink") for the first six months: $600,000, $3.5 million, $1 million, $3 million, $1.8 million, $600,000, and $100,000. And the seventh month, as in the skit, was the first month that the flow showed positive numbers. In honor of the event, we passed out bottles of black ink with a sticker on each one that read, "Thanks for our first black ink." I also signed each label. (By the way, finding bottles of black ink in a company that had long ago given up fountain pens was no small feat; Jean Kohler wiped out Kodak's entire supply and then depleted the stock of a local stationery store.)

In any case, everyone found the skit entertaining and a great symbol of the first signs of a turnaround. Ron Heidke, who had joined us for the occasion, got up and said, "Nice going. I plan to keep my black ink on the top shelf of my bookcase." Little did he know that our team would be presenting him with a surprise check of his own in a few months, when we bettered the budget by an impressive $4.9 million. Tim and Rich made up a three-foot-by-five-foot check, which he put on his wall as a commemoration of the event. For me, the check represented yet another historic first, and I jotted down in my Daytimer a word that Ron used for the first time since the beginning of the Team Zebra flow: "turnaround."

STRAIGHT TALK II

When I told my wife, Kathy, that I was getting ready for another round of Straight Talks, she asked if I needed to have my head examined. "You became the world's first human football last time you did this, Steve. Are you a glutton for punishment?"

While the flow was looking better every day, there was still some anger that hadn't been dissipated. But I'd made a promise that Straight Talks would continue, and that I'd once again talk to *everyone* in the flow. This time, though, I decided to test the waters ahead of time by rehearsing my talks with various members of the manufacturing operation. Marty Britt helped assemble a "diagonal slice team" that included supervisors, managers, secretaries, shop floor operators—people from every level and department within the flow.

"We still have a long way to go," I said to the slice team during our first straight talk "rehearsal," "but there are some great signs of improvement, and signs that we've finally stopped the bleeding at the neck. As Bob McKinley, our financial guy, put it, 'the Zebra lives.' " I then detailed how our financial performance was on the upswing, how deliveries were better, how conformance had improved, and waste levels were down. I was especially pleased to announce the cycle time reduction plans.

Sam Lobiando, a finishing supervisor in Building 313, said, "You know, this is all good, but people really want to know about their future here—what's in store for them, Steve."

Linda Nichols from testing and appraisal echoed Sam's thoughts: "That's right. And people want to know about the equity issues between us and the other flows. They want to know about the pay freeze, too."

Gary Mascioletti, a technician who worked on new products, then stepped up to the plate and said that people in the flow wanted

to know if we were going to have a continuing role in new products coming down the pike, or would they be sent off to other plants (SGMM's initial plans to move products to other plants left many with an uneasy feeling).

These were all good questions and caused me to revamp my pitch around issues much closer to the hearts of everyone in the flow. I resisted dealing with personal issues or those better left to the departments, concentrating instead on flow or company-wide issues.

When it came time to present Straight Talk II, the preview strategy proved itself beautifully (the "diagonal slice" might have been one of the best things we ever did). People were far less concerned about venting themselves than about learning how things were going and what they could do to become part of the solution to our problems.

During the 25 or so sessions, which were generally scheduled off-shift so that all 1,500 people in the flow could attend, I also worked hard to reinforce the theme that we were making products important to society. At one meeting, I described Kodak CFT Film, which is used to determine if a patient needs bypass surgery, and Kodak MIN-RH Film, used in the detection of breast cancer.

At another, I talked about Kodak WL Surveillance Film. "Guess what? Every time you use your ATM card, you're being photographed with a camera loaded with 2210 Film. Same if you're robbing the bank. Smile for the camera."

Other products that stimulated people's curiosity were Kodak INDUSTREX R Films, which are used to nondestructively test the welding integrity of nuclear power plants, airplanes, pipelines, and even the space shuttle; Kodak Holographic Film, used to produce the three-dimensional images on credit cards; and Kodak Exploration Film GLR, used by geologists to record shock-wave information during searches for oil, natural gas, minerals, and water.

Team Zebra as featured in May 12th, 1992 issue of *Fortune* magazine.
(John Abbott)

George Eastman and Thomas Edison introduce color movies—1928.
(Photo courtesy of the Eastman Kodak Company.)

Eastman using Kodak box camera during transatlantic trip on
U.S.S. Gallia—1890. *(Photo courtesy of the Eastman Kodak Company.)*

TOP: Kodak Park, 1894.

BOTTOM: Kodak Park—today. *(Photos courtesy of the Eastman Kodak Company.)*

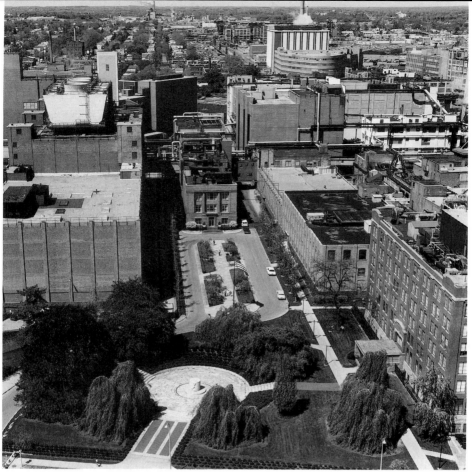

TOP: Kodak Park entrance with Eastman Memorial in foreground.

BOTTOM: Typical Team Zebra production operations.
(Photos courtesy of the Eastman Kodak Company.)

Team Zebra leadership team—1990. *(Photo courtesy of the Eastman Kodak Company.)*

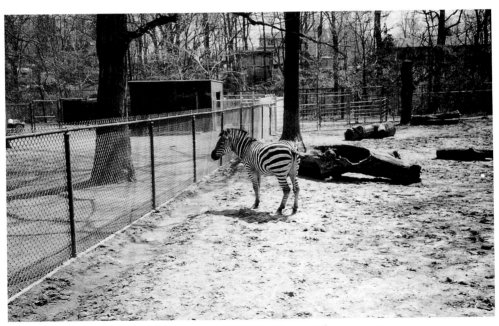

One of Seneca Park Zoo zebras—inspiration for Team Zebra mascot.
(Photo courtesy of the Eastman Kodak Company.)

Steve Frangos with zebra friend.
(Photo courtesy of the Eastman Kodak Company.)

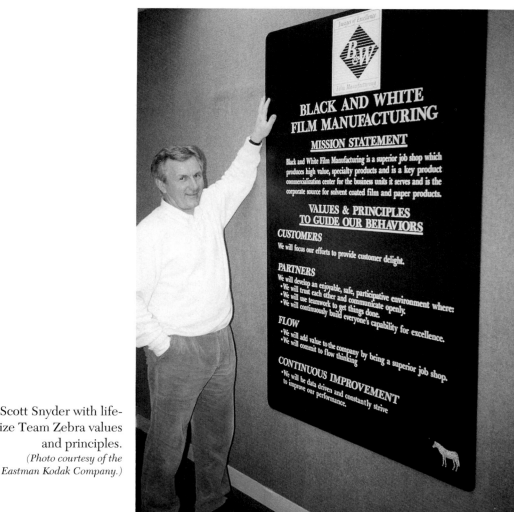

Scott Snyder with life-size Team Zebra values and principles.
(Photo courtesy of the Eastman Kodak Company.)

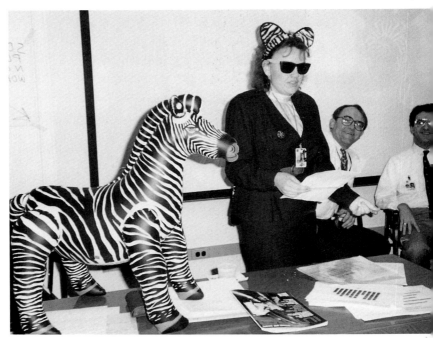

Marty Britt accepting Zorba award.
(Photo courtesy of the Eastman Kodak Company.)

Bob Brookhouse and Charles Champion with Whirling
Dervish award. *(Photo courtesy of the Eastman Kodak Company.)*

Rapping customer delight. *(Photo courtesy of the Eastman Kodak Company.)*

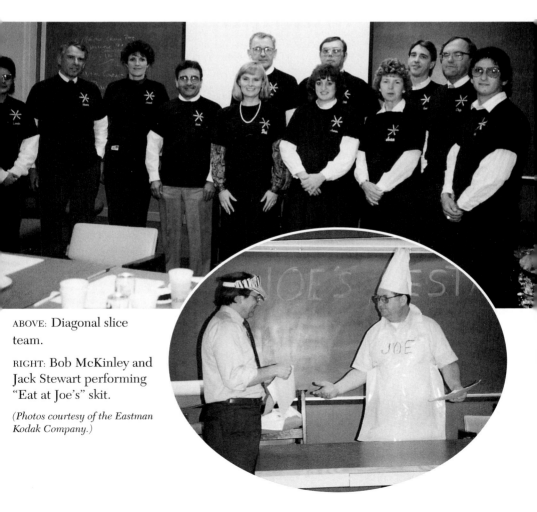

ABOVE: Diagonal slice team.

RIGHT: Bob McKinley and Jack Stewart performing "Eat at Joe's" skit.

(Photos courtesy of the Eastman Kodak Company.)

The Wall.
(Photo courtesy of the Eastman Kodak Company.)

The Pole.
(Photo courtesy of the Eastman Kodak Company.)

The Trust Fall.
(Photo courtesy of the Eastman Kodak Company.)

Tim Giarrusso with catapult.
(Photo courtesy of the Eastman Kodak Company.)

TOP: Operation Prime Time—communicating and learning together.

LEFT: Laser team strutting their stuff.

BOTTOM: Visit from North Pole on MRP II day.

(Photos courtesy of the Eastman Kodak Company.)

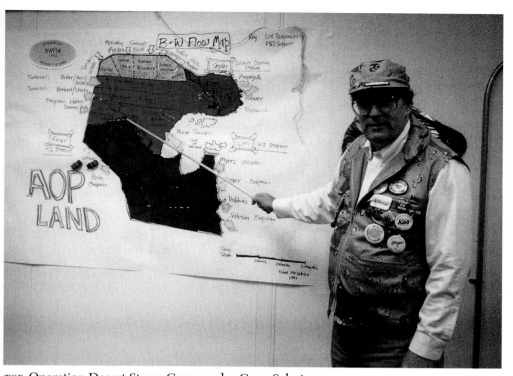

TOP: Operation Desert Storm Commander Gene Salesin.

BOTTOM: CEO Kay Whitmore with Zebra mascot. *(Photos courtesy of the Eastman Kodak Company.)*

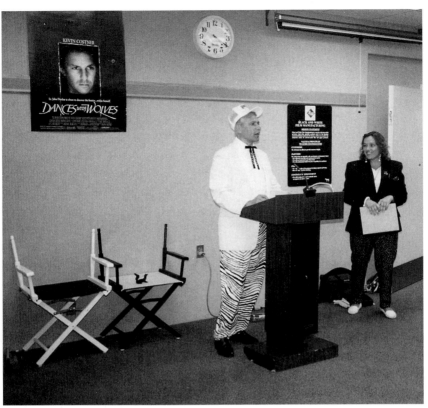

Dances with Zebras awards ceremonies.
(Photo courtesy of the Eastman Kodak Company.)

Ron Heidke joins a
celebration.
*(Photo courtesy of the
Eastman Kodak Company.)*

(Photo courtesy of the Eastman Kodak Company.)

Black and White, Black and White...

Everybody's a Partner...

East and West, We're the Best...

Everybody's a Partner...

Look at us grow pos-i-tive cash flow...

Ma-kin-ley would be proud of us...

Black and White, Black and White...

Everybody's a Winner...

(Sung to the tune of "Edelweiss")

Eastman Mansion—now International Museum of Photography, East Avenue, Rochester, NY.

(Photo courtesy of George Eastman House)

As I described the significance of these vital products, I had a growing sense of excitement in the crowds. But while I didn't spend the hour-long sessions dodging rocks and spears, as I did during the first Straight Talk sessions, I wasn't about to assume that everyone would be content from here on out. At the end of the sessions, Marty passed out comment sheets that asked people to rate the value of the talks, and list other questions they'd like to see addressed.

Signing the comment form was optional, although a surprising percentage did write down their names. I contacted each and every one who signed to talk about their questions. This might have been the most important aspect of the Straight Talks campaign. Not only did it signal that the flow management was serious about people's concerns, but it also gave me terrific insights into what people were thinking and feeling about our business.

During my review of comments, one of our team leaders told me that he thought the idea of positive reinforcement was a great change at Kodak, but that some of the actions in the B&W flow were hollow. For instance, he noted that free movie tickets were often given away in his group. But one of the people who received them for exemplary performance lived in, Batavia, a small town about an hour from Rochester—it would be difficult for this person to make the trek into the city just for a movie. In other words, the reinforcement was just too impersonal. So I asked one of our people who happened to live in this town to purchase two tickets to the local movie house. I then made them available to the team leader so he'd be ready for the next positive reinforcement opportunity. The team leader was stunned that we would do that. As a result, I made a new friend, and the flow acquired a new "ambassador" who would spread the good word about our intentions and sincerity.

By the end of Straight Talk II, I was more than talked out. But, by all counts, it was a tremendous success. We celebrated with the

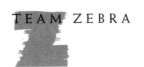

slice team by taking them out for—what else?—slices of pizza, slices of cake, and Slice soda. We also passed out T-shirts that read, "I told Steve what to say." And I received a very special T-shirt of my own. It read, "I listened."

AWARDS GALORE

Even though the f (fun) word was not formally in use, we constantly sought new ways to recognize people's accomplishments and celebrate small and large victories alike. As we cruised into the summer months of 1990, "award mania" was infecting all levels of the flow, both for individual and team accomplishments. In fact, celebrating achievements and passing out awards became an integral part of the B&W flow culture. For many, this was a dramatic change in attitude, because the old culture traditionally did not readily applaud people for doing something right. Perhaps that's why we went so far to the opposite extreme.

One of the earliest awards was for Zorba the Zebra—an inflatable animal that I purchased in the Denver airport. When Zorba and I returned, the management team decided that our plastic mascot would serve as a rotating award. Joe South was honored as our first recipient of the "Zorba," for his work with our MRP II (formal planning) system. The only rule was that Joe would have to pick the next winner, and the next winner would select his or her successor. This ingenious twist, offered by Marty Britt, turned out to be a great way of getting people to look for innovations and exemplary jobs in their own parts of the flow.

As Zorba saw more corners of the flow, the ceremonies during which he was handed over to winners became more elaborate. And zany. When Jan Chapman, a financial analyst in Building 30, won

the award for her work on our 1990 budget, she was greeted outside her door by 10 members of the Gang of 33, who sang a Marty Britt original rap song honoring both her fine work and that of Chip Wagner. The rap went like this:

> The AOP [Annual Operating Plan] had little form, it was like an
> amoeba
> That's why Chip and Jan deserve Zorba the Zebra
> Boom ch ch Boom Boom
> Boom ch ch Boom Boom
>
> It was so complex we could hardly see-a
> A little patch of forest for all of the trees-a
> Boom ch ch Boom Boom
> Boom ch ch Boom Boom
>
> Zorba the zebra
> Always glad to see ya, he will never leave ya
> Boom ch ch Boom Boom
> Boom ch ch Boom Boom
>
> So here's to Chip and Jan with many thanks from me-a
> It's a real thrill to give you Zorba the Zebra
> Boom ch ch Boom Boom
> Boom ch ch Boom Boom
>
> So this AOP ain't no verbal diarrhea
> We managed to attain on-time delivery-a
> Boom ch ch Boom Boom
> Boom ch ch Boom Boom
>
> From a humble beginning on the River Genesse-a
> Chip and Jan assembled the flows AOP-a
> Boom ch ch Boom Boom
> Boom ch ch Boom Boom

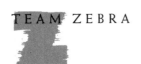

It was the best in the corporate arena
It should draw coverage on the national TV-a
Boom ch ch Boom Boom
Boom ch ch Boom Boom

So now I'd like to thank you on my bended knee-a
And give to Chip and Jan Zorba the Zebra

I wasn't the only one on the lookout for fitting Black & White awards; Tim found a great skunk during one of his travels out of the state. The idea was to award "Stinky" (on a rotating basis) to people who demonstrated the ability to step out of their "comfort zone" and do things differently.

Not all of the awards were found in souvenir and gift shops; many had a delightful homemade flavor, which was in keeping with the make-your-own-equipment ethnic spirit of our business. As I explained earlier, much of the gear we used was created right in the Kodak machine and engineering shops. So in the spirit of self-reliance, it was fitting that we'd concoct our own awards as well.

The "Whirling Dervish" award was a case in point. The idea was to honor the stream with the best monthly improvement in inventory turns. Bob Brookhouse thought up the name for the award and Bill Poole, with help from Kris Daniels, one of the secretaries, made the trophy—a block of wood holding up a toy pinwheel. Each month, after reviewing the inventory figures, Bill would announce the team with the best improvement and then present the pinwheel. One of the streams, solvent coating, won it three times in a row, after which the stream manager, Charles Champion, decided not to "hog the wheel" and had the machine shop make a permanent windmill-like Whirling Dervish award out of wood and metal, complete with a plaque. He then relinquished the award for others to enjoy.

Other gatekeepers invented their own awards, such as the Quality Award for Best Improvement in Conformance, and there

were probably countless awards that we never heard about. But, by any measure, award mania was having a very beneficial effect; people were finding B&W an exciting place to work. Nothing better summarizes the change in mood than the conclusion of a skit put on by Bob and Tim during a lunch meeting in June of 1990:

"How do I get in?"

"Keep trying—something's bound to open up."

"My pa would roll over in his grave if he heard me trying to get into black and white!"

BLACK & WHITE ON THE MOVE

While the new desirability of B&W jobs was indicative that we'd begun to turn around the most difficult—and probably most important—issue of the flow, it took another six months, before we received hard-core validation of on-the-job satisfaction for the period beginning in June 1990. This came in the form of greatly improved company employee survey numbers. The surveys cover how people feel about their jobs and the company, the supervision, pay and benefits. The results of the surveys are consolidated by organization and then sent to management in the form of quarterly trends.

By mid-year, BWFM results showed improved levels. "Don't be too quick to celebrate this one, Steve," advised Marty Britt. "These numbers could be pretty volatile. One incident and we might see them drop like rocks again. Let's be cautiously optimistic."

I agreed, but couldn't resist jotting down the latest figures in my Daytimer; I reserved a space for critical numbers and milestones that I'd want to remember long after I'd retired.

FOUR SCORE AND . . .

The morale improvement wasn't the only exciting news in the second half of 1990. For May, June, July, and August, Black & White had achieved matrix scores of 700 or greater (remember that a score of 300 represented no improvement over the prior year, and 700 was the "stretch" target level that Ron had set for us).

To commemorate this monumental change, Bob Brookhouse and Tim Giarrusso wrote a speech called "The Gettysburg Address." They also collared Joe South, a very tall and lanky Abe Lincoln look-alike (once we decked him out in a beard and top hat), to deliver the address to the Gang of 33. Joe's resonant and melodious voice rang out, in tones that would make any orator swoon with envy:

> "Four scores of 700 hundred or more, our B&W flow management team enabled forth from this site, new levels of continuous improvement, conceived in quality, delivery, productivity, and other cash flow, dedicated to the proposition of highly valued, low-volume, specialty products.
>
> "Now we are engaged in a great manufacturing war, a war we will win for our customers. . . .
>
> "And I would like to thank you for your efforts and contribution."

While the entire flow was buoyed by the remarkable four-month performance, no one was prepared for the astonishing performance of September, when we scored 880—an unimaginable all-time high. This major milestone called for a pizza and Buffalo wings celebration, of course, complete with buttons that featured a zebra and the phrase "Best Ever, 880, BWFM." We were even honored by a visit on October 24 from the new CEO,

Kay Whitmore, who had taken over the helm from Colby Chandler earlier in 1990. Kay, accompanied by Dick Bourns, Sr., vice president of worldwide manufacturing, came to hear about our recent successes. With great pride, a group of partners described our first year of progress in all flow operations, from sensitizing to testing and finishing, and told of things to come like Sensi-X as I presented "880" buttons to Dick and Kay. Our CEO was genuinely enthusiastic and clearly pleased, which made the victory all the sweeter.

FEEDING FRENZY

To provide recognition for everyone associated with Black & White Film's performance turnaround, in December of 1990, we decided to present every partner with a dinner certificate, good at local restaurants for meals worth about $100 in total ($75 plus tax and tip). We'd used dinner certificates in the past for individual and team achievements, but had never applied the concept on a flow-wide basis. The certificates, good for six months, were accompanied by a letter of appreciation, a summary of our specific accomplishments, and a pin with the new logo. Although intended to be used in Rochester-area restaurants, we received phone calls from as far away as Florida from maître d's and restaurant owners who wanted to verify that the certificates were real. By March of 1991, I had received more than 400 letters, notes, calls, E-mail messages, cards, and the like thanking flow management for this extraordinary show of appreciation.

Not only were the dinner certificates appropriate, sincere, timely, and personal, they were also symbolic of how far we had progressed with our starving business in just a few months. They were also cost-effective; while we spent nearly $150,000 on the

dinners, the turnaround had saved the company many millions of dollars and probably ensured continued savings in future years. How do we know that the certificates paid off? The following E-mail message from a partner says it all:

> I'd just like to thank you for recognizing the members of the Black & White Flow for our contributions to the success of the Business. I've worked hard this year to help the business succeed. I really appreciate being recognized for the efforts I've put forth. The dinner certificate is an excellent reinforcer because my spouse (who has put up with lots of ''I can't because I need to do something for work'' comments) will be able to share in the celebration of our success.
>
> Thanks again. I hope next year will be another banner year for us!

KEEPING THE ZEBRA ALIVE

There's an old Chinese philosophical saying that goes like this: Reversal is the Movement of the Way. In plain English, it means that once you've hit bottom, the only way you can go is up; when something's reached its peak, the only direction possible is down. Everyone on the management team realized that the flow certainly hadn't reached its performance peak. They also knew, however, that whatever ground we achieved, we'd have to work relentlessly to maintain it. As Bob Brookhouse put it, "The Zebra breathes today. But it might not tomorrow unless we keep infusing it with energy."

In recognition of that need, we convened the management

team at Mendon Ponds and held our first off-site workshop. Located about 20 minutes south of the city, Mendon Ponds provided the perfect reprieve from telephones, brushfires on the factory floor, and other inevitable interruptions. As the name suggests, the Park consists of a series of small ponds, some of which are interconnected by footbridges. With the exception of an unusually early bumper crop of hungry mosquitoes, the day couldn't have been more perfect (the mosquitoes appeared to be interested only in Jack Stewart, a fact that we found amusing, since we held the workshop in an outdoor structure called the "Stewart Shelter").

Our workshop had several important objectives. The first was to begin to understand how we could sustain our performance improvement effort by developing a cohesive human resource strategy. The second entailed developing and sharing "R-plus" (positive reinforcement) lists. This was an eye-opener for a lot of people. "One person's R-plus list can be another's nightmare," I warned them. And indeed that turned out to be the case. For instance, some people enjoy public recognition from others, while others are embarrassed by it. Some like material mementos (things), while their counterparts prefer sentimental remembrances like notes and pictures.

The final, and probably most important, goal at Mendon was to understand the difference between managers and leaders. To this end, we introduced concepts found in William Hitt's book, *The Leader Manager* (I'd learned about the book from Ron Heidke, who had also incorporated the exercise into his workshops).

Hitt encourages leaders to evaluate themselves in key areas such as visioning, coaching, and becoming change agents, and then reveal their self-assessments to their immediate team members. I did just that and then asked people to fill out an assessment about my own self-perceptions, so I could get a reality check. (Long after the workshop, Tim Giarrusso got a charge out of reminding me of how I was the first Kodak manager to "expose himself in public.")

Everyone spent 20 minutes or so assessing my personal assessment, while sipping coffee and soft drinks from new zebra mugs we passed out at the beginning of the workshop. When the votes were in, I was pleased to find that people agreed I was building the team well, and had done a good job of clarifying the vision. But I was equally grateful to learn that I could improve on how well we were positioned for the future and how well we measured ourselves. The fact that I survived this exercise with a strengthened sense of self would hopefully, if anything, spur others on to do the same. For as Hitt points out, leaders must have an accurate sense of where they're strong and where they need to shore things up. And one thing was clear—it would take a fine-tuned cadre of leaders, not managers, to sustain the remarkable gains we'd achieved during the first six months of flow.

202.

One of the occasions when Smith regrets the absence of his Kodak.

CHAPTER 8

FORMAL STRATEGIES FOR A NEW B&W

"People empower themselves, but most managers still try to go off and empower others. What many managers don't realize is that they have to first empower *themselves*, and then create an environment in which self-empowerment can take place."

When I heard those words on July 10, 1990, spoken by empowerment authority Peter Block, my pulse started racing. I was lucky to be part of a group of 26 managers selected to participate in a workshop held at the Strathallan Hotel in Rochester. Charlie Newton, Kodak's corporate director of executive and organizational development, had arranged for the workshop in the hopes that by applying some of Peter's ideas, we could accelerate the empowerment process throughout the entire corporate structure.

During the session, Peter raised a number of inspiring points

about the choices that all managers face—choices between the bureaucratic spirit and the entrepreneurial spirit. Between maintenance and greatness. Between dependency and autonomy. And between caution and courage. Though the "right" choice seemed obvious, he cautioned us that making choices was actually very difficult, because it often meant abandoning existing patterns and ways of doing business.

Peter also explained that you'll find three types of unempowered people in any organization: "Cynics have no faith or hope. Victims see others as responsible for everything that's wrong with the company. Bystanders have no commitment and simply watch the world go by. In contrast, empowered people show courage to face the harsh realities holding them back and see their own potential for resolving the problems at hand—empowered people have the courage to say what their role should be in building the organization."

At the end of the session, Peter asked us to think about what we would do to empower ourselves. It was then that I committed more energy to actively help all 1,500 "Zebras" choose to become empowered themselves. My first step would be to begin treating them like partners. Marty Britt and Rich Malloy, who also attended the session, enthusiastically supported the idea, and we resolved that from here on, we'd refer to *everyone* in the flow as "partners," including managers and supervisors.

It would have been easy for skeptics to write off the "partner concept" as just a hollow slogan or, worse, an insidious way to manipulate people into thinking that they actually had a voice in company affairs.

Our idea was similar to that of professional partnerships. Our partners would share in the glory when the organization advanced (having the wage dividend in place as a profit-sharing reward definitely helped). But it would also require commitment to the business. And we didn't just declare people partners (with an official announcement); we made it clear that they had to *behave* like a

partner. We'd ask people, "Do you want to make a difference in our business? Do you want to be part of the superior job shop that makes vital products for society? Here's an opportunity to do so and become a problem solver at the same time. That's what being a partner is all about."

In time, "partner" had all but replaced "employee," "shop floor operator," or "manager." For manager and supervisor partners in particular, the concept took some getting used to, because it required letting go. Managers and supervisors are trained to have rigid control over acts that bring about good for the business. This kind of thinking, of course, prevents empowerment from taking place. If those in authority are to allow people to empower themselves, they've got to have the courage to relinquish some control. People will see themselves as partners only when they believe that they can use their expertise and familiarity with their jobs to do things more efficiently and productively.

Another precondition for creating an empowered organization is to make sure that the right tools are in place for people to do their work in new ways. For us, this meant the implementation of two types of strategies, one for manufacturing and the other for human resources.

MANUFACTURING GOES FORMAL

Many people at Kodak refer to both the art and science of film manufacturing. The "art" part comes from years of experience in the business and the development of a sixth "sense" for film. The science part is a matter of engineering and chemical principles. It's also a matter of imposing strict order on the processes used at each stage and the synchronization of the manufacturing stages. Initially, the Black & White flow management concentrated on three key strategies for gaining control: MRP II, ISO 9000, and Cycle Time Reduction.

OUT OF CHAOS: MRP II

There are two ways to run a manufacturing operation: by the seat of your pants, or with tight control and coordination. If you fly by the seat of your pants, running your company with what is known as an "informal system," people probably won't be working to the same requirements and you won't be able to consistently produce the right products at the right time. You'll also be in a continual state of chaos, with a constant flood of emergency orders and outages causing major disruptions and costly overtime. Many people will have the job of "expediter," which amounts to crashing key orders through the system.

The opposite arrangement is the formal system. At the heart of it lies MRP II, which stands for "manufacturing resource planning" (ignore the "II"—it's an unfortunate misnomer). MRP II is a formalized planning and scheduling system that coordinates all parts of a manufacturing company. Far more than just a fancy computer program, MRP II is based on "thoughtware"—people learn to do their jobs differently and to synchronize with everyone else.

For example, in the old days, an operation might have decided to make 10 batches of a particular product, without thinking about the impact on others downstream. Under MRP II, all changes are made through a process that ensures total communications; any operation that will be affected by the change will be involved in the decision, thereby ensuring that the change is feasible and "value added."

Through integrated communications, MRP II led us from chaos to an orderly state in which Team Zebra could effectively manage the 250 product families and 7,000 final products for which we were responsible. And in doing so, the flow was able to dramatically lower costs and cut inventory. Best of all, it allowed the flow to liberate the

massive amounts of energy being expended on maintaining the informal system. The partners could then use that energy to solve other problems and enjoy additional productivity gains.

The general process for implementing MRP involves off-site education of managers and supervisors, followed by in-house training of everyone in the company whose job will be affected by the new approach to manufacturing. In fact, the film- and paper-making organizations had started to implement MRP II several years before the change to flow, but the project had proceeded in typical big-company molasses fashion.

Of all the steps in the implementation process, the education was far and away the most important. Many a company has invested heavily in MRP II software while skimping on the education and training side, only to experience disappointing results. Ray Reed, our outside consultant for MRP II, kept emphasizing the importance of "thoughtware and cultural change." What counts is the "thoughtware," the people side of the equation. People have to understand the need for inventory and material accuracy, and how MRP II depends on linkages among all functions of the company— if one link breaks, the whole system suffers.

As with other forms of education, Team Zebra tackled MRP II in an unusual fashion, blending nuts and bolts materials with a slightly off-the-wall approach designed to encourage participation from everyone in the flow. In one session geared for supervisors in February of 1991, we used black and white "Koosh" balls (which have "fuzzy" rubber prongs) to illustrate why the manufacturing wing of Kodak had to act in concert with the financial, marketing, and sales operations. (From the first days of the flow, Koosh balls were used as a reminder to listen attentively to someone who's making a point—the holder of the ball. Tim and I scoured through a bin full of Koosh balls at Kennedy Airport, looking, of course, for the black and white ones. The cashier gave us a puzzled look and shook her head as we carried a bagful to the gate.)

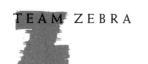

Within five minutes of beginning the Koosh ball exercise, a spirited dialogue would inevitably ensue, such as the following:

"Wow," exclaimed Tom, "we'd planned to sell 20,000 B&W Koosh balls but now we have orders totaling 60,000!"

"That's great!"

"That's *not* great," retorted Holly. "There's no way we have the material to make another 40,000."

"We'd better tell Jan over in finance," answered Tom. "She probably won't mind losing sales of 40,000 Koosh balls."

"Lose 40,000 sales!!?" screamed Jan. "Get the material you need—I don't care what it costs!"

The dialogue continued, at each step of the way revealing the fallout from not being able to respond to the marketplace. It was an easy transition from pretending to make and sell Koosh balls to actually making and selling film. The principles are the same.

We conducted several rounds of these role-playing sessions with key people, who in turn were able to use their newfound understanding to explain the interlinking of the company to the flow. Ultimately, getting people on the shop floor to appreciate the importance of thinking as if they're part of a business chain would make the difference between success and failure of the MRP II effort.

Another innovative teaching tool was developed by Bob Brookhouse: the "Executive Kodawipe." You won't find Kodawipes on the shelves of your local photography store, nor will anyone in customer service at Kodak be able to help you locate them. The Executive Kodawipes were plain paper towels that Brookhouse had people decorate with squares (using black felt tip pens, of course). Brookhouse asked everyone to imagine that they were producing the Kodawipes for a manufacturing company. Once people had decorated a fair number of the towels, he'd call out, "Oops! This month a major customer wants polka dots." Everyone would reach for clean towels and begin again. Then he'd throw another curve.

And another. Finally, the conference table would look like someone dumped a trashcan on top of it as everyone madly scrambled to keep up with the changing demands. The point of the exercise was to show how product changes and unexpected marketplace opportunities can create havoc in manufacturing—something not uncommon in the film-making business.

By mid-1990, the MRP II effort was well under way, although one of the black and white streams, solvent coating, which made a variety of high-tech film and paper products for the business and industrial world, had blasted through the process straight through to "Class A" operations (MRP II implementations are rated from Class A to D; Class A means that the company uses MRP II as a fully integrated system that ties together manufacturing and financial operations—the pinnacle, while Class D means that MRP II is essentially used as an expensive electronic calendar for scheduling plant functions). Normally, companies require 18 months to complete an MRP II implementation, and often fine-tuning time after that to achieve Class A status. Through the leadership of Charles Champion and dozens of partners in Building 329, the MRP II solvent coating team went from education to Class A in just under 10 months.

In solvent coating, the MRP II implementation was part of an overall strategy to achieve "business excellence." It succeeded because it had total commitment from the stream partners and flow leadership. Everyone in solvent coating understood that MRP II wasn't just a quick technological fix for old problems; rather, it was a formal manufacturing model used to measure the quality of manufacturing operations. As Charles is fond of saying, achieving MRP II Class A in solvent coating proved the stream's ability to deliver to the customer the right quantity of goods in the required time frame.

Upon the attainment of Class A, Team Zebra threw a major bash for all members of solvent coating and their spouses. Held at

the Eastman mansion, the event (probably the loudest ever held in the residence) featured gourmet food, music, tours of the photographic galleries, and special recognitions awards by Ron Heidke. (Several months earlier, when Ron had visited solvent coating, he had challenged everyone to get to Class A and offered a celebration of their choice if they could accomplish it by year end. They clearly made the most of his offer.

Solvent coating's success was soon followed by that of other units in the flow, and by the end of 1991, the entire flow was operating close to Class A. When the color paper flow achieved Class A, the first full flow to do so, black and white did something unique; a team of managers trooped over to Building 9, where color paper was headquartered, and carried out a group Zebra cheer. This form of applause for our sister flow was not only appreciated, but was symbolic of the "you win, we win, we all win" mentality we were working to generate. The color paper flow adopted "a horse of a different color" as its mascot soon thereafter. Dick Pignataro, the manager of the flow, sent me a T-shirt with the flow's new emblem in appreciation of our support and recognition of his people's accomplishment.

FASTER THAN A SPEEDING ZEBRA: CYCLE TIME REDUCTION

Everyone on the BWFM management team realized that cutting cycle time for regular and new product development was crucial to our success in the marketplace. And just as MRP II had been under way in parts of the flow before the streams began their individual implementations, we already had a taste of the benefits of reduced cycle time from our work with X-ray finishing. Prior to forming the flows, certain finishing operations had managed to cut the time

between starting and delivering an order from more than four weeks to just a few days. The finishing teams accomplished this feat with a two-prong attack. First, it physically altered the flow, eliminating all of the "buffer" storage (one-third of the space), and moving related pieces of equipment closer together. Next, it convinced the shop floor people that they were part of a "24-hour team" rather than individuals on three independent shifts. This was considered so important that finishing shut down for a full week while people attended a "retraining" workshop that drove home the 24-hour team concept.

Managers who had been in finishing in the preflow days and had been assigned to BWFM were eager to apply the same kind of thinking to the sensitizing operations. This was a much more ambitious task, however, because a great deal of traditional thinking had to be undone. Many people simply accepted that it took a certain amount of time to make film, and that was that.

Under the guidance of graphics stream manager Rich Malloy, who made cycle time reduction a personal crusade through the Sensitizing Excellence or "Sensi-X" program, people began to understand the importance of reducing the time it took to make product. "At first," says Rich, "the partners thought that we wanted to cut cycle time for its own sake. Faster is better. We had to demonstrate that it wasn't just a matter of doing your existing job faster. The key was understanding all of the transactions that were involved in the process and to ask which ones added value and which could be eliminated altogether. In other words, we tried to get people to focus on simplification."

Simplification was also the key to bringing new products to market. The complexity of passing new product designs and problems from group to group grossly extended the amount of time needed to bring new film goods to the marketplace. In fact, it was a standard joke that developing new products at Kodak was like passing a grenade over the wall—when it exploded, it was the next

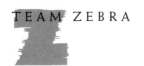

guy's problem to reassemble it and pass the bomb on to the next person. Bob Bacher, the materials manager for graphic arts, spearheaded a major effort to tear down the walls and "defuse" the grenades. He accomplished this act of bravery by getting together all those who would be involved with a new product—the researchers, designers, product engineers, and shop floor operators who would actually have to make the film—before any work was done on it. By all measures, the approach was a stunning success. After about a year, new product commercialization time was cut in half, giving us a major competitive boost.

Our improvements in cycle time and development time reduction were readily appreciated by Kodak's senior management. In April of 1991, when the new vice president for manufacturing, Vern Dyke, came to visit the sensitizing operations in Buildings 29 and 30 (Ron Heidke had moved on to become corporate quality director), he nodded with approval as various members of the Sensi-X team described the progress that the flow had made. But when they showered him with replicas of $20 bills adorned with pictures of CEO Kay Whitmore, he broke into a wide smile—he understood that BWFM truly was going to save the company the kind of money being tossed out onto the floor.

MAKE MY DAY—AUDIT ME: ISO 9000

While the flow formation gave us an incentive to accelerate the MRP II project and formalize our planning and scheduling operations, it also pushed us to implement a formal quality initiative called "ISO 9000." The ISO, which stands for "International Standardization Organization," had developed a series of standards for addressing the quality of manufacturing systems and processes and offered certification to companies that successfully passed a rig-

orous audit by a third party inspection team. In our case, the British Standards Institution, BSI, conducted the audit. The auditors look for compliance in 18 key areas, such as product identification and traceability, measurement and test equipment, and management responsibility.

Interest in ISO certification for BWFM began with the health sciences stream, which thought it would be extremely beneficial from both a competitive and an internal performance standpoint. As we explored the value of ensuring that our quality system met each standard, we quickly realized that all of the products in the flow would benefit from the effort. Many of our products were sold in Europe, where ISO was readily accepted and could well become a requirement in the future. Kodak would have been at an immediate disadvantage if it didn't have the certification our competitors did, and might have scrambled to obtain it if certification became required by law in the future. Some major U.S. customers were also inquiring if Kodak was ISO 9000–certified, so the handwriting was on the wall.

Beyond the marketing implications, ISO seemed just what the doctor ordered for giving our quality improvement efforts a shot in the arm. The process of preparing for the certification would help people pinpoint incorrect procedures and problems that diminish quality and cause costly correction steps in order to ensure that customers continued receiving the kind of top-notch products they'd come to expect from Kodak.

Given such impressive benefits, we sought ISO certification for the entire flow, not just health sciences. (Specifically, we applied for ISO 9002, which is geared to our particular type of business; other ISO standards are designed for engineering and design companies.)

Beginning in May 1991, the flow began preparing for the BSI audit which was scheduled for the beginning of the next year, initiating a major documentation campaign designed to capture all of the

practices and procedures carried on in the film manufacturing processes. (One BSI auditor later stressed the importance of documentation this way, "If someone hadn't written down the notes and lyrics to a Rodgers and Hammerstein musical, others would not have been able to perform it throughout the world.") During the actual audit, a BSI auditor might ask someone to explain what he or she was doing, then compare the explanation against the written procedure. The auditor might then follow the product through its various manufacturing phases and note how well each person along the processing "odyssey" adhered to the procedures. In addition, the auditor would want to know if people on the shop floor had the authority and expertise to correct a process that might be out of control.

"The corrective aspect is extremely important," Beth Krenzer stressed. As quality manager, she had responsibility for coordinating the audit preparation. "The whole point of ISO is to document your quality system, say what you do, and do what you say. Whether you make microchips or potato chips, your equipment isn't perfect, nor are your procedures. All manufacturing processes have problems, and the goal is to have quality systems in place that enable operators to quickly recover and minimize the negative effects."

The days before the audit were marked with lots of surprise "miniaudits" and quizzes in which Team Zebra partners grilled one another on the fine points of their jobs. One of the managers even had special buttons made up that read: "Make My Day: Audit Me!" "It was almost as if people were itching for the 'real thing,' " Beth recalls. The "real thing" finally happened in February 1992, when Black & White passed with flying colors, and BSI fully recommended the flow for ISO registration. In the spirit of Team Zebra, the award was great cause for a recognition celebration and the wearing of zebra buttons that proudly said, "BWFM: ISO 9000: We did it!"

A COMPREHENSIVE HR STRATEGY FOR BWFM

Manufacturing wasn't the only part of the business that needed a dose of formal structure; the flow would also need a comprehensive human resources strategy that would maintain the commitment from our partners. In the past, there was an unstated assumption that if you offer people good pay and benefits, you'll automatically earn their commitment and loyalty. To be certain, the company had long been perceived as offering very attractive benefits, such as the wage dividend and excellent health care coverage. The fact that Kodak had remained unionless in the United States all these years was in itself strong testimony that people were satisfied with the way the company was treating them. But as the events of 1989 had proven, past generosity tends to be forgotten in the midst of immediate crises.

The changing marketplace of the '90s and Kodak's changing internal needs, called for a number of new strategies, including one for HR. Our HR expert, Marty Britt, introduced us to the work of Dave Ulrich from the University of Michigan, who had served as a human resources consultant to Kodak. Dave insisted that an effective HR strategy had to be linked to a sound business strategy through an empowered workplace. Such an HR strategy could be achieved by refining practices that increased the organization's capabilities in the areas of the selection of people; rewards and recognitions; appraisals; work structures; capability building; and communications. Some of our HR practices were cast in stone—the flow management couldn't alter the salary structure, benefits, or the way that people were appraised for promotions and raises. And the work structure—the flow—had been planned for us through the reorganization of Kodak Park. But we had total

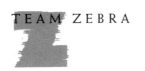

discretionary power about the way we selected people for jobs, the way we trained them, and how we communicated our intentions and goals. More important, we could choose the organizational capability that best supported our business strategies, then get creative about the HR practices and make them work for us.

CHOOSE YOUR PATH

While we planned and refined all elements of our new HR strategy, job selection was one area where we were able to have an immediate effect. Traditionally, your future at Kodak was determined for you, much like the army. Supervisors decided what was best for you and your development, and you simply moved on. Of course, you could always say, "No," although this would likely derail your career. But, in most cases, the transfers represented a positive career step, so there was little reason to dispute them.

Take my own career. When I joined the company, I was first hired as an industrial engineer, helping to decide where equipment would be placed on the factory floor during new plant installations. (Kodak was still building like crazy in the late 1950s). After two stints in the army (I spent time in the Far East and was later recalled during the Berlin crisis), I was asked to work for the roll film division, and was involved with both professional and amateur products. This was a lateral move, but provided an opportunity to work in one of the Park's important and rapidly growing line divisions. In my new position, I learned about product design, quality assurance, process development, and packaging.

Two years later, I was asked to head the finishing group that made aerial films for the space program. I trusted my supervisor, who said the offer would be a good thing for me to take up, and stayed with the group for about five years. This was exciting work,

since it was critical for both the country and the company, and offered the opportunity to be involved with all elements of a business from research through customer service. It was in this job that I began to realize what could be done if you let people solve their own problems and exercise their creativity. I became an enthusiastic fan of Douglas McGregor, the author of *The Human Side of Organizations*. McGregor talked about Theory X—managing under the assumption that people really don't want to work, they just want to get by, and Theory Y, the management philosophy that says work is a natural process, and that people enjoy taking on new responsibilities. There was clearly too much Theory X in practice, something I desperately wanted to change.

After my work with the aerial photography film, I was asked to move into the paper organization as the production supervisor for paper finishing. This was a major official supervisory job, with responsibility for some 500 people involved with converting black and white and color photo papers into sheets and rolls—quite a challenge, given that there had been very little interaction between the film and paper fiefdoms. Based on my film "roots," I set up an "embassy" system in which "ambassadors" from paper met with people in film and vice versa. As a result, we made good gains, and two years later I had the opportunity to return to roll film as one of the two assistant superintendents. This marked my official attainment of middle-management status, an important career milestone. From there, I was asked to do a brief corporate assignment in which I served as an administrative assistant to the executive vice president of U.S. and Canadian operations.

Next, I was bounced back to the Park, where I was in charge of all sheet film finishing, with responsibility for 700 to 800 people. Then I was sent back to paper, where I worked with development and quality assurance for color paper products as a director for paper service. Next stop for me: Colorado, as assistant to head of the finishing division. Two years later, it was back to Rochester in

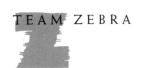

the paper world as a production manager, followed by a promotion to division manager of the photo sheet finishing division (it was here that I acquired the somewhat dubious moniker "chief sheet head"). After helping Ron Heidke restructure the Park, I was appointed manager of the Black & White Film flow—Team Zebra.

I mention this tortuous maze of jobs because others created it for me. In retrospect, everything worked out for the best, but I had very little to do with planning the steps. That's just the way careers evolved at Kodak. Our teammate, Tim Giarrusso, though much younger than I am, had a similar experience. As an undergraduate at the Rochester Institute of Technology, he approached a Kodak representative during a seminar about a co-op student job, and was subsequently hired. "That was my first and only career move at Kodak," he jokes. "Since then, my career has sort of unfolded by itself, with a little help from friendly and seemingly invisible sets of hands."

Team Zebra management wanted people to take a more directed approach to creating their own futures, in part, through job posting that gave people the opportunity to learn about new positions as they became available. Supervisors were also given ideas and support for getting people talking about where they *wanted* to be, what skills they *wanted* to develop, and how they could achieve their goals. This in itself was perceived as a major departure from past practices. And it gave the flow management great credibility in its effort to convince partners that it cared about their futures.

HOWDY PARTNER: ELECTRONIC COMMUNICATIONS

By the middle of 1990, it wasn't uncommon to read about job opportunities on the E-mail system. Of course, E-mail is nothing new in corporate America, and it had been in use throughout the

Park for a number of years. But for the first time, it would be accessible to *everyone*. Initially, some managers did resist the open access to the electronic mail system:

"It cost too much to give everyone passwords and place terminals for common access," some managers warned.,

"Big security problem—you're giving people keys to the electronic safe," others said.

"Ripe for abuse—people are going to spend a lot of time reading news and jabbering on-line to their friends and family members," still others claimed.

In fact, the resistance had less to do with practical issues than about letting go. In the past, information in general, and E-mail in particular, had been the privilege of managers and supervisors, and represented a certain status.

Beginning in the fall of 1990, everyone in the flow received a password to the E-mail system, and terminals were available throughout the organization in meeting rooms, cafeterias, and common hallways. At first, some people were shy about getting on-line. But within six months of assigning passwords, BWFM had become a culture of "great communicators." As a result, Team Zebra could exchange information that normally would have sat in one small pocket of excellence—not because of an unwillingness to share the information, but because there wouldn't have been a means for communicating it across the flow.

Marty upped the incentive for getting people involved on-line by ensuring there were electronic tidbits about company happenings, opportunities, changes in policies, and various topics near and dear to the hearts of our partners.

Team Zebra also gave E-mail a new twist by encouraging people to use it to share "team victories." I believe that more than anything else, the team victories enabled us to raise our capabilities and become a unique learning organization. Anyone who solved a problem or did something in a new way was free to write up their results. The

team victory topics ranged from complex technical fixes to notices of thanks and congratulations to other partners. Gene Salesin, product quality director for graphics films in our graphics stream, once wrote the following under the subject "problem-solving technique."

> At the last BWFM Communications Meeting, Tim Giarrusso suggested a problem-solving technique that we all could use during the meeting break which turned out to be amazingly effective for me, and I thought I would pass the idea along to those of you who did not attend the sessions so you could see the benefits of ''communicate, communicate, communicate.''
>
> Tim suggested that we write down a problem we were currently wrestling with on a piece of paper and then tape the paper to our shirt or blouse. The problem would then be ''in the open'' for anyone to help with during the break.
>
> My problem was finding someone to take on a one-year assignment as the Graphics Stream Coordinator for the 1991 SQ [strategic quantification] and AOP [annual] operating plan.
>
> Bill Poole immediately recognized my problem and suggested a candidate to me who accepted the assignment.

Other times, team victories were used to communicate success stories with a particular product or flow. For example, Gus Behner of coating operations penned (or "keyboarded," more accurately) a story about 100 percent conformance to specifications with one of the finishing processes.

> The success of any finishing operation is heavily dependent on the quality of the sensitized wide

roll received from the sensitizing operations. This was recognized back in 1986 when a vendor/ vendee team was formed between the operations. Since then, by meeting on a regular basis, this team developed specifications, shared informa- tion, and worked to improve the level of confor- mance of wide roll being sent to Building 12. But it wasn't until recently that a major breakthrough occurred. Nagging problems of stuck film, unre- ported imperfections, incorrect length, incor- rect tape usage etc. demanded further action. In 1989 a ''core team'' was formed from within the vendor/vendee team. Consisting of members from Black and White Sensitizing, Black and White Testing, and Dental Finishing, this team really dug into solving the problems. The results speak for themselves. Conformance in 1990 is up over 90 percent and in September, Black and White Sensi- tizing supplied Dental Finishing with 100% con- forming product!!!! Fantastic performance and a real good example of the type of improvement that can be realized by working together as a flow. Thanks to all involved for a great job!

DANCES WITH ZEBRAS

"*Dances with Wolves* wouldn't have had a prayer of winning the Academy Award if *Dances with Zebras* had been around," I joked with Marty.

I was referring to a video that contained three- to four-minute clips from each department and staff units. The idea was to use the

production in our third round of Straight Talks. The clips included more than 200 partners who created skits, wrote rap songs, made costumes, and selected music that would be the vehicles for demonstrating how they were living and breathing our mission, values, and principles in each of their areas of responsibility. The entire video was shot by a partner in the flow, Terry Eastley. Although Terry had no formal training or experience in video making, he steadfastly traipsed across Kodak Park at all hours of the day and night to capture the images for the video.

The finished *Dances with Zebras* was shown on feature-length-sized movie screens in various auditoriums to all of the BWFM partners, and was celebrated in a "Hollywood-style" premiere screening party during which the leadership team passed out movie tickets along with Oscar statuettes with the participants' names engraved on them. This was a labor of love for a significant part of the population in the flow, and the appreciation was deeply felt, as summed up by the words of one partner who had participated in a skit:

"While walking back from the session premiere, I had a chance to reflect on the Zebra experience. Nowhere else [in Kodak] do I see the effort of Black & White Film Manufacturing in designing a theme around their flow that makes people feel like they're part of something unique. Since the Black & White flow has started, the quality of work life has improved vastly. People enjoy coming to work and want to do a good job and tell their accomplishments in a fun way. When I bought a new car this spring, the first thing I did was make sure my new keys were on my Black & White Film zebra key chain. I feel the way I do because management keeps us informed, gives everyone a chance to become involved and understand what their job really is. Thanks for letting me be a part of it all."

Clearly, the resources that went into making and showing *Dances with Zebras* were well spent; we'd surely get back far more than we put in, Marty insisted.

And in recognition for Marty's own spectacular job in coor-

dinating *Dances with Zebra* (a great songwriter and poet, she also helped people compose their music and write their lyrics), we gave her what became known as the "mother of all R-pluses." For the past year, I'd heard her talk about her idol, Don Henley, the singer of Eagles fame (at first I felt like a dinosaur, not knowing the Eagles from the warthogs). In recognition for her work with the *Dances with Zebras* project, the leadership team arranged for her to meet Don at a concert he was putting on at the Finger Lakes Performing Arts Center, about 30 miles from Rochester. A limousine transported Marty and her friends to the concert in style. After all, she helped us to reach our dreams, why not return the favor? That's what the spirit of Team Zebra was all about.

OPERATION PRIME TIME

"*Ten* percent?!" grumbled one of the flow supervisors.

"That's right," Marty answered with a straight face during a supervisors' meeting at the end of 1990 in the conference room of Building 2. "All managers will be spending 10 percent of their time being available for communication with partners in the flow. And that doesn't mean routine communication, either; it means being available so that people can drop by to discuss ideas about solving problems and improving their on-the-job performance."

The "10 percent concept" was one of the few things I "mandated" while serving as manager of Team Zebra. It quickly came to be called "Operation Prime Time (OPT)." The goal was to drive home the point that communication was the key to creating an empowered organization. And it was based on the realization that it would be unfair to ask people to become problem solvers and self-starters unless they had access to their managers and supervisors. While 10 percent of "prime time" may seem like a lot, Marty and

others in the flow management were convinced that the benefits would be well worth it.

In the spirit of the project, Marty constructed a board that resembled a TV monitor and hung it on a wall in one of our conference rooms. All supervisors were required to sign the board three times, beginning with their agreement to incorporate the "10 percent factor." Next, they'd sign when they'd developed their Prime Time plans. The plans entailed finding new ways for managers to make themselves accessible to the partners on their team. Some decided to join partners for coffee breaks, and would even come in early or stay late to catch people leaving on the previous shift or coming in on the next one. Others would make it a point to visit with people on their birthdays or employment milestones and ask them to describe their hopes, dreams, and aspirations for their jobs. Regardless of the specifics, all managers attended Prime Time lunches with one another so they could exchange ideas and help each other refine their plans. When people had revised and finalized their plans, they were invited to sign the board yet another time.

Why all the signings on the board? Marty insisted—and I agreed—that the multiple signings would convey to all managers and supervisors how seriously the flow was taking the Prime Time project. It wasn't long before even the most skeptical managers acknowledged the incredible value of the program. Not only did it enable them to get closer to the partners, but it finally put the distrust of the crisis of 1989 behind us. I believe that Prime Time was largely responsible for the enormous improvement in the employee company survey data on those questions relating to whether or not people trusted their supervisors, and this had a spillover effect on overall morale—even about things that hadn't tangibly changed. After all, how suspicious can you be of your supervisor when he or she is willing to sit down and sip coffee with you—maybe even pick up the tab?

All out-doors invites
your Kodak

EASTMAN KODAK COMPANY,

ROCHESTER, N. Y., *The Kodak City*

CHAPTER 9

UP THE LEARNING ORGANIZATION: BUILDING CAPABILITIES IN BLACK & WHITE

Looking up from the ground, the telephone pole in the training area seemed to touch the sky, even though it was actually only about 25 feet tall. Tom Babcock winced, then began climbing the pegs, one by one, until he reached a small platform secured to the top of the pole. Below, his team members cheered him on as he made his ascent, while two instructors advised him where to place his feet. After Tom finally hoisted himself onto the platform, he slowly turned around in a full circle, being careful not to look down. He then sucked in his gut and let out a blood-curdling scream as he leaped off the platform, ringing the cord of a hanging bell on the way down.

No cause for alarm, though; Tom was wearing a fail-safe harness and guy wire apparatus that gently broke his fall well before he

reached his teammates. Why did Tom (and a group of Team Zebra partners) subject themselves to this kind of "masochistic" exercise? It was part of a week-long training session in October of 1990 at the Pecos River Learning Center near Santa Fe, New Mexico. The idea of the "pole jump" was to demonstrate that fear is all in the mind. With the safety harness system and watchful eyes of the instructors, there was virtually no chance of getting hurt. Even so, most people experience a moment of sheer terror when they hurl themselves off the platform (screaming and ringing the suspended bell are supposed to take your mind off the fact that you're about to do something that part of your brain instinctively deems rather dangerous).

The fear associated with the jump isn't all that different from the fear most people have changing the way they do their jobs. Innovation at work requires a certain amount of blind faith and guts as you "push the envelope" as far as you can and vault into the unknown. It's scary, even when there's a supportive environment such as the one we established in the flow. Just as you couldn't get hurt doing the pole jump at Pecos, you'd never harm yourself by taking a risk in the Black & White Film flow. Besides, you had your teammates there to support you all the way. Still, through years of working in traditional environments, most of our people had developed self-preservation instincts centered around avoiding risk; better to stay the course than risk getting your ideas rebuffed or your head lopped off.

To encourage risk taking, Bob Bacher, the worldwide graphics materials manager, had the good foresight to realize that Pecos-style training would help those he worked with take the risks and change their old ways of doing business; you don't overcome a 100-year legacy simply by declaring that everyone will do things differently. In the spring of 1990, Bob had read about innovative capabilities-building techniques that Larry Wilson, a motivational consultant and founder of the Pecos River Learning Center, had devel-

oped to help people boost their risk tolerance and ultimate performance. Bob further researched the Pecos course, and decided that it would be well worth it to send a pilot team to a week-long capabilities-building program called "Changing the Game: From Playing Not to Lose to Playing to Win."

The idea of "changing the game" and "playing to win" particularly appealed to Bob Bacher. One of his critical success factor projects involved cutting commercialization time for new products, and given the changing marketplace, the stakes for the winners were at an all-time high. The Pecos sessions were designed to help people reexamine how they brought new products to market. Bob's group named their improvement effort "Commercializing to Win," in honor of the Pecos spirit.

The Pecos course turned out to be an ingenious blend of talk, music, and high-energy exercises, offered in an upbeat and emotionally charged atmosphere. Through experiential learning, the Pecos program helps people to uncover buried layers of creativity and to relate in new ways to others with whom they might have worked side by side for many years but had never really come to know.

The zany exercises were especially important in building confidence and a sense of team affiliation. In one exercise, called the "trust fall," team members would stand on a platform eight feet above the ground, and fall backward into the outstretched arms of their colleagues. The exercise underscored how everyone could count on their teammates as a "safety net." All they had to do was let go of fear and take a risk. (In a related exercise, the "blind trust walk," one person would don a blindfold and then place his or her safety in the hands of another team member during a walk over tree stumps, up stairs, and around various obstacles. The exercise, as in real life, pointed out how everyone depends on someone else, whether they want to or not.

Another exercise entailed having two people stand on a V-shape

wire suspended a couple of feet above the ground. The partners started at the closed end of the V and worked their way toward the open end, holding hands to keep their balance for as long as they could. The idea was to go as far as possible without falling. Remarkably, people's desire to help one another resulted in the team's proceeding beyond their expectations.

In yet another exercise, team members were taken to a pond that, they were told, contained poisonous fluids; any contact would result in sure death. Yet, in the middle of the pond, there was a valuable object, the key to cleaning the pond, that had to be retrieved. "Here are your tools," the Pecos instructor informed the Zebra team. "Go get the key." The tools consisted of ropes, pulleys, wires, hammers, etc. Somehow, the partners had to use the tools to rescue the key before the clock ran out. People quickly found that, together, there was no shortage of brilliant ideas. One of the most memorable sights was Tim Giarrusso, blindfolded and suspended upside down over the pond by a rope connected to two trees, his chest just skimming the supposedly toxic pond. Tim's teammates had devised an ingenious rope pulley arrangement that allowed them to "airlift" him to the site of the key. "That was really learning to fly by the seat of the pants," Tim said with a chuckle upon his return to solid ground.

In addition to the pond exercise, there was the famous "corporate wall climb," which literally involved climbing a 40-foot wall. The wall, which seemed awfully unscalable from the ground, was pitched at a slight angle and studded with small projections. "Over here" . . . "Don't look down" . . . "That's it!" were common refrains as team members, tethered together, helped one another place their feet on the projections and pull themselves up ropes suspended from the top. The lesson? Working in concert with your team, you can accomplish the seemingly impossible.

Near the conclusion of each learning session, everyone in the group sat in a circle with his or her team members. Each partici-

pant would ask his or her partners if they had anything to say, at which point they would offer their praise (no negative thoughts were allowed, even as humor). The "asker" would be constrained to only say, "Thank you." This proved to be something very hard to do for everyone in the circle—we're all shy about giving and receiving praise. This seemingly simple exercise proved to be a very supportive and powerful way for people to express their feelings about one another, and an uplifting and memorable way to end the event.

The Pecos program not only focused on positive team-building exercises, but also helped us understand the major deterrents to working together as teams: punishment for failure; destructive competition; turf and separativeness; hypocrisy; and lack of truth telling. The Pecos trainers talked about blame, too—how we readily blame others for our own misfortunes. They reminded us that most of the people we label as SOBs are really FHBs—fallible human beings, like the rest of us.

Many of the key points people learned at Pecos were encapsulated in pithy epigrams, such as George Bernard Shaw's "All progress is made by discontented people," "The truth shall set me free, but first it shall make me miserable," and Winston Churchill's "Plans are useless; planning is invaluable." Other sayings and gems of wisdom were coined by Larry Wilson himself: "I've got to do it myself, and I can't do it alone"; and "Leaders help people change the game from me to we." One Wilson phrase in particular stands out to many people in the flow as the essence of Pecos: "If you always do what you've always done, you'll always get what you've always gotten."

Each of the partners who had attended the Pecos River session with Bob Bacher felt that the course had dramatically changed their lives forever. The BWFM leadership team was lucky to have had several participants—Rich Malloy, Tim Giarrusso, Gene Salesin, and Tom Babcock. Upon their return, Charlie Newton, who had brought Peter Block to the company,

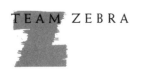

immediately understood the impact of the experience and devised an ingenious plan to train many more Kodakers without the cost of flying people to New Mexico. Newton asked, "Why not bring New Mexico to Rochester?" While we all would have appreciated a little Sunbelt weather, the flow settled for its own Pecos-style training center in our Marketing Education grounds on the banks of the Genesee River south of Rochester. The center, constructed with help from trainers from Pecos River, included many of the same exercises as those used in New Mexico, such as the pole jump, the corporate wall, the trust fall, and others. The idea was to use Pecos instructors in our own facility to train batches of partners throughout the remainder of the year. During the course of 1991 and 1992, more than 500 Team Zebra partners enjoyed the benefit of the capability-building experience (as did others from various parts of the company). They attended in groups and always had the same objective of accelerating progress on important improvement projects they had already undertaken, and of understanding that they could choose to empower themselves to make a difference.

BUILDING ON PECOS

One of the most important things that Pecos taught us was the value of experiential learning. That meant experiencing something outside the context of work, reflecting on the experience, drawing some lessons, then applying the learning back on the job.

Tim Giarrusso was so excited about the concept of the experiential learning he'd had in New Mexico that he became a champion of the process. He also made some enhancements of his own to the Kodak/Pecos program. For example, he incorporated parts of a seminar on statistical process control or "SPC" offered by Texas

Instruments. (The basic idea of SPC is that you use statistical data to monitor your manufacturing processes in "real time" and then make corrections. So instead of making 1,000 widgets, conducting a sample, and discovering that the whole batch is defective, you stop the manufacturing process as soon as a process parameter goes out of control; that way, you can potentially save 999 bad widgets.) Rather than teaching SPC as a mathematical concept—math being an intimidating or boring subject for lots of people—TI found a clever way to demonstrate the core concepts: the old-fashioned catapult. It was this innovative approach to teaching that caught Tim's fancy; he knew that it was not only a great way to demonstrate SPC, but also that it could be adapted to teach partners at various levels about how our business works.

In February 1991, he sent two partners to a TI seminar in Chicago, and authorized the purchase of four catapults. Normally, only those at a supervisory level would have been sent on such a trip. But Giarrusso chose a shop floor melter, John Scobey, and an internal consultant, Theresa Lundhal, to attend the session. John and Theresa were then invited to incorporate the learnings into our own capability-building efforts.

The TI catapult measured about 15 inches long and 8 inches high. The arm, which allowed for seven adjustments and calibrations, terminated in a cup large enough to hold a Ping-Pong ball. Powered by a series of rubber bands stretched over a fulcrum, the catapult could easily lob a ball across the room. By adjusting the arm and varying how far back you pulled it, you could precisely eject a ball onto a paper target.

The catapult event was offered as an integral part of the indoor Pecos-style training. The catapulting took place in a classroom equipped with conference tables. Perfect launching pads, actually. Once everyone understood the mechanics, Tim would organize them into teams of throwers, spotters, catchers, and data collectors. The throwers would actually operate the catapults,

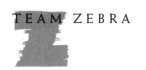

while the catchers would retrieve the balls. The spotters, who became known as the "truth tellers," got down on the floor and would call out "Hit" or "Miss" and describe whether the ball was short, long, or too far to the left or right. And the data collectors would keep meticulous track of the score and the adjustments.

(Interestingly, after demonstrating the use of the catapults during one session, the managers had the most difficulty performing the "day-to-day" tasks—they constantly fiddled with the adjustments, causing the balls to miss the targets altogether. This brought about much [well-deserved] needling from the shop floor operators, who experienced far better results—they knew when to keep their hands off the adjustments and just let the machines do their job. Of course, the managers just needed to "let go" and find other ways to add value.)

All of this was far more than just a fun way to spend an afternoon. Once people got the hang of the catapult, Tim would relate the concept to the manufacturing of film, telling them that they had x pieces of raw materials (the balls). Hitting the target was the equivalent of making good product; missing meant creating waste.

Eventually, Tim built in all of the elements of running our business through the catapult model, assigning a budget to the raw materials, explaining how cost-effectiveness works, and describing the impact of quality on customer delight. Tim also discussed the choices we make about the work environment we create. Through the catapulting sessions, he explained how partners could choose to create an empowering environment based on high levels of trust, support, energy, open communications, and feedback.

Our capability building was quite influential in the progress that the flow made in helping partners choose to make a difference. Once the Pecos training started, it was a rare week that flow

management didn't get at least one emotional note from someone who explained how much the training had helped enhance their working and personal lives.

CAMEO ON THE RIVER

A month after the cycle time reduction crew returned from Pecos River, the BWFM management team set out for the Cameo Inn, a bed-and-breakfast (actually, a lovely renovated 19th-century mansion) located near Youngstown, New York, on the Niagara River about an hour from Rochester. With its spacious rooms and fireplaces, it seemed like the ideal spot for reflecting and rejoicing about the tremendous gains BWFM had made the first year, and more importantly brainstorming on how we would sustain its forward momentum. It was clear that Team Zebra had saved the black and white film business for now, but we still had to work hard to ensure the future of the flow.

Consistent with our values and principles, we showered one another with more positive reinforcement (R-plus). Prior to the workshop, I had assigned each manager an "R-plus partner," the idea being that each person would give his or her counterpart a gift of appreciation (I also placed a $10 limit on the exercise). On the afternoon of our first day at Cameo, I received a poem about our first year in BWFM written by Sue Donovan, the manager of the health sciences stream staff; Tim received an 11-inch-by-14-inch black and white framed photograph of his daughter from Russ Williams, the manager of emulsion making; Bob Brookhouse was presented with a box full of garage sale purchases from Scott Snyder—it looked like junk to most of us, but Bob loves to shop for hidden treasures. Don Monacell, the graphics stream sensitizing manager, an avid golfer received golf balls; and Charles Barrentine, the health sciences

sensitizing manager, a serious fisherman, was given a fishing "kit." There were as many different R-pluses as there were people at the workshop. Each one carried great personal meaning for the recipient; it revealed that team members really understood one another on a personal level. That knowledge and understanding is a major component of the magic that bound together the BWFM management team.

The R-plus sharing experience put everyone in a great frame of mind for discussing how we could further improve our performance. And the timing was perfect, coming on the heels of the first Pecos training, and prior to the building of a Pecos-like training center in Rochester. Tim and several "Pecos Pioneers" relayed what they'd learned and told how Pecos had helped them grow as individuals and members of the flow. Tim led us all through a fascinating team-oriented "carpet maze" exercise that helped participants to appreciate what they could learn from past mistakes. The exercise involved a hopscotchlike board and entailed changing rules not always known in advance. Like the real game of life, you never knew what you'd encounter, and the only way forward was to solve problems and learn from mistakes. If your partners were around, and trust abounded, you'd risk your way through the maze. Not surprisingly, our first attempts at the carpet maze were very tentative and represented sad displays of cautious rather than courageous, behaviors.

We also took the opportunity to reconsider our original vision drawings and discuss how our hopes and dreams for the future had changed. We all still wanted the same things, but we simultaneously concluded the need to "increase the net" and bring more partners into the vision. "Vision II" or "Son of Vision," as some called it, made far more references to our partners, and to specific goals that each person in the flow could relate to, such as cutting cycle time and meeting customer-focused goals. We internalized the keys to change and empowerment, starting by looking at ourselves in the mirror.

In typical Team Zebra spirit, the entire workshop was dotted with songs and skits commemorating the first year. Marty, Tim, and Chip had written a number of the skits and songs, with Marty playing the keyboard and Rich accompanying her on the banjo. We poked fun at ourselves in a playful way, about moving from being victims to being accountable for the results we generated. And as a cap for the event, we donned sweatshirts bearing our new logo and took a team picture. We then held a mock funeral for the ways of the past. When we started the workshop, I felt we'd entered the inn as a strong management team; when we left, we'd earned the title of "leadership team;" revitalized and poised for the future. Before Cameo, we'd all been in "Kodathink" mode—do the best with what you have; at the end of the session, we believed that we could break through the toughest of barriers and make BWFM a GREAT organization. It was this orientation that made it possible for us to ultimately achieve unparalleled levels of performance.

BOLSTERING THE FIRST-LINE SUPERVISORS

By the fall of 1991, random acts of empowerment abounded, and the changes in people's attitudes and expectations were remarkable. A number of partners admitted that for the first time in years, they actually looked forward to coming to work, because they knew their ideas would be taken seriously and they would have an opportunity to solve long-standing problems, rather than just coping with them. Most important, they felt that they would have a chance to truly make a contribution to the flow.

Ironically, this very empowerment created an uncomfortable "squeeze" situation for some of the first-line supervisors who'd

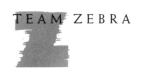

worked their way up through the ranks. From above, top management in the flow insisted that supervisors help partners form self-directed work teams. From the shop floor, partners wanted to be more heavily involved in the decision-making process, and expected more opportunities to become creative problem solvers.

Both demands, of course, were alien to supervisors who were used to the old "drill sergeant" school. In the traditional Kodak model, supervisors were chosen based on their demonstrated knowledge of certain manufacturing processes, and their ability to produce high volumes of product. While this approach guaranteed that the technical requirements of the work would be in good hands, it couldn't ensure that supervisors would have good managerial or leadership skills.

In the early days, when much of the work was mainly manual and repetitive, the old style of management might have been adequate. But in a new era of highly trained workers who expected the opportunity to participate with their minds as well as their bodies, the traditional model was no longer effective. Regardless of flow, today's marketplace demands everybody's best ideas about improving performance and quality in order to keep the company ahead of its competitors.

For some supervisors, the change to a coaching/facilitating mode would be very threatening. That's why flow management launched the Breakfast Club and Operation Prime Time earlier in the year; both were designed to help our first-line supervisors understand and adopt the "new" way in the organization. The flow management also made a point of ensuring that all first-line supervisors attend the Pecos-style training program at the Marketing Education Center. The goal was to make them "co-conspirators" by including each one in all the planning for the capability building going on in the flow.

"Pecos really helped us to change our focus from tending to day-to-day business to coaching and mentoring," says Sam Lo-

biando, a first-line supervisor who served in the graphic arts flow. "For the first time, we were asked to help people develop their skills and go beyond their job descriptions. For some people, this was very difficult; others were eager and willing to accept the new challenges. But once supervisors got going, it was like a 'domino effect'—we constantly thought of new ways to coach people."

In addition to helping first-line supervisors go beyond what Sam calls "day-to-day" business, in the fall of 1989, flow management began a new selection process that would "sprinkle" the supervisory ranks with professionally trained people such as engineers. The mix of capabilities would surely strengthen the supervisory teams. Not surprisingly, this new policy caused some discomfort at first, as Tom Larkin, an engineer turned supervisor, discovered.

"A lot of people applied for the supervisory position that opened in sensitizing, and I was kind of a surprise choice," Larkin recalls. "I knew there would be some resentment, so for the first six months, I just kept my mouth shut. I made it clear that I had a lot to learn, but also had a lot of ideas and skills to offer, such as my knowledge of process engineering and experience with implementing technical improvements. My peers were skeptical at first—not only wasn't I from the ranks, but I wasn't even from film sensitizing. But eventually—six to nine months—they started asking my opinion of things, and I felt part of the team. One of the most gratifying things happened at a retirement gathering for one of the older supervisors: 'I really resented you when you came on board,' he said. 'But you made great contributions. Thanks!' "

Not only did the flow expand its supervisory skills and knowledge base, but it also began applying our "empowerment principles" in the selection of ALL new supervisors, whether they were up through the ranks or professionally trained. In a dramatic break with the past our supervisory selection interviews involved partners from "the floor" (those who would eventually be coached by the

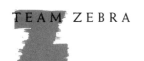

person chosen for the job), internal customers, and the department manager. Also the black and white leadership team put aside the conventional criteria and developed a hiring screen that essentially asked two key questions of each candidate.

During the interview, we'd first ask the candidates about a problem they'd helped solve in the past. People invariably fell into two camps on this one. Either they'd brag about what they did, or they'd tell us how everyone they worked with became part of the solution. Obviously, we were interested in people who put the team first.

Next, we'd ask them about something that upset them and what they had done about it. Again, the responses fell into one of two camps. Either people talked about the "system" and blamed everything under the corporate roof, or they'd talk about how they tried to make a change. Even if they didn't succeed, it was an indication of self-empowerment. Of course, we sought the latter.

Typical responses to our new questions were as follows:

QUESTION: Tell me about someone who came to you with a problem—how did you help him or her?

UNEMPOWERED ANSWER: *I* arranged to have equipment modified. . . . *I* went to the planners to adjust a schedule. . . . *I* contacted a supplier about defective materials.

EMPOWERED ANSWER: I suggested that *they* discuss this equipment with the maintenance people. . . . I offered to arrange a meeting with the planners so we could all prevent the problem from happening again. . . . I encouraged a face-to-face meeting with other vendors so we could talk about solutions to the problem.

QUESTION: Tell us about something that bothered you and how you responded.

UNEMPOWERED RESPONSE: Well, I was frustrated because with all this red tape you can't get anything done around here. . . . Workers just don't have the same kind of ethic I had when I was on the line. . . . Kodak is a big company with lots of rules—you just have to accept that it's hard to get things done. . . . If management makes a decree, give 'em what they want.

EMPOWERED THINGS: If the rules don't make sense, try to find ways to change the rules. . . . If the rules violate the principles on the walls, call it to someone's attention. . . . Explain to management the outcome of their decrees, saying "this is what I think you want, and if we did things this way, you'll get what you're looking for."

After a few minutes of these kinds of answers, it became readily apparent who was suited to the kind of supervisory style we wanted and who would foul the environment we were striving to create. As a result of our new selection process, the flow's supervisory team became a real mixture of up-through-the-ranks people and those with technical degrees. All, however, had an understanding of and a keen interest in helping others become empowered.

WINNING AT THE LEARNING GAME

The goal of our capability building was ultimately to create what in 1993 jargon would be called a "learning organization"; for us, that meant an organization in which knowledge flows seamlessly from one part to the next, and is transformed and adapted to the particular needs of individual groups. This is far more sophisticated than the mere shuttling of data and sharing of facts; it is a classic case of

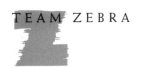

what information specialist Richard Wurman calls "bridging the black hole between data and knowledge." In too many companies, the sharing of raw data is confused with the sharing of useful information; performance and other numbers without analysis and insight won't help anyone do their job better or apply new ideas to old problems. In our case, there was an explicit effort to interpret information for one another and to package ideas in a way that would lead to meaningful improvements throughout the flow.

Our catchphrase for this sharing of knowledge was to "steal shamelessly but remember to say 'thank you.'" Through B&W views and informal seminars put on by the partners, the flow management made a concerted effort to broadcast our success stories. At the same time, people were encouraged to aggressively seek innovative solutions in one part of the flow and employ them in our own. "No one ever got knocked for using a good solution that originated in someone else's head," Tim Giarrusso says with a grin.

Team Zebra had a number of "master thieves" in our organization, such as Rich Malloy. Before developing Sensi-X, the cycle time reduction project for Black & White, Rich visited and made careful observations of other sensitizing organizations both at the Park and in other plants, such as the film-making facility in Colorado. After attending the Research Lab's bestowing of a team achievement award for solvent coating, I suggested that we model our own awards on the same approach, and look for team success stories within the flow. Charles Champion took the ball and ran with it until a group he formed created the BWFM Team Achievement Awards.

The Team Achievement Awards (plaques, actually) were created to provide a formal vehicle for teams to monitor their activity against expectations as well as to receive recognition for their accomplishments. All teams were encouraged to score themselves regularly on seven dimensions: communications, teamwork, project focus, analytical approach, institutionalization, creativity, and

reinforcement. Each team scored itself on a matrix, with no follow-up audits to ensure the integrity of their scoring; this was another way of reinforcing the principle of trust.

Whether it was borrowing ideas for awards or a processing technique, all of the acts of "shameless thievery" contributed to the development of an organization with a tremendous ability to share ideas across functionally disparate subgroups. At the same time, Team Zebra partners always welcomed others to visit and share our learning experiences in that "win-win" spirit.

Team Zebra received third-party validation of its success during a human resources conference where I met Cal Wick, a leading expert in assessing learning organizations. Marty, Tim, and I independently filled out the assessment form, yet each racked up scores in the high 80s and 90s. According to Cal, the norm for large companies is somewhere in the 60s.

What is even more remarkable than Wick's assessment is the fact that BWFM had become a learning organization in such a short period of time. Team Zebra started in the summer of '89 as a ragtag collection of angry people who had never been used to sharing ideas. In our old culture information was traditionally held close to the vest and only made available when it could be wielded as a club. By the summer of 1991, information was still a club—but one that partners held collectively and used to pound problems, not one another.

*If it
isn't an
Eastman
it isn't
a
KODAK*

THEIR VACATION STORY—AS TOLD BY HER KODAK

There are Kodak stories everywhere. In summer—the days of lake and sea and mountain; in winter the story of the house party, the Christmas tree, the happy gatherings of family and friends; all the year round the story of the children and the home—in all of these lies the

Witchery of Kodakery

*Put KODAK on
that Christmas list
Catalogue at the dealers
or by mail.*

EASTMAN KODAK CO.,

ROCHESTER, N. Y., *The Kodak City.*

CHAPTER 10

THE MAGIC BEHIND
TEAM ZEBRA

"Steve, come here—quickly!" my wife, Kathy, called out to me as my brother-in-law and I returned from watching the Jerry Ford golf tournament on August 12, 1991. The CNN news anchor was in the midst of announcing that Kodak was downsizing again and offering rich incentives for people to retire early. The goal was to trim the workforce by 3,000.

This occurred while we were vacationing in Vail following my youngest daughter's college graduation from the University of Colorado. "Hey, Steve, you're just 55—why not take the money and start up a Greek pancake house chain?" my brother-in-law asked jokingly. We all laughed as I reminded everyone how my father, who had been in the restaurant business, always warned me, "Do anything but the food business . . . it's too tough!"

The timing of the Kodak offer seemed unbelievably seren-dipitous, given the conclusion of the financial responsibility brought on by my daughter's graduation. Nevertheless, I put it out of my mind since I just wasn't ready to stop working. Besides, my thoughts were centered on what this might mean to Team Zebra.

On the flight back to Rochester, I began mulling it over again. Not the pancake house, but the thought of taking the knowledge of my Kodak experiences, especially the Zebra journey, and helping other companies create positive work environments. I broached the possibility of "retiring" as I talked with Kathy, more as a fanciful whim than anything else. She was her usual supportive, yet practi-cal, self, encouraging me to balance my personal desires with the financial realities that lay ahead of us. "Besides, what exactly would you do?" she asked.

I shrugged my shoulders and answered, "Become a traveling empowerment salesman, I guess." As the plane reached cruising altitude, I moved the idea of early retirement to the back of my mind, reclined my seat, then drifted into my favorite flying mode: napping.

Not surprisingly, I returned to Rochester to find the Park abuzz with the news of the retirement plan, called Resource Redeploy-ment and Retirement—"R-cubed," for short. The details were certainly attractive—for every year of service, there was a week's worth of pay, with a 52-week cap. Employees could receive their money along with their earned retirement benefits in either a lump-sum payment or as a lifelong annuity. Everyone over 55 was eligible, and many people who had enough time with the company would receive upgraded retirement benefits. Kodak sweetened the deal by offering a Social Security "bridge" for those under 62 until government payments kicked in. It would also pay health benefits, offer a $5,000 retraining allowance, and provide free career and financial planning seminars.

The company estimated that the early retirement plan would attract 3,000 takers, the number required to avoid involuntary dismissals. To Kodak's surprise a large majority of those eligible took the offer—about 8,500 people.

Between September and October, I began more seriously entertaining the idea of starting a new career. While there would always be room for improvement in Black & White, the Zebra was strong and kicking. The flow had overcome seemingly impossible hurdles and had saved many jobs. As Bob McKinley put it, if we were making cars, the results of our turnaround would be all the more stupendous. We sustained steady production volumes while offering our customers a gaggle of new features and "options." The "cars" were also considerably more sophisticated and harder to make. Our production costs had improved by some $40 million during this incredible journey, and we'd cut our inventory by some $50 million. We also slashed cycle time to all-time lows. In finishing, what took four to six weeks was now done routinely in two days, and in the sensitizing operations, what had historically required 42 days was now done in less than 20. We brought new products to market in one-half the time it used to take us. And deliveries were on schedule 95 percent of the time. Waste was also at record lows, and morale was near the top in the company. Now it was a matter of sustaining the energy and making continuous progress.

It would be egotistical of me to assume that the energy of the flow would wane or the gains of Team Zebra would be erased if I left the company. Vern Dyke, the general manager of Kodak Park, and Dick Bourns, the vice president of worldwide manufacturing, both assured me that if I chose to take an early retirement, the flow would survive and prosper. Still, the decision to leave after 34 years was the most agonizing and wrenching of my life.

The big nudge for me was the sudden attention we had received from outsiders in the fall of 1991. C. J. McNair, a professor

at Babson College and an experienced researcher and author, visited Team Zebra as part of a benchmarking study for the Consortium of Advanced Manufacturing International—CAM-I. The study was titled "Best Practices in World Class Organizations." C. J. was awestruck with our performance and spirit, and advised me to pen a book on the flow story. I laughed and thanked her (what did I know about writing books?).

Then the McKinsey people came for a visit. They'd helped organize Kodak into business units eight years earlier and wanted to see how we were doing. Their reaction was the same as C. J.'s and won us a place in *The Wisdom of Teams*, written by Jon Katzenbach and Doug Smith, two senior McKinsey consultants. Also, *Fortune* magazine arrived and featured the Zebras in full regalia in an article by Tom Stewart titled "In Search of the Organization of the Future." Finally, the Work in America Institute sponsored a case study on the Team Zebra successes.

Clearly, the outside world hungered to learn how we transformed an ailing business into a superior part of the company. Could I help others create their own "Team Zebras"? Only one way to find out: on November 25, 1991, a week before my last official day, I wrote my final "Steve's View," an E-mail "column" I'd been writing for the past year:

```
Author: Steve Frangos, BWFM
Subject: Final ''STEVE'S VIEWS''—So Long!
My heart is filled with JOY and SADNESS. Joy be-
cause of all the friends I've made during the past
2¹/₂ challenging years and sadness that I won't be
a part of this wonderful journey on a day-to-day
basis anymore.
    STEVE'S VIEWS have been a great way for me
to stay in touch with everyone since it has
```

supplemented other forms of communications. TRUST is one of our most important principles and I've believed from day one that open communications are the key to creating the kind of environment we all desire and deserve.

You've been such great partners—we accomplished so much in such a short time. BWFM has a vital mission for the company, makes important products for society, and has superb partners with the values, principles, energy, and commitment necessary to perform in a totally successful way. I have complete confidence in your future both because of the programs we have underway as a foundation and, more importantly, because of YOU and what you bring to this business.

I'm counting on you to achieve that success with even greater spirit and, yes, even more FUN. Remember, not too long ago few of us even imagined work and fun could go together—let alone that we'd be doing that to such a great degree.

As I move to a new career I do so with high confidence that others can benefit from what we've learned and I plan to tell them (actually brag) about our experiences, successes, and how we did it. So in an important way you'll be with me and I with you. And I'll never forget you and the things you've taught me.

Now how about a big ZEBRA cheer, partners!

As one of my parting gestures, I presented the leadership team with a story I had written several months earlier, before even contemplating leaving. The idea of "The MAGIC Zebra Fable" was

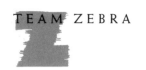

to present our partners with a reaffirmation of our vision and inspiration to extend their work to even greater heights. The fable opened like this. . . .

> Once upon a time in a kingdom called Imaging there was a Park filled with big and little yellow boxes and big and little red-bricked buildings where there lived a **MAGIC ZEBRA**. This zebra was over 100 years old and planned to live forever— because it was magic AND because it was so incredibly great at what it did. That wasn't always true, in fact; it was sometimes overshadowed by more colorful animals in the kingdom, and even some other black and white animals in other kingdoms. Right around its 100th birthday, it began to "flow" into different ways of doing its work, and it was then that it did many things better than ordinary zebras and for that matter other animals (even the colorful ones) not just in the kingdom but in the whole wide world.

The fable ended with the following moral:

> Magic can only work if you really believe in it—and this fable only becomes fact when many believe it can happen and dedicate themselves to creating the kind of environment that helps others grow. Everyone then becomes accountable for keeping their riders—oops, customers—delighted.

HOW WE EARNED OUR STRIPES

The turnaround of Black & White offers scores of lessons for managers of service as well as manufacturing companies. I believe that 10 "Zebra Truths" in particular allowed the Black & White flow to achieve its stunning results.

Zebra Truth 1. The Management Team "at the Top" Must Become the Leadership Team

If those at the top of a hierarchy don't change, there is little chance that the rest of the organization will. The old saw, "People talk with their feet, not their mouths" says it all. In Team Zebra's case, we were blessed with a diverse group of good managers who became exceptional leaders and contributed to our becoming a "boundary-less" organization. They were passionate about their work, driven to attain the vision, committed to the mission, and, most important, devoted to living the values and principles they advocated for the whole organization.

Without this model behavior and willingness to "let go," try new ways, and exhibit visible passion, our significant culture change could not have occurred.

Zebra Truth 2. Positive Recognition and Reinforcement Wins the Race

These days, there's a tendency to brush off the "warm and fuzzy" stuff as just so much "New Age fluff." In fact, it's positive recognition that makes people want to reach for the high bar. As we discovered, a one-dollar zebra pin presented with sincerely deep thanks often gets people to do more than cash incentives, and will ALWAYS get people to do more than the threat of retribution.

Our relentless pursuit of new ways to recognize people paid off dramatically. Since Team Zebra didn't invest heavily in new equipment or technical programs between 1989 and 1991, the stunning turnaround could only have resulted from people and mind-set changes. For bottom-line-oriented managers, that translates into phenomenal leverage—and a bargain by anyone's standards.

Zebra Truth 3. You Need a Custom Toolbox to Lead Your Organization Out of Crisis

Most companies respond to crises in one of two ways—with a knee-jerk "SWAT" approach ("slash and burn, slice and dice, downsize and rightsize") or by adopting whatever management fad happens to be in vogue at the time. Some of the former may be necessary to stop the bleeding, and new management ideas are always worth considering. But simply putting a company on a low-fat diet won't lead to sustained improvements unless it's coupled with a comprehensive reevaluation and revamping of the way work is done. Similarly, no single management theory will save a dying zebra—or tiger, lion, or hedgehog, for that matter.

We did our share of hard-core belt tightening, and we were always on the lookout for innovative management ideas that would allow us to inspire our partners and build their capabilities. But rather than viewing any particular technique as a "silver bullet," we focused on building a "tool kit" customized to our particular needs. Sure, we were doing "reengineering," "total quality management," "time-based competition," and other trendy-sounding techniques. But we never worried about labeling our approach. Rather, in our eclectic fashion, we stole and borrowed ideas and adapted them to the flow. Add two parts of Dave Ulrich's strategic HR thinking to one part of Aubrey Daniels's performance management, fold in a thick layer of Peter Block's empowerment thinking, and garnish the mixture with Larry Wilson's rich assortment of capabilities builders. What do you have? A recipe for success for the Black & White flow.

Of course, what worked for us might not be appropriate for other companies (at the end of this chapter I'll talk about adapting our lessons elsewhere). But the concept of building a tool kit can be applied to any company in any crisis situation. The key is to mold the tools to your unique culture. We took performance manage-

ment, for example, and "Kodafied" it, giving the concept a unique twist, building a scoreboard that everyone could relate to, and reinforcing the desired behavioral changes through celebrations. So rather than forcing the flow into the performance-management model, we adapted the core theories of performance management to fit our needs.

Zebra Truth 4. People Put the "Pow" in Empowerment

During the early 1990s, many people wrote off the term "empowerment" as just another management fad. Some had found that trying to empower their workforces actually produced negative results, largely because their cultures were too heavily based on heavy-handed rules. In the context of such constraints, empowerment can become just a hollow slogan and another attempt of management to manipulate people into believing that they actually have some control over their work lives.

Even when efforts to empower are sincere, they often fail because of the common misconception that you can delegate empowerment the way you delegate authority. In fact, partners often confuse delegation with empowerment. By simply giving people more authority, you might bring about surface-level changes so that they feel better about their jobs. But you'll never effect real cultural change without the "fire in the belly" that ignites when people make a decision to empower *themselves*. Besides, delegating authority without having support systems and resources in place will greatly reduce the likelihood that increased responsibility will lead to empowered thinking.

A corollary to this truth is that you can encourage and enable, but you can't empower anyone else. *Empowerment is a choice that people make.* And they do so because there's something in it for them—and not just monetary rewards. In Team Zebra's case, many

partners chose empowerment when they learned that they work on products that have a very important value to society. They chose empowerment when they understood that as a job shop, Team Zebra was unique within the corporate umbrella; no other facility in Kodak Park could do what we were doing. And they chose empowerment when they felt genuinely included in our vision for the future; the sheer amount of time management spent listening to partners' ideas was a compelling reason for people to choose the empowerment route.

Zebra Truth 5. Fun Is NOT a Four-Letter Word

While I've always believed that work should be fun, I never "mandated" it. That is, we never had a deliberate strategy to develop skits, cheers, and songs. Yet the fun and zaniness became critical parts of our culture, and being stricken with full-blown "zebramania" was a badge of commitment. What made our antics all the more unusual was the fact that Kodak is a conservative company, and Rochester a conservative community. I think it was highly significant that people eventually got comfortable wearing (sometimes outlandish) black and white garb, and stopping work to break into a cheer for a partner who'd done something unusual.

Not every culture will support the kind of "visible spirit" that became our hallmark. Yet *every* culture can accommodate some level of enjoyment, and when people loosen up, their creativity reaches new heights.

Zebra Truth 6. Cultivate Owners to Success in Business

Anyone who feels he or she has a stake in your business will go the extra mile, take the extra step. True, we had the company wage dividend, which gave partners a tangible return on their perfor-

mance through profit sharing. But there's a whole level of participation that goes far beyond financial incentives and into the realm of empowerment—that's what being a "partner" is all about.

I think the concept succeeded for us because we stumbled onto it well *after* we had begun creating an environment that facilitated empowerment. So by the time we had begun using the term, we had already done a good job of cultivating the idea of ownership through partnership. Had we started out from the beginning calling everyone "partners" and emphasizing their role in the business, I'm sure we would have been greeted with skepticism and anger. But since we "walked like we talked," partnership was a natural evolutionary step in the development of the flow.

Zebra Truth 7. Trust Starts in the Trenches

If location, location, location is the key to property value, then communication, communication, communication is the key to rebuilding trust that's been eroded by an unfortunate turn of events. As painful as my first Straight Talk sessions were, I believe they were the key to getting people to believe that they were important and that they were the reason the business would succeed or fail. Long ago, my father taught me that people only *loan* their trust to others and can *withdraw* it very quickly. And the biggest reason that people withdraw their trust is a lack of truth telling. The Straight Talks laid it all out on the table, with no excuses or attempts to gussy up the ugly facts. And while lots of people initially used the sessions to vent their personal anger, the message was loud and clear that we intended to tell the truth, the whole truth, and nothing but the truth.

We constantly reinforced our commitment to honesty, openness, and truth. One of the most personally touching award ideas came from the leadership team, which created the Stephen J.

Frangos Award as I was leaving the company. Originally, the award was designed to honor excellence in communications and would be presented to a single partner monthly. The award certificate depicted the BWFM logo and a picture of the zebra, as well as a communication logo that contained a circle and the words "communicate, communicate, communicate," written sideways, up, and down. It was realized that our philosophy of "I win, you win, we all win together" would be better served if there were a multitude of winners. I'm told that more than 500 partners have won the award. And the benefits to the flow in terms of building cohesiveness and trust have been immeasurable.

Our eagerness to tear down the "silver curtain" mentality that had traditionally isolated functional groups also sent a strong message that we were serious about eliminating turf battles. This in itself went a long way to encouraging people to develop trust and switch their focus from internal competition and suspicion to the flow's customer-based goals and needs.

Another trust-building action we took was the reassignment of nonperforming managers and supervisors. While the vast majority of supervisors readily became coaches and facilitators, some just couldn't relinquish their position of control. Based on partner feedback, we moved several of these people to staff positions, where they were ultimately happier and more productive. This sent a clear message to the partners that we were serious about their voices and that supervisors were there to help them build their capabilities and careers. It also sent a strong signal about desired behaviors to those who aspired to supervisory levels.

Finally, in a complete break with tradition, we made it abundantly evident that only work consistent with our values would be reinforced, while mistakes would be used as learning experiences. I think that our Team Zebra celebrations and ceremonies were well received not only because they injected fun into the workplace, but because they gave people confidence that stepping out of their

comfort zones was a risk-free proposition with everything to gain personally and professionally.

Zebra Truth 8. First-Line Supervisors Are the Backbone of an Empowered Organization

In today's rush to "flatten" organizations, first-line supervisors are often seen as superfluous. Even some companies that have embraced the empowerment concept and are eager to develop self-directed work teams make this mistake. Unfortunately, you just can't cut out first-line supervisors and expect to get much out of your empowerment efforts; these people are critical to making an empowered workplace a successful workplace. When trained to be coaches and facilitators, first-line supervisors can translate the vision of the organization into the small daily actions and decisions that determine whether the right products or services are delivered to the customer in the right way at the right time. And that, of course, will ultimately determine how well the company succeeds in the marketplace.

We discovered that the first step to making supervisors our "empowerment lieutenants" was to understand that we couldn't convert anyone from a "direct control mode" to a coaching mode by executive decree. Many, although quite willing, didn't understand the shift or have the slightest notion about how to go about supervising in new ways. In all likelihood, we could have simply bred resentment and anger.

A more effective approach is one based on education and personal development. In our case, we had a 100-year heritage of the drill sergeant model, and many of our first-line supervisors were 20- to 25-year veterans of the company. We took into account that asking people to change the way they do their jobs is a threatening proposition, and that asking them to relinquish the authority

they've "earned" can seem downright outrageous—unless you can offer something better. In our case, that "something better" was a set of unprecedented opportunities: the opportunity to have a far greater influence over people through enlightened coaching and teaching; the opportunity to become part of a team that develops effective solutions to persistent, long-standing problems; and the opportunity to help create a more satisfying and enjoyable workplace.

We used the Breakfast Clubs and Operation Prime Time as forums for teaching, communicating, and sharing ideas; the social type of meetings fit our culture nicely and accommodated the structure of our work-hour shifts. But we just as well could have met for weekly afternoon or evening sessions. The medium is irrelevant; what counts is that you open the doors for the free exchange of ideas. Peer learning is critical, because everyone makes faster gains when they learn from one another. There's also the "critical mass" phenomenon—when enough first-line supervisors are reporting about their acts of coaching and facilitating, others will feel safe trying the "new style." There's even a certain amount of peer pressure to be functioning in the "enlightened mode," too.

Another key to our success with this important group of partners was our ongoing effort to upgrade the overall skill level of the supervisory ranks. The Breakfast Clubs, Operation Prime Time, and other group get-togethers were excellent opportunities for supervisors to learn new skills. We also sent supervisors with each group that attended Pecos, so they would build their capabilities along with their partners. And I believe that our new policy of mixing "up-through-the-ranks" supervisors with people who had professional training was an important step in boosting our supervisory rank's overall skill base.

In short, we enjoyed a great deal of leverage by concentrating time and energy on our first-line supervisors. And I doubt that the

flow would have been nearly as successful as it was if we hadn't recognized that first-liners were in the best position to help everyone achieve their hopes, dreams, and goals.

Zebra Truth 9. Extended Families Can Provide the Inspiration for Change

Early in the Zebra journey we talked about how the 1,500 of us might be thought of as 10,000 or more if you included all those who depended on us. Certainly our family dependents, our customers, our suppliers, and other stakeholders could be considered part of an "extended family."

Internally, we devoted ourselves to ensuring that our internal customers and suppliers were treated just like family in terms of information, recognition, and respect. Team Zebra's strong customer-based performance measures honored how we were influenced by this part of our "family." We also strove to understand these customer needs, so we could provide them with better products and service.

We also paid close attention to people's actual family dependents. Our dinner certificates, for example, which recognized our 1990 performance turnaround, was a sincere and unusual way of saying "Thanks" to this important group of people. The tremendous response to the certificates further confirmed that partners were thrilled at the opportunity to share their success with those closest to them. At one of the final team functions that the leadership team staged before I departed, we heard from our partners' spouses, parents, and friends about how they perceived the Team Zebra experience. Many heartwarming things were said, epitomized by one partner's spouse:

"The feeling of caring for the group expands even into the time that they are not at work. The thing that I have found most touching

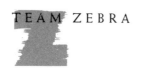

is that this group has been so supportive and encouraging to my husband. He has often said to me, 'I don't think I ever recall having been with a team of people who are so thoroughly encouraging to one another, so caring.' And I thank you for that."

Zebra Truth 10. The Totally Empowered Organization Is Greater Than the Sum of Its Parts.

People in organizations are as empowered as they choose to be. They constantly make choices in the context of their personal lives, their families, the communities, and their places of work. Business organizations, too, choose whether or not they will be empowered. Unfortunately, most elect to maintain the status quo, changing only when motivated by unbearable pain, such as that caused by a financial crisis; by the realization that market share has been eroding; by the sudden appearance of an aggressive, upstart competitor that offers new technology, lower prices, or better service; or by any number of situations that can throw a business into a tailspin.

The good news is that regardless of its motivation or the stage of its natural history, a company can achieve and enjoy the benefits of total organizational empowerment. Black & White entered the crisis of 1989 as a very unempowered organization; Team Zebra emerged at the end of 1991 as a collection of empowered individuals and teams that somehow added up to more than the sum of the parts. That intangible "extra" gave us the power to become effective competitors in the world marketplace. With cycle time reduced to unthinkably low levels, we could offer better levels of customer satisfaction than our competition. With inventories and waste shrunk to acceptable levels, we could produce higher-quality product at lower cost. And with new product development time drastically cut down, we could demonstrate unparalleled respon-

siveness to the needs of our customers and become known as an innovator in the global marketplace.

Part of the process of creating a totally empowered organization is the implementation of tools and techniques that span every function within the company, such as MRP II or ISO 9000. But even in situations where formal business strategies aren't appropriate, total organizational empowerment can be achieved by building cross-training and educational efforts that define and reinforce the links among internal customers. When people understand the "big picture" and how they fit into it, the organization suddenly becomes more than a collection of empowered individuals and transforms itself into a creative problem-solving machine that can quickly address any obstacle in the road.

Total organizational empowerment requires what I call "cascading leadership," which means that leadership permeates all levels of the company. This has nothing to do with titles or clout; shop floor operators can exhibit great leadership when they take a risk and prove that problems can be solved and resources saved by doing jobs differently than they'd been done in the past. Supervisors and managers can also exhibit outstanding leadership when they find new ways to help people develop their creative problem-solving abilities within their teams, when they help people learn from their mistakes, and when they find innovative ways to support and reinforce empowered thinking and action.

The totally empowered organization is, in effect, like a great family, waiting with outstretched arms as our team members did during the Pecos "trust fall" exercise. It encourages risk taking by minimizing consequences of failure. And the more people are willing to risk, the greater the chances that the organization will attain new levels of performance, profitability, and prosperity.

LESSONS FOR OTHER ORGANIZATIONS

From a purely practical standpoint, every company is already pay-ing people to show up for work every day. So why not maximize the outlay of capital? As in the case of quality programs, there's a need to provide some capability training and "reeducation" to get people thinking about their jobs in new ways. To be sure, though, when a company invests in the creative energy of its people, it will enjoy a return that compounds itself year after year after year.

But can other companies "clone" the Team Zebra experience? "Clone," no. Adapt, yes. All company cultures are unique, so what works in one may not be successful in another. Even within a large company, different "subcultures" may require their own empower-ment strategies. When asked why the Team Zebra spirit didn't spread throughout the rest of Kodak, I can only say that not everything we did in Black & White was appropriate for the other organizations in the company. This translation becomes even more difficult when you try to simply "clone" what we did at other companies.

Still, I believe that there are certain "universals" that apply to any company about to embark on a journey into the realm of em-powerment. I've distilled the following ideas from the Team Zebra experience, and wholeheartedly believe they can be tailored to any company wishing to unleash the creative potential within its people.

1. *Mean it—cause you can't fake it.*

You can implement certain improvement programs on a scale of 1 to 10, deriving certain benefits from the mere fact that you've brought them on-line. Later, your company can enjoy greater

benefits as you put more energy and resources into the program. With empowerment, however, it's all or nothing—you can't fake an empowering environment. People quickly catch on if their creativity is underutilized, and they'll deeply resent being asked to take risks when there's no bona fide support net to catch them if they fall.

A related concept is that for every thwarted "act of empowerment," it becomes increasingly difficult to get people to take risks in the future. Remember my father's comment that trust is only *loaned*—and easily *withdrawn*.

2. *Letting go is the biggest roadblock to total organizational empowerment.*

Empowerment can be a very threatening proposition for many in your management ranks. This isn't surprising, and those who feel threatened shouldn't be condemned; it's only natural to feel a sense of ownership in the privileges and authority that come from years of climbing the success ladder. The goal is to transfer that feeling of ownership from individual status and authority to a sense of being part of a larger team. People can and do feel a sense of satisfaction from organizational victories. But it may take time for them to become comfortable with a departure from the past ways, especially when they've been evaluated for so long on their ability to control others and force conformance to a set of rules.

Top management, too, may fear that letting go will lead to anarchy—which can happen if delegation is really abrogation in disguise. If you don't tie empowerment to goals, people can become autonomous "loose cannons" who leave a wake of destruction in their path. With well-defined objectives, however,

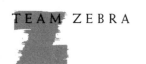

empowerment leads to interdependent teams that work in concert toward translating a shared vision into bottom-line reality.

3. *Align the letting-go process with the capabilities-building process.*

You can't ask people to let go without simultaneously building their skills and capabilities. Otherwise, you're asking them to step into a dark void with no maps, signposts, or night lights to show the way. Capabilities building can take many forms; the key is to select those that best meet the character of your culture. Whether you have people jump off 25-foot poles or settle back into classroom seats, the key is to find appropriate opportunities that you can adapt to your organization. Every company is the best expert on its own people, if it just stops, looks, and asks what will best get the job done.

4. *Build a solid HR strategy to create a solid empowerment strategy.*

As sexy as "empowering environments" might sound, the key to creating one lies with something far more mundane: your HR strategy. An HR strategy that leads to an empowered workplace takes into account certain fundamental beliefs about people and their relationship to their jobs. These were best summed up by Douglas McGregor 30 years ago when he formulated his theories of human behavior and work. According to McGregor physical and mental work is as natural as rest or play; people will exercise self-direction, once committed to an objective; commitment is a function of rewards associated with achievement; people learn to accept and then seek responsibility; the ability

to apply imagination, ingenuity, and creativity to solving organizational problems is widely distributed among people.

If you start off with McGregor's conclusions and combine them with Dave Ulrich's teachings—that organizational capability is a result of shared mind-set, organizational values, common vocabulary, active leadership, and business knowledge—you'll have the basis for a powerful HR strategy that will likely include the following elements:

- *Effective communications.* Communication must be open and cut across the entire organization; it must be up, down, and across, and it must be everyone's responsibility, not just those "in charge."
- *Rewards and recognitions.* For most people, pay and benefits aren't the stumbling blocks to choosing empowerment. Once you've wrestled through the right kind of monetary rewards, what people crave and respond to is "soft stuff"—the pats on the back, the acknowledgment of work well done and so on.
- *An empowering selection process.* Don't select people to be in positions of authority if they don't understand empowerment. Remember that some people get it from the start, some people learn it over time, and some people will just never be comfortable with it at all. Develop filters like those we used to weed out people who hog the glory for themselves and leave the failures to the rest of their team.
- *Self-esteem building appraisals.* Use appraisals as a coaching tool and a means of reinforcing what people do right, rather than a hatchet for telling them what they do wrong. Build expectation into the appraisal process; when people know what they're supposed to do, they'll live up to it. Make your appraisals dynamic, too, by keeping them in synch with changes happening in the business. Finally, include customers and peers in the feedback loop.

- *Capability building.* Go beyond training and use capability training to enhance people's skill sets beyond the requirements of their jobs. Your people will act like partners and pay you back tenfold. Technical skills are critical, and so are "social skills." And communicating, teamwork, and leadership must be enhanced for everyone.

5. *Tie empowerment strategies to other strategies.*

You don't "do" empowerment they way you "do" Just-in-Time, ISO 9000, or MRP II. Empowerment is a complement to virtually every system and process in your company, whether it takes place in the boiler room or the boardroom. That means you don't just "set it and forget it" and hope to reap the rewards. You constantly need to create new opportunities for people to exercise their creativity and choose an empowered way of doing their jobs. Continuous improvement breeds continuous empowerment. And continuous empowerment leads to TOTAL empowerment. To paraphrase the old Kodak slogan, "You press the button and WE do the rest!"

A final word of advice for those who embark on an empowerment strategy: be patient. If patience is a virtue, as the old saying goes, it's an absolute essential when it comes to empowerment. Like a cautious banker, people are particular about how and where they lend their trust. Every workforce will respond differently to the empowerment opportunities at hand, depending on the amount of divisiveness that characterized the culture in the past. Change may be almost imperceptible at first. But eventually a "critical mass" will form, and the culture will be born anew—spirited, like a frisky zebra colt.

"On the Lookout"

This is just one glimpse of interesting days in a Boy Scout Camp. You can see all the fun for there are forty Kodak pictures in the Boy Scout Story :

"Proof Positive"

The pictures help to tell a real detective story with a boy scout Kodaker as a wide-awake detective. It is a story of Scouts' honor, and is told in such a manly boy's way that it will make every Scout proud of his organization.

A copy of "Proof Positive" will be mailed without charge to any Boy Scout or to any other boy that is interested in them.

EASTMAN KODAK COMPANY

437 State Street **Rochester, N. Y.**
The Kodak City

POSTSCRIPT:
VISIONS OF
BLACK & WHITE

"So, what are you guys dreaming about lately?" asked Charlie Newton as he sipped an iced tea in the dining room of the Rochester Yacht Club. In June of 1993, it was my turn to host the "YFR" (young fogy retirement) group at lunch. As usual, I chose one of my favorite spots. From the club's dining room, you could see the Genesee River flowing north into Lake Ontario.

"Golf. And travel," said Phil Leyendecker, who had helped with our Team Zebra HR strategizing. Phil now works as a consultant who networks HR managers of large companies. "I'm busier now than before I retired."

"Inventing a time machine and meeting George Eastman. I'd love to talk shop with him," said Rod Lowe. (Rod had perfected a process for converting old photographs into unusual pieces of art— a hobby that's become a second career.)

While the other nine members of the group who took the "R-cubed" early retirement package in December 1991 joked about what they were doing and what they'd like to be doing, I sat back in my seat and stared out over the lake, which was remarkably still that day. If it had been a mirror, it would have reflected the dream I often have these days about the incredible journey of Team Zebra, and how we took a group of people from the depths of despair to the heights of accomplishment and acclaim in such a short period of time.

I dream about how we created an environment of trust, honesty, teamwork, and coupled it to customer-driven performance measurements, then invited people to become partners in translating our vision into reality.

And I dream about inspiring others to elevate their own organizations to the kind of high-spirited, top-performing, and fully empowered state that the Zebras enjoyed.

In retrospect, we did have a great terrific start. Despite all of the grief Kodak experienced in the late 1980s, I believe it's a great company with more than 100 years of success on many fronts. It has been very generous with its employees and the surrounding community. Its customers are loyal and admire its products and services.

Many of the elements of the crisis of 1989 have improved, too. The settlement with Polaroid is over and didn't bust the bank as some predicted. Hundreds of millions of dollars have been spent to address environmental matters, with much more committed for the future.

Despite these victories, financial performance has disappointed many. For 1992, Kodak was nineteenth in sales on the *Fortune* 500 list and twelfth in profits. Twenty years ago, the company was third in market valuation, while 10 years ago, it was seventh; as of March 1993, the company had slipped to twenty-fourth place. The first half of 1993 was also a tumultuous time for the company. The stock

was on a roller coaster. An outsider CFO was hired to help restructure the company's financial position, but left after a short stay. In early August of 1993, the Board of Directors asked then CEO Kay Whitmore to resign and announced the search for an outsider to replace him.

Yet, unlike other giants in tough situations, Kodak continues to be profitable . . . just not as much as people have grown to expect based on the company's history. One aspect of the fiscal crisis that seems to have been forgotten is that Kodak's earnings never dipped into the red; rather, its margins slipped and profitability simply wasn't as strong as it had been in the past. Still, it continues to churn out innovative new products like photo CD and single-use cameras, both of which hold great promise for the future.

And what about Black & White? When I left, I knew the flow was in good hands. For the flow's first year, circumstances dictated that the budget be set by a small number of people—Bob McKinley, Bob Brookhouse, and myself—strongly guided by Ron Heidke's expectations. In the second year, the Gang of 33 became full partners in examining past performance and setting "stretch"-type goals for 1991. In addition, we went well beyond the traditional financial-only kind of budget to one that covered all aspects of our performance including quality and human resource strategies. And for the 1992 budget, which was set in the fall of 1991, the leader for the effort, Gene Salesin, a chemical engineer with little financial background, adopted the theme "Operation Budget Storm," along with 150 partners. Operation Desert Storm had just been concluded in the Middle East, and, using the military theme, we had a very spirited budget campaign, replete with war maps, a revised version of the "Battle Hymn of the Republic," fatigue caps, and other related paraphernalia. The team devised a very tough budget "built from the grass roots" instead of dictated from above.

When the budget was presented to Vern Dyke, I happened to be attending a networking conference with other companies in

Cincinnati. Although I was aware of what was to be presented, it was a major act of letting go, since Kodak managers were traditionally expected to be there when their unit budget was conveyed presented to top management. Since all 150 partners attended the presentation, Vern had to visit us in our "war room." The process was so successful and enjoyed so much ownership that by the time 1992 ended, the demanding financial goals were exceeded by more than $15 million.

Today, the legacy of Team Zebra lives on. No one is better qualified to talk about its ongoing strength than my successor, Bill Wallace. (Bill had been part of the original flow planning team, but had taken an overseas assignment. For him, it was like stepping into a time warp.) Here's what Bill had to say:

As my management relationship with Team Zebra began in July 1992, two points became quite apparent:

1. The original "mission" developed by Team Zebra in 1989 was equally as relevant in 1992.
2. The partners were totally committed to, and lived by, their established principles regarding customer satisfaction, communications, trust, and capability development.

This highly visible "mission" and "principles" were the solid foundation on which the flow was built, and by which it continues to operate today.

During the past year, both shareholder and corporate pressures have accelerated requirements to improve productivity and earnings. All Zebra partners have accepted these challenges, and continue to demonstrate significant improvements in product quality cycle time, process control, and equipment efficiency. Paradigm shifts in all areas are contributing to labor

cost and inventory reductions. Continuous change, teamwork, and empowerment are now accepted ways of life.

While our long-term strategy continues to be dynamic, a deep pride in, and strong ownership of, the business remain. Regardless of the challenges confronting the Black & White flow, both now and in the future, Team Zebra remains "full of spirit and kicking the competition."

When we first started the Team Zebra journey any talk about being "full of spirit" and "kicking the competition" would have evoked gales of laughter, and possibly a recommendation for immediate psychiatric treatment. Yet deep in my heart, I knew that we were involved in something far more reaching than a new organizational chart—we had begun a process that would fundamentally transform our business. I knew that we would unleash the phenomenal potential of the partners who brought with them an intimate knowledge of the film-making process. And I knew that many of the partners shared my loyalty to the company and my belief that it was worth giving whatever it took to help get it back on track. For the past 100 years, Kodak had served its employees, customers, and the surrounding communities well. As one partner, a third-generation "Kodaker," told me during a research visit for this book, "Kodak had been very good to my grandfather, my father, and now me. So when the outside world was beating on the company, that really hurt. When a good friend is down you lend a helping hand without asking 'What's in it for me.'"

While it would be naive to assume that everyone in the flow shared the same kindred feelings about the company, I think it's fair to say that most of the people in Team Zebra felt the challenge of being an underdog (or in our case, an endangered species), as well as the thrill that comes from pulling out of last place and galloping across the finish line to win an upset victory against seemingly

impossible odds. Everything was stacked against us when we began the flow, everything except our people. And if you've gained anything from the Team Zebra story that you can apply to your own organization, it's the importance of understanding and valuing your real partners. When you believe in your partners, you can pull through the toughest times and go on to build for a prosperous future. No one said it better than George Eastman himself. While on Safari in Africa in 1926, Eastman stood motionless while filming a wild rhinoceros that was charging directly at him. Rather than running for cover, he waited until someone in his party shot the beast, which dropped at his feet. When asked why he didn't flee, he replied, "Trust. You just have to trust your people."

INDEX

About the Authors

Stephen J. Frangos served with Eastman Kodak Company for 34 years, culminating his career there as the manager of Black and White Film Manufacturing operations in Rochester, New York. Under Steve's leadership, the black and white film making operation, known as "Team Zebra," underwent an exciting transformation from an unempowered and failing part of the company to one of the most productive and highly desirable organizations in the corporation.

Currently, Steve is an executive consultant for Achieve International, a division of Zenger-Miller, Inc., an international consulting and training company with over 3,000 clients worldwide.

A recognized authority on creating "total organization empowerment," Steve has lectured on the subject for a number of universities and professional societies throughout North America. He has also worked with a wide variety of manufacturing

companies and service organizations to assist them with their excellence efforts.

His formal education includes a degree in chemical engineering from Carnegie-Mellon University. He has also attended executive development programs conducted by Duke, Harvard, and George Washington Universities.

The proud father of three daughters, he resides with his wife, Kathy, in Rochester, New York.

Steven J. Bennett is a full-time author who has written and/or collaborated on more than 40 books on subjects ranging from business and computing to environment and parenting. He lives with his wife and two children in Cambridge, Massachusetts.

C. Scott • B. Johnson • R. Denning • T. Worthy • P. Messer • S. Wagor • M. Palis
M. Chatzikonstantinou • T. Babcock • D. Berback • R. Lewis • L. Denning • D. Johnson • O
R. Brodner • S. Zehr • D. Jurs • E. Reichert • M. Groth • S. Yim • W. Shaw • A. Redn
E. Morrill • R. Sidebotham • V. Ariola • B. Randolph • C. Farr • D. McDowell • M. Lana
G. Kramb • C. Karniski • W. Owens • C. Herrera • R. Hart • R. Jackson • A. Anderson • N
A. Jackson • J. Farrell • M. Snyder • R. Hidalgo • S. Meier • C. Mendola • B. Daley • B.
M. Taccone • W. Dupra • P. Schreiner • A. Watson • N. Kelley • W. Egbe • M. Pittman • F.
P. Goodwin • G. Williams • W. Ziegler • S. Kos • H. Ettinger • M. Fenush • D. Davis • D. V
J. Epps • R. Swarthout • T. Spatovico • S. Eckert • R. Ientilucci • J. Magin • R. Powers •
T. Spino • R. Countryman • L. Pereira • J. Wilson • J. McCullough • J. Besse • S. Dasson
D. Stasko • J. Pratt • W. Marzano • M. Oliva • B. Smith • P. Briggs • R. May • S. Tobey
R. Panik • P. Brauch • J. Hawthorne • G. Murray • W. Schultz • M. Lieders • K. Adam
B. Lorenzo • D. Brewer • C. Deruyter • G. DiMora • P. Chaney • B. Denaro • J. Foss
G. Billingsley • M. Marzulo • D. Nicholson • J. Boone • D. Rusin • A. Dimartino • A. Obaid •
J. Welch • E. Taillie • C. Anderson • F. Simmons • F. Julian • K. Carvey • B. Margis • D.
D. Schroeder • F. Russo • D. Fair • D. Harris • D. Manuel • D. Blanchard • P. Leutz • R. Ri
C. Evans • P. Burns • B. Winzenried • N. Waddell • O. Gibson • D. Gabriele • R. Greene •
R. Gillette • J. Smith • J. Farkas • J. Scott • G. Kalweit • K. Albano • T. Mikolaichik •
C. Wood • S. Stenzel • D. Barber • V. Colern • F. Bischoping • F. Monfort • L. Gammill •
D. Merzke • T. Slattery • W. Morgan • G. Wooten • M. Hayward • D. Thomas • W. Shul
E. Moorehead • B. Carter • M. Maurice • D. Lewis • N. Bacon • R. Williams • G. Locke
K. Nichols • E. Michaels • N. Otero • R. Stewart • J. Votry • D. Kramer • L. Forshee • V.
S. Dagostino • G. Michniewicz • B. Talbot • D. Turkington • H. Habgood • S. Campbell
C. Billerbeck • S. Lobiondo • D. Nettnin • E. Olivo • E. O'Leary • R. Watson • W. Drake •
G. Morin • D. King • F. Ussia • C. Hendrickson • D. King • W. Lowery • D. Bartz • T. Ng
R. Newman • R. Fosher • A. Phillips • L. Hawkins • T. Francis • C. Bellinger • J. Engle • R.
L. Fumia • S. Rutledge • J. Forkell • R. Phillips • B. Jenkins • P. Knight • S. Morrison •
L. Lassiter • R. Troutman • D. Rath • D. Fritz • M. McWhinney • H. C. Brumfeld • D. Lovi
W. Bastian • L. Briggs • R. Furino • T. Purdy • W. Siolauskas • D. Resch • D. Provost • J
A. Huss • K. Jason • G. Conley • N. Adams • W. Young • R. Bowen • T. Severn • D. Den
D. Pagano • S. Steinwachs • K. Pickett • R. Barley • K. Maurer • K. Efing • J. Schaub • S
F. Marsocci • W. Baconcini • M. Difranco • M. Durning • A. Gonyo • P. Wandtke • R.
D. Speciale • G. Schlueter • J. Shonk • M. Purol • E. Fishbaugh • L. Cooper • P. Gillette
J. Kohler • R. Miller • M. Johnson • T. Neary • J. Smith • S. Richardson • C. Ernst • R. Pres
N. Bovenzi • R. Jackson • C. Pond • W. Swartz • D. Parmele • L. Zazzara • A. Smith • K. I
E. Jablonski • D. King • I. Gordon • B. Helfert • N. MacQuarrie • S. Jabaut • C. Barrenti
S. Culhane • B. Friday • W. Coon • B. Douglas • D. Abbott • C. Henchen • H. Damouth
C. Elias • G. Dailey • W. Sly • C. Decker • T. Hargrave • R. Wallace • P. Khieu • T. Wasn
D. Albro • S. Mosley • B. Lipinski • B. Barnhart • T. Raab • A. Stephens • J. Pettit • J. Ski
Z. Bogojski • M. Ciaccia • D. Dermody • V. McMullen • N. Campa • A. Cripps • G. Linn •
A. Strout • S. Burge • R. St Pierre • P. Snyder • L. Joseph • R. Derue • K. Fisher • R.
J. VanNeil • M. Perrin • T. Smith • F. Morales • M. Martin • S. Lamkin • D. Stith • D.
A. Agnello • J. South • S. Brown • M. Santana • R. Pagano • A. Pickens • R. Mullins •
A. Henry • R. Nothnagle • C. Calnan • J. Fleig • K. Ochs • W. Beck • J. Waffle • S. Weis
F. Gulick • D. Schuster • W. Earle • B. Miller • S. Allen • B. Mather • J. Cappello • J. C
T. Fuller • R. Brown • J. Civitello • E. Bizari • K. Koenig • J. Nardi • K. Allocco • G. C
M. Vandeviver • G. Janus • P. Sullivan • G. Walters • T. Kettles • W. Thomas • D. Helm
G. Sutton • L. Gayle • E. Phillips • B. Claybaugh • I. Crandall • F. Bernabei • T. Gangro
W. Rizkallah • S. Disalvo • R. Spinelli • T. Parker • D. Morgan • J. Sentman • B. Castle
D. Carpenter • W. Zinner • D. Stein • L. Smith • D. Wille • J. Divito • A. Weiser • T. Mc
R. Schappel • P. Mandrino • M. Newton • R. Wiesner • S. Sferrazza • L. Scalia-Graves • K.
D. Hart • S. Smiley • A. Cavallaro • D. Yost • S. Klingler • G. Quaring • P. Schneider